W9-CAI-517

Virtue and Magnificence

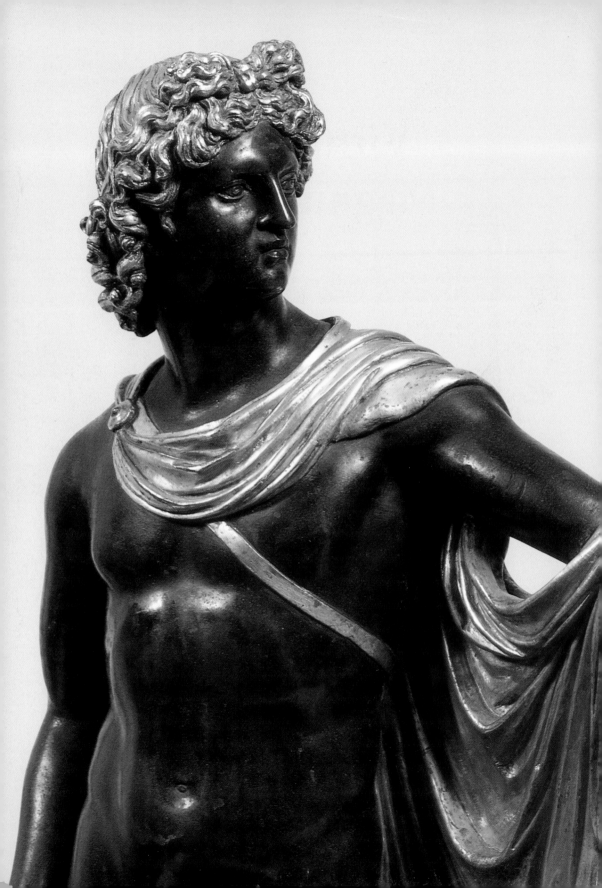

Virtue and Magnificence

Art of the Italian Renaissance Courts

Alison Cole

PERSPECTIVES

HARRY N. ABRAMS, INC., PUBLISHERS

Acknowledgments

I would like to thank the following people for their help and encouragement. I am particularly grateful to Sharon Fermor for her consistent and unerring support, and to Lesley Ripley Greenfield and Tim Barringer for suggesting that I undertake such an important and rewarding project. Many thanks as well to Lauro Martines and Francis Ames-Lewis for generously reading the book at manuscript stage and offering constructive comment. I also benefited from the suggestions of Evelyn Samuels Welch, the genealogical research of Shayne Mitchell, and the invaluable resources of London University's Warburg Institute.

In addition, I am grateful to my editor Jacky Colliss Harvey and my copy-editor Damian Thompson for their sensitive and thorough reading of the text. Special thanks, too, to my picture editor Susan Bolsom-Morris for her energy and resourcefulness in tracking down the finest illustrations.

On a more personal note, I would like to thank my family – Keith, Jay, and Louis – for their support and patience; my father, Michael, for looking over the manuscript; and my brother Sam in Rome for keeping me in touch with Italy at all times.

Frontispiece ANTICO *Apollo,* page 164 (detail)

Series Consultant Tim Barringer (Victoria and Albert Museum)
Series Director, Harry N. Abrams, Inc. Eve Sinaiko
Editor Jacky Colliss Harvey
Designer Karen Stafford, DQP, London
Cover Designer Miko McGinty
Picture Editor Susan Bolsom-Morris

Library of Congress Cataloging-in-Publication Data
Cole, Alison.
 Virtue and magnificence : art of the Italian Renaissance courts/
Alison Cole.
 p. cm. — (Perspectives)
 Includes bibliographical references (p.2) and index.
 ISBN 0-8109-2733-0
 1. Art, Italian. 2. Art, Renaissance — Italy. 3. Art and state —
Italy. 4. Art patronage — Italy. I. Title. II. Series :
Perspectives (Harry N. Abrams, Inc.)
N6915.C595 1995
709'.45'09024 — dc20 94-34268

Copyright © 1995 Calmann and King Ltd.

Published in 1995 by Harry N. Abrams, Incorporated, New York
A Times Mirror Company

All rights reserved. No part of the contents of this book may be reproduced
without the written permission of the publisher

This book was produced by Calmann and King Ltd., London

Printed and bound in Singapore

Contents

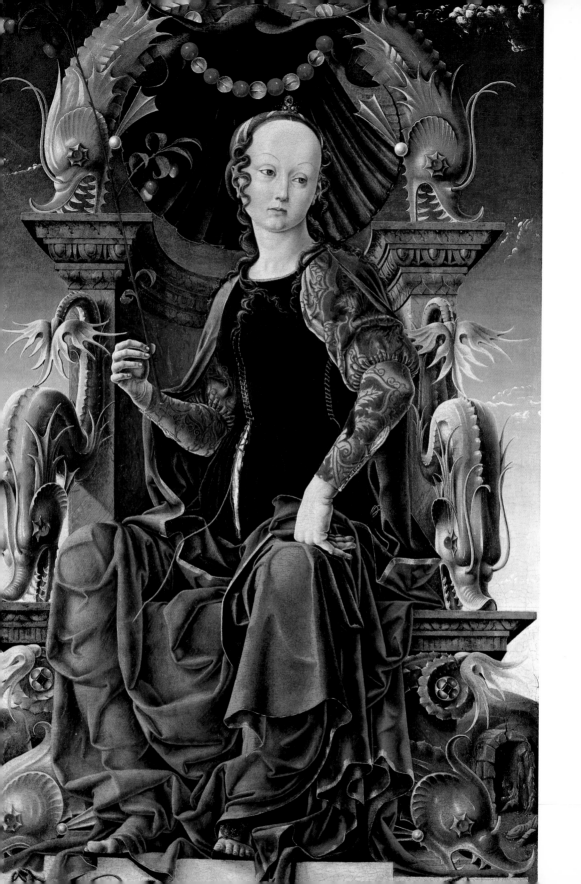

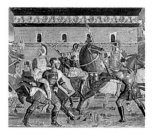

The Renaissance Court

1. COSIMO TURA
Allegorical Figure (the Muse
Calliope?), 1458-60. Tempera
and oil on panel, 45³/₄ x 28"
(1.1 m x 71.1 cm). National
Gallery, London.

Tura painted this fantastic
figure as part of the decoration
for the Este villa of Belfiore,
Ferrara.

S tudies of the Italian Renaissance – a period that embraces the fifteenth and early sixteenth centuries – tend to focus on the famous centers of Florence, Venice, and Rome. Yet, despite their undoubted importance, these are only three among the many artistic centers that contributed so enormously to the flowering of the arts in Italy at this time. In late medieval writings, the idea of *rinascità* (rebirth) defined a movement rather than a period, focusing on the revival of classical learning and an exhilarating sense of renewed human potential in the moral, political, and creative spheres. This revival gathered pace in the fifteenth century, nurtured by princes and popes as well as doges, bankers, merchants, and clerics. The regional courts, with their hunger for novelty, love of magnificence, and thirst for recognition, played a key role in the dissemination and development of Renaissance ideas. The way they seized on the latest trends and innovations, or adapted them to suit local traditions and political agendas, helps to account for the richness and diversity of Italian art during this period. It is therefore worthwhile to concentrate on the visually splendid culture of five princely courts: Naples, Urbino, Milan, Ferrara, and Mantua (FIG. 1).

Since the fragmentation of Italy, which accompanied the fall of the Roman empire in the fifth century, the country had never regained a stable national or cultural identity. After about 1200,

it evolved into a ragged patchwork of city-states with no community of purpose: there were republican oligarchies like Florence, Siena, Lucca, Venice, and Genoa; the papal court of Rome; and numerous princely courts, which were either imperial fiefs (territories that owed allegiance to the Holy Roman Emperor) or papal states (those that owed allegiance to the Pope). These territories were nominally required to pay dues or give military service to their imperial or papal overlord, but in practice enjoyed virtual independence. To the south was the great Kingdom of Naples and Sicily, while to the north was the wealthy and powerful principality of Milan. The other major princely courts, Ferrara and Urbino (established duchies from the 1470s), and the marquisate of Mantua, were small in comparison, their prestige due in large measure to their patronage of the arts. There were also the tiny marquisates of Saluzzo and Monferrato as well as minor courts such as Rimini, Bologna, and Pesaro, which were ruled by papal vicars.

There has recently been a great deal of discussion about what constitutes a princely court. The Italian term *corte* defines an enclosed space, as in a courtyard. In a political and social context, the court defined the space inhabited by the prince (the lord of a territory), his consort, household, courtiers, and officials; this space had invisible boundaries which were determined by those who exercised power and influence on behalf of the prince. At the heart of the court was the palace or castle, which functioned as the ruler's principal residence, the city's prime fortification, and, increasingly, as the financial and administrative center of government (FIG. 2). This usually formed part of a complex of court buildings constructed around ceremonial spaces and thoroughfares, sacred chapels and monasteries, gardens and hunting parks. Defensive structures such as moated walls and massive ravelins could provide a sense of security and enclosure, but the "enclosed" nature of courts stemmed more from the attitudes of their ruling elites. Some rulers, like Ercole d'Este of Ferrara, chose to distance themselves and their immediate household from the populace at large, in

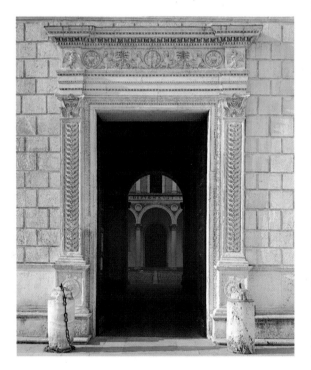

2. Doorway to a courtyard of Federico da Montefeltro's Palazzo Ducale in Urbino, built toward the latter half of his rule (1442-1482).

keeping with the idea of the divine authority of princes (FIG. 3). Others were more accessible. Among the ruling classes, subsumed as they were into the court structure, a sense of superiority, of being an "insider," led to a careful shepherding and bestowing of privilege.

In a physical sense, the court was not sealed off from the outside world: court personnel changed constantly, there were streams of visitors to and fro (as well as resident ambassadors and diplomats from other centers who were almost part of the court household), and those who were employed by the court did not necessarily reside within it. Galeazzo Maria Sforza's court of Milan, which underwent great expansion during his rule, was full of "foreigners" and provincials; it was also intimately integrated, through marriage, with the small court of Savoy. Matrimonial and military alliances meant that there was much interconnection between courts, rather than sharp demarcation (FIG. 4). Usually, when relations between city-states were harmonious, this was mirrored in their cultural exchanges. Ruling families were also integrated with the lesser nobility, to whom they often married their illegitimate offspring. The distinction between court and civic or ecclesiastical institutions was sometimes similarly blurred, for the prince participated in large civic projects and funded religious orders. In addition, the court traveled – though much less so than in northern Europe, where power was dispersed through the lord's various country estates rather than concentrated in the city. In Italy, when the court journeyed from city-center to rural villa or from state to state, it took its urban identity and a large proportion of its personnel with it.

The court did, however, retain a remarkably consistent character: courtiers came and went, but their roles were still determined by the ruler and his family, as well as by set rituals and the existing structures of local government. Power was exercised both by the prince, who had overriding authority, and by the court's bureaucratic machine, which often acted autonomously within the prince's general dictates. Some princes delegated control of construction work and artistic projects to highly placed intermediaries, who vetted designs and oversaw various stages of

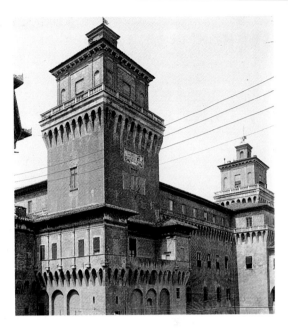

3. The fifteenth-century Torre del Leone of the Este castle at Ferrara.

4. Dish from Faenza, c. 1476. Tin-glazed earthenware, diameter 18" (45 cm). Metropolitan Museum of Art, New York.

The dish shows the arms of Matthias Corvinus, King of Hungary, and Beatrice of Aragon. It was made to commemorate their marriage in 1476.

execution. A measure of a court's power was its ability to recruit the best people, from military generals to foreign musicians, and retain their services for as long as they needed them. Many outsiders were attracted to court by the financial and social rewards; others used it as a staging-post in their careers. A number of courtiers led double lives, working within the court structure as well as for outside employers. Artists were often transient members of the court household; their mobility led to a dissemination of different regional styles and rapid assimilation of the newest techniques.

While hundreds of laborers and artisans were sucked into the great artistic projects of the courts, it was the nobility who dictated the form of most of their endeavors. Renaissance society was extremely conscious of social divisions: noble birth was of prime importance, although an opportunist *condottiere* (mercenary captain) like Francesco Sforza could rise to the rank of duke through his connections and abilities. Profession was very much the key to social mobility, with arms (soldiering), the law, and letters conferring a degree of nobility. At its simplest, life divided itself into the serviceable categories defined in Niccolo Machiavelli's play *The Mandrake Root* (*Mandragola*, published 1524): gentlemen/tradesmen; rich/poor; natives/foreigners. At the end of the fifteenth century, Leonardo da Vinci submitted an idea for the urban remodeling of Sforza Milan in which a raised section of the town facing the sun was designated for the court and nobility, while a lower shaded section, down some stairs,

5. CIRCLE OF ANDREA MANTEGNA *The Justice of Trajan* (front panel from the marriage chest of Paola Gonzaga), 1477. Tempera, stucco relief, and wax color on wood, 27¹/₄" x 7' ⁵/₈" (69 cm x 2.1 m). Landesmuseum, Klagenfurt.

This panel is from an elaborate gilded *cassone* (wedding chest), one of a pair taken to Germany by Ludovico Gonzaga's daughter, Paola, on the occasion of her marriage in 1477 to Leonhard, Count of Görz. The two chests illustrate (in a continuous frieze) a moral tale from antiquity which furnishes the newlyweds with a stirring example of "Christian" virtue. The story, however, takes second place to the splendid military procession. The buildings include the Mantuan church of Sant'Andrea, and the Gonzaga emblem of the sun blazes from the *all'antica* cornice of the main palace facade.

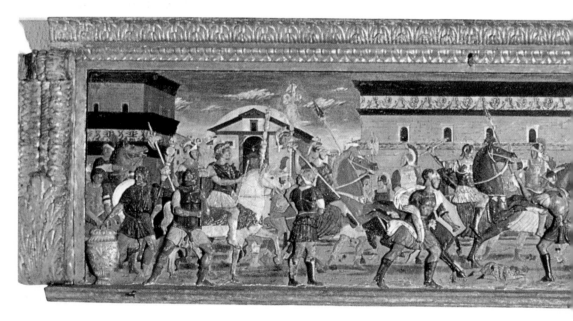

6. MASTER OF THE PALA
SFORZESCA
Pala Sforzesca, c. 1496-97.
Tempera on panel, 7'6 ⅞" x
5'5¼" (2.3 x 1.6 m). Brera,
Milan.

Detail of the figure of Beatrice,
wife of Ludovico Sforza.

was allocated to the workers and the poor. This crude upstairs/
downstairs demarcation makes it clear that court art was fash-
ioned by an elite, mainly for an elite audience.

With the huge traffic in international diplomacy, Italian
courts enjoyed close contact with foreign courts, particularly
those of France, Germany, Spain, and Burgundy. Though their
stature remained essentially provincial, Italian courts enhanced
their international standing by bestowing lavish hospitality on
visiting dignitaries and marrying into high-ranking foreign fam-
ilies (FIG. 5). As Leon Battista Alberti wrote in his treatise *On the
Family* (*Della Famiglia*, written between 1435 and 1444), mar-
riage had a bearing on "counties, regions, and the whole world."
None of the Italian courts, however, could command the inter-
national cachet enjoyed by Rome at the end of the fifteenth cen-
tury. Yet in some sense art was a great leveller among them as
they competed for prestige and tried to keep pace with prevail-
ing standards. Thus Italian princes imitated the interior splendor
of Burgundian castles, collected French chivalric romances, cov-
eted French and English chivalric orders, and adopted the ele-
gant dress and civilities of the Spaniards (FIG. 6).

Most princes doubled as *condottiere*, earning huge salaries by
hiring out their troops and expertise to larger Italian powers. For
some states like Urbino, which had little local industry or
resources, the ruler's *condotta* (mercenary contract) was the main
source of income. An education in arms and horsemanship was
crucial to a prince and those who wished to serve him. Indeed
princelings were usually sent to
other courts or to famous *condot-
tieri* to learn their skills, and
these were practiced on the hunt-
ing field or in athletic and joust-
ing contests. From the 1440s, it
became customary for rulers to
give their children a humanist
education, so that chivalric ideals
of honor and glory could be
combined with examples of
ancient statecraft and military
strategy. More importantly, the
ethics of ancient Rome and
Greece provided them with a
moral framework within which
to construct their public and pri-
vate lives Humanism derives its

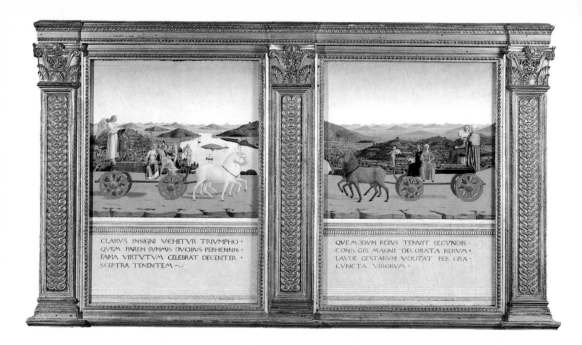

CLARVS INSIGNI VEHITVR TRIVMPHO ·
QVEM PAREM SVMMIS DVCIBVS PERHENNIS ·
FAMA VIRTVTVM CELEBRAT DECENTER ·
SCEPTRA TENENTEM ·

QVE MODVM REBVS TENVIT SECVNDIS ·
CONIVGIS MAGNI DECORATA RERVM ·
LAVDE GESTARVM VOLITAT PER ORA ·
CVNCTA VIRORVM ·

name from the "humanities," a syllabus that covered grammar, rhetoric, poetry, history, and moral philosophy, and placed great emphasis on the ability to read classical texts in Latin, the language of the educated elite. Many of these texts had been rediscovered in the late Middle Ages and were enjoying an unprecedented revival.

Rulers' wives often received a humanist education as well, but their role as patrons of the arts was circumscribed by lack of funds: money allocated to them went largely toward the costs of running their own households, and most of a wife's personal expenses were paid by her husband (clothes and finery reflected honorably on the provider). While the consort took an active interest in the decoration of her own apartments, and the commissioning of small devotional pictures or illuminated manuscripts, she was rarely involved in projects of a more public nature. The court of Ferrara, where Isabella d'Este was raised, seems to have allowed women a greater role in political and artistic decision-making. Here Eleonora of Aragon ran affairs of state in her husband's absences on *condottiere* business, and Lucrezia Borgia (wife of Alfonso d'Este) presided over a glittering artistic and literary circle. Double portraits of the ruler and his wife, nevertheless, reveal the limited sphere the consort was expected to occupy. On the reverse sides of Piero della Francesca's panels of Federico da Montefeltro and his late wife Battista

Sforza (FIG. 7), he is accompanied by the Cardinal Virtues (justice, prudence, fortitude, and temperance), she the Theological Virtues (faith, hope, and charity). Battista's inscription reads: "She that kept her modesty in favourable circumstances, flies on the mouths of all men, adorned with the praise of her great husband's exploits."

The individual character of the courts was determined very much by their size, wealth, and origins. The Este of Ferrara and the Gonzaga of Mantua emerged from landed families with large country and urban estates, gaining their income from agriculture and condotte rather than business or commerce. Visconti-Sforza Milan had a thriving industrial base, but was predominantly military in character. Conversely, the economy of republics was usually based on their regional importance as commercial or industrial centers. In these city-states the nobility had been largely absorbed into the town and there was a thriving middle class. Florence, Genoa, and Venice were ruled by governmental committees, dominated by a few patrician families. Venice celebrated her Byzantine heritage, her wealth, and her status as a center of international trade with a great Mediterranean empire. The close link between religious and governmental institutions is manifested by the resonance of Christian imagery in Venetian state art.

Florence, which was dominated by the Medici faction from 1434 to 1494, appropriated some of the chivalric culture of the courts. Her complex and ambiguous status as a "courtly" center has often been debated. The Medici, however, were bankers, not soldiers schooled in chivalric ideals, and many of their commissions in the courtly vein are more self-consciously aristocratic than those of their princely counterparts. They did not preside over a large court, and there is no sense of a dominant "courtly style." Several of the skills that helped shape the distinctive character of Florentine art – practical mathematics, literacy, and numeracy – are products of Florence's mercantile ethic. The guilds that represented these interests – from the silk and wool merchants to the stonemasons and woodcarvers – commissioned the majority of public works in the early decades of the fifteenth century, subjecting them to rigid controls. Guilds, like princes, competed with each other for prestige alongside Florence's wealthy entrepreneurs, who built increasingly elaborate palaces and private chapels. The humanist Leonardo Bruni traced Florence's ancestry back to republican Rome, and Florentine humanists celebrated civic morality rather than the imperial virtues prized by the courts. Nevertheless, the Medici Bank's

7. PIERO DELLA FRANCESCA *Allegorical Triumphs* from the *Diptych with Portraits of Federico da Montefeltro and Battista Sforza* (reverse), c. 1472. Oil on panel, each panel: 18⅝ x 13⅛" (47 x 33 cm). Uffizi, Florence.

Battista is shown reading a prayer book, borne along in a chariot pulled by unicorns (symbols of chastity), and accompanied by the theological virtues. She is dressed in deep red, the color of martyrdom (she had died shortly after giving birth to Federico's son and heir), and rides through a landscape of approaching dusk. Federico is crowned by Victory, accompanied by the cardinal virtues, and rides towards her in a subtly contrasted landscape (which is nevertheless continuous with Battista's), filled with radiant light. The inscription below his chariot alludes to his right to wield the sceptre as he is borne along "in outstanding triumph."

international network of branches gave the family an extremely high external profile, and other states recognized their "princely" power and influence.

Rome had its own distinctive agenda: to assert its spiritual authority, religious splendor, and political power in the temporal sphere (as overlord of Italian territories). With the re-establishment of the papacy in Rome by 1420 (after the Great Schism and a long interval of absence, spent chiefly in Avignon), there was an urgent need to assert the city's credentials as the sole Christian capital. From a small market town and unprepossessing center of pilgrimage, it slowly transformed itself into a city whose architectural and literary splendors could rival those of Naples, Florence, and Milan. Again the language of antiquity was adapted to the purpose, as Rome reinvested itself with its former imperial grandeur. In addition to the popes, powerful baronial families and wealthy cardinals of the papal court patronized the arts and scholarship on a large scale. In the social hierarchy, cardinals were on a par with princes, and many created satellite courts of their own.

The relative neglect in Renaissance studies of the secular courts can be largely attributed to the problem of survival of works of art from these centers (FIG. 8). Due to fluctuating political fortunes and continual redecoration and modification of palaces and chapels, many key works have been destroyed and are known only through archival documents (reports from ambassadors and diplomats contain a wealth of material) and descriptions in contemporary literature and treatises. Nevertheless, enough works survive to give an outstanding picture of the aesthetic richness of the courts. In the last decade, there has been a resurgence of scholarly interest in this area and a spate of publications has appeared. While some have concentrated on art as a manifestation of aristocratic extravagance and despotic power, there is a new and more enlightening tendency to set the art within its broader cultural context and examine its complex variety of functions and values. Although there may be no such thing as an all-encompassing "courtly" style in the arts, it is rewarding to identify regional "courtly" styles and manners and explore the distinctive uses of art at court.

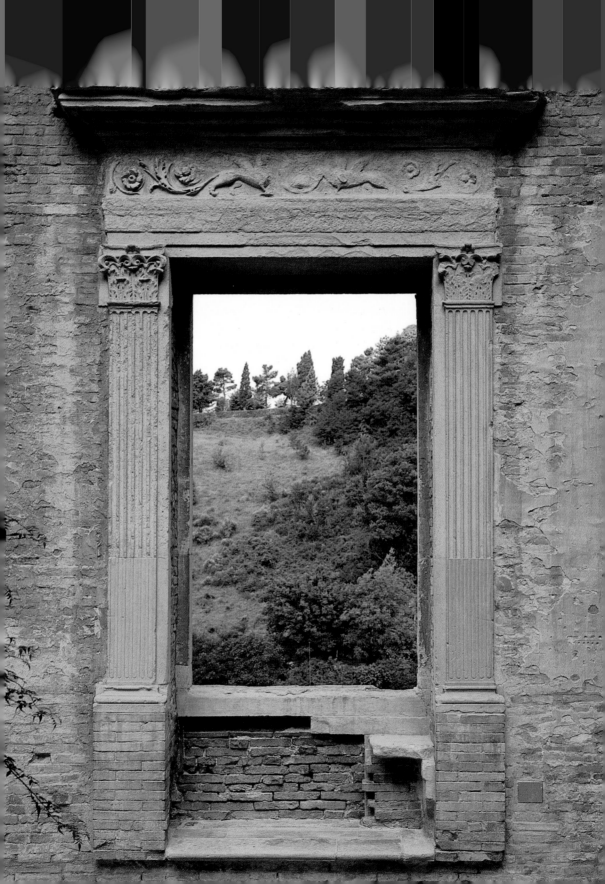

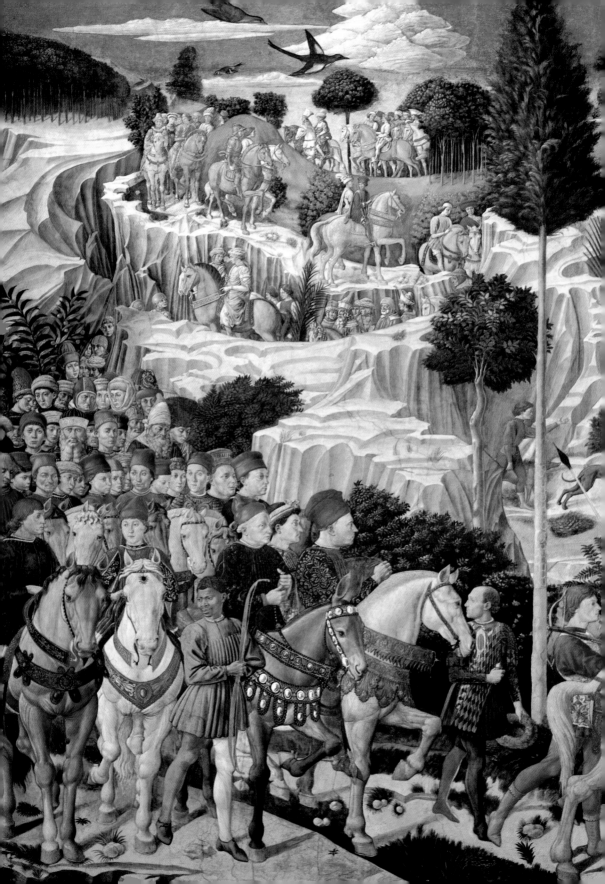

ONE

Art and Princely "Magnificence"

9. BENOZZO GOZZOLI
Journey of the Magi (detail),
1459. Fresco. Chapel of the
Palazzo Medici-Riccardi,
Florence.

Gozzoli's luxurious fresco
decoration was
commissioned by Cosimo's
son Piero de' Medici
(depicted in profile, on the
white horse), who had a
pronounced taste for costly
materials and took a keen
delight in rich incidental
detail.

For the Renaissance ruler, money lavished on art and archi-
tecture was money spent honorably. The moral and social
reservations about wealth that had persisted throughout
the fourteenth century (backed in many cases by laws prohibit-
ing luxurious display) were gradually dismissed in the fifteenth
century. Even in republics like Florence, where conspicuous
expenditure was discouraged for fear that it might provoke
envy, there was a gradual acceptance of Cosimo de' Medici's
duty, as head of the dominant Medici faction, to enrich the city
with marvellous buildings. Florentine humanists such as
Leonardo Bruni and Leon Battista Alberti, themselves from dis-
tinguished aristocratic families, cited the ancient Greek philoso-
pher Aristotle in support of such costly display: wealth, they
argued, was a prerequisite of virtue in the public arena, for only
the rich were presented with the opportunity of using money
virtuously and for the public good. Nevertheless, Cosimo – head
of a great banking family, not a princely dynasty – had a delicate
balancing act to perform. One citizen, annoyed by the display of
Cosimo's coat of arms (the *palle*, or balls) on so many of Flo-
rence's buildings, complained that Cosimo was trying to ram his
"wretched *palle*" down everyone's throat. Mindful of such reac-
tions, Cosimo rejected ambitious plans for his palace from the
architect Filippo Brunelleschi and accepted a more sober design
by Michelozzo di Bartolomeo in its place. Aristocratic embellish-

11. BONIFACIO BEMBO
Queen of Staves/Knight of Cups, from the Brera-Brambilla Visconti-Sforza Tarot set, mid-fifteenth century. Each card: 7 x 3½" (17.8 x 9 cm). Brera, Milan.

Bembo's set of tarot cards was commissioned by Duke Filippo Maria Visconti of Milan, and completed under his successor Francesco Sforza and his wife Bianca Maria Visconti. The cards are sprinkled with Visconti-Sforza arms and mottoes: the golden horse caparison of the Knight of Cups (on the right) is adorned with the Visconti sun with its distinctive wavy rays.

ments were reserved for the inner courtyard and interior, where Cosimo entertained visiting ambassadors and princes away from the public gaze (FIGS 9 and 10).

Rulers of principalities traditionally had fewer moral qualms about the virtues of spending lavishly and openly on art and ceremony. Where a prince was unpopular, as in the case of Milan's Duke Filippo Maria Visconti, who laid out enormous sums on architecture, extravagance was routinely defended by propagandists as *magnificentia* (FIG. 11). The Aristotelian theory of magnificence had been revived in the early fourteenth century as part of the political ideology of Filippo Maria's ancestor, Azzone Visconti, Lord of Milan (ruled 1302-1339). Azzone's magnificence – displayed in the decoration of his "honorable" church and "dignified" palace, as well as his great communal building projects and spectacular sacred pageants – is vividly described in one of Galvano Fiamma's contemporary chronicles. The magnificence of these projects is expressed largely through the costliness of materials, the quality of workmanship, and the rarity and exoticism of objects; even the lofty moral tone of a fresco cycle (depicting illustrious princes – among them Charlemagne and Azzone) and the involvement of celebrated masters can be seen in this context. Among the "indescribable" wonders that Fiamma lists are figures "in gilt, lapis lazuli [ultramarine], and enamels"; a cross encrusted with precious pearls and endowed with miraculous properties; and a cathedral campanile adorned with a metal angel holding aloft the Visconti emblem (the viper).

Azzone's magnificence was made possible by the vast wealth he had acquired through his conquest of other territories. It was thus a public statement of confidence in Milan's economic and political power, and a way of masking behind-the-scenes political tensions. In propagandist terms, magnificence belonged to times of peace, when the lord was free from his enemies and could dedicate himself to making his house "glorious" and secure. Fiamma makes clear the effect that Azzone's fortified palace was intended to have on his subjects: "thunderstruck in admiration," they were to judge him a prince "of such power that it [was] impossible to attack him". Public buildings revealed that he had the common good at heart, while the sacred chapels

10. MICHELOZZO DI BARTOLOMEO
Courtyard of the Palazzo Medici-Riccardi, Florence, begun 1446.

The square courtyard, with its "antique" arcade, is decorated with reliefs, painted garlands, and Cosimo de' Medici's ubiquitous coat of arms. Originally it was adorned with statuary.

and cathedral renovation bore witness to his unstinting piety. Popular sacred festivals, with artistic decorations and banners, showed Azzone in the same light: magnificent in the service of both the state and the church.

In the fifteenth century, the princely ruler still saw art and architecture very much in the context of magnificent display. He did not have to look to the prestigious courts of northern Europe as models, but rather to the courtly traditions of his own region. This had the advantage of giving his rule a popular basis – founded in local and, particularly, civic pride – as well as historical continuity. Dynastic continuity was further emphasized by employing local artists who had worked for the previous

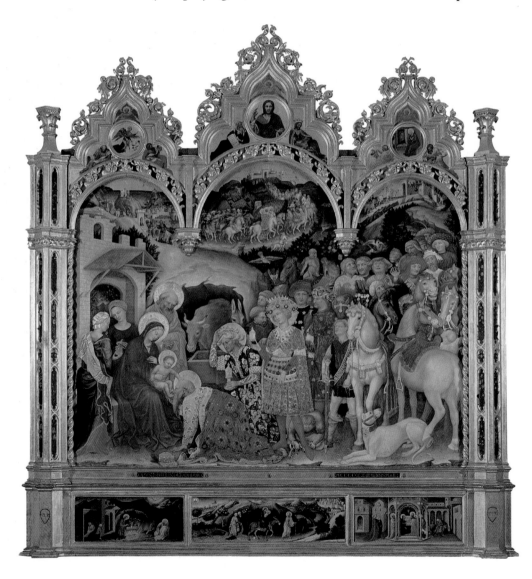

regime, or by completing projects that had already been embarked on (see FIG. 11, page 18). Increasingly, with the humanist revival of interest in the ethics of ancient Greece and Rome, rulers combined these local precedents with a conscious emulation of the "magnificence" of the Roman empire. The humanist Giovanni Pontano, in his treatise *On Magnificence* (*De Magnificentia,* written about 1486), cites the grandiose remains of Roman civilization, Charlemagne's bridge at Mainz, and Cosimo de' Medici's churches, villas, and libraries (along with those of Popes Nicholas V and Sixtus IV) as examples of truly "magnificent" works.

In his treatise *On Architecture* (*De Re Aedificatoria,* written about 1450; published 1485) Alberti wrote: "And is it not true perhaps to say that the whole of Italy is fired by a kind of rivalry in renewing the old? Great cities which in our childhood were built entirely of wood have suddenly been transformed into marble." This spirit of competition and thirst for renewal was particularly vigorous among the courts. Thus Francesco Sforza of Milan was anxious to find out about Guillem Sagrera's work on Alfonso of Aragon's Castel Nuovo in Naples before he embarked on the rebuilding of his own castle of Porta Giova, while Federico I Gonzaga of Mantua wanted to model his Domus Novus on the ducal palace at Urbino, "which, we hear, is wonderful." The prestige gained through architectural "magnificence" was all the greater for the fact that rulers were widely credited with the conceptual designs of their own buildings. After the Peace of Lodi of 1454, which brought a new political stability to the peninsula, whole cities were redesigned with the court at their heart. Rivalries were made all the more intense by a complex network of marital relationships. The northern Italian courts were dominated by three families – the Este, Gonzaga, and Sforza – who were eager to emulate each other, yet anxious "not to displease by imitation" as Beatrice d'Este, wife of Ludovico Sforza commented.

The courts borrowed many of their common values from French and English chivalric literature, and throughout the century medieval French was still regarded as *the* aristocratic language. As a legacy of the papacy's years in Avignon, cardinals and princes continued to amass collections of exquisite French ivories and statuettes. In art, the International Gothic style – an elegant mixture of Lombard, Sienese, and Franco-Flemish stylistic influences (FIG. 12) – persisted well into the century as an established aristocratic visual language, existing side by side with the new Florentine ideas. Flemish artists were greatly respected

12. GENTILE DA FABRIANO *Adoration of the Magi* from the Strozzi Altarpiece, 1423. Tempera on panel, 9'10½" x 9'3½" (3 x 2.8 m). Uffizi, Florence.

The Umbrian artist Gentile da Fabriano achieved fame at the northern Italian courts for his "decoration of buildings." He painted this altarpiece for the wealthy Florentine citizen Palla Strozzi. Strozzi's aristocratic aspirations are perfectly expressed through Gentile's courtly International style. The main panel is thronged with elegant figures, dressed in a variety of patterned and textured fabrics. Symbolic color (radiant gold heavens and haloes) mingles with descriptive detail, ranging from hedgerows and buildings to the "real" gold of crowns, brocades, and ornamental horse trappings. The golden accessories – especially the gleaming sword hilts and spurs – allude to Strozzi's membership of the chivalric Order of the Golden Knights.

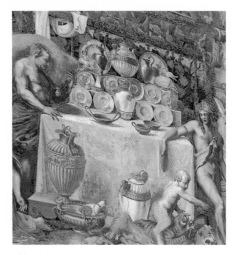

13. Rinaldo Mantovano and assistants, from designs by Giulio Romano
Sala di Psiche, 1527-30. Fresco, Palazzo del Te, Mantua.

Detail showing the sideboard, with its display of precious vessels, and gold- and silverplate.

in Italian courtly circles, and Flemish musicians and tapestry weavers regarded as the finest in the world.

While the Italian nobility envied the splendor and expansive social entertaining of the northern European courts, they also believed in their own innate superiority. This was founded on their strong urban identity, which gave them a sense of commercial sophistication and social refinement. Giovanni Pontano, in his treatise *On the Prince* (*De Principe*, 1468) written for the young Alfonso, Duke of Calabria (heir to the Kingdom of Naples), acknowledges that Italian rulers import many fashions from France, but reminds Alfonso that "Italians like dignity." Elsewhere, he expresses the popular xenophobic view that the French eat merely to satisfy their greed, while the Italians eat with *splendore* (splendor). This "splendor" resides as much in the ritual of entertaining and its aesthetic accompaniments as in the food itself. Toward the end of his life, Pontano wrote a treatise, *On Splendor* (*De Splendore*, published 1498), which stressed the beauty and adornment of the wealthy man's place of entertaining: even in the country, the character of the villa should be "urbane" rather than rustic. There should be polished furniture, knives with carved handles, pictures, statues, tapestries, and sideboards decked with marvellous ornaments. Objects are prized for their beauty and craftsmanship, and are there to be viewed and handled with pleasure, rather than locked away (FIG. 13).

Splendor was not just the province of princes: courtiers like Alfonso I's historian Bartolomeo Fazio spent the rewards of their labors on the delightful trappings of refinement. As soon as Fazio received the generous payment for his history of Alfonso's reign (1,500 ducats; nearly sixty times more than the annual salary of one of Alfonso's foot soldiers), he sent to Venice for a special glass bowl trimmed with gold in which to chill his wine, and ordered the finest pewter vessels from England. The enjoyment of such objects, including exquisite porcelain or maiolica, is captured in Giovanni Bellini's *The Feast of the Gods* (FIG. 14). The Mantuan court physician and poet Battista Fiera, who treated Francesco Gonzaga for syphilis, used his payments to set up busts of three key figures – his Mantuan patron, the Roman poet Virgil (born in Mantua), and the "Mantuan Virgil," Battista Spagnoli. Splendor, like magnificence, had its deficiencies and excesses, and there was always a danger of appearing mean or vulgar. As examples of the two extremes, Pontano gives the

fake gems of Galeazzo Maria Sforza of Milan and the gold chamber pot of the Roman emperor Heliogabalus.

"Magnificence" was also ruled by decorum, and the wise ruler observed this. In Aristotle's *Ethics* (third century BC) it was defined as "making the appropriate gesture on the great occasion": in other words, the sums spent had to be impressive not only in size but also in aptness. In many recent historical studies of courts, a disproportionate emphasis has been placed on the lavishness of court art, and not enough on the complex scale of values that it reflects. Weddings, coronations, "triumphs," funerals, and state visits, where rulers and important dignitaries from various territories gathered with huge entourages of courtiers, were arenas for particularly ostentatious display, because the ruler had to mark the importance of the occasion and conform to the standards of luxury expected from an international court.

14. GIOVANNI BELLINI
The Feast of the Gods, 1514 (landscape repainted by Titian in 1529). Oil on canvas, 5'7¼" x 7'4¼" (1.7 x 1.8 m). National Gallery of Art, Washington, D.C.

Bellini's painting, owned by Duke Alfonso d'Este I of Ferrara, uses oil glazes to suggest the lustre of blue and white Chinese porcelain, and the gleam of pewter and Venetian glass. The draperies – in imitation of shot silks – enhance the scene's splendor.

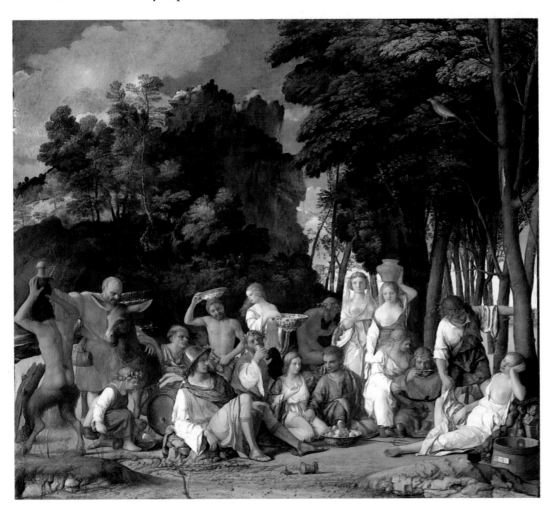

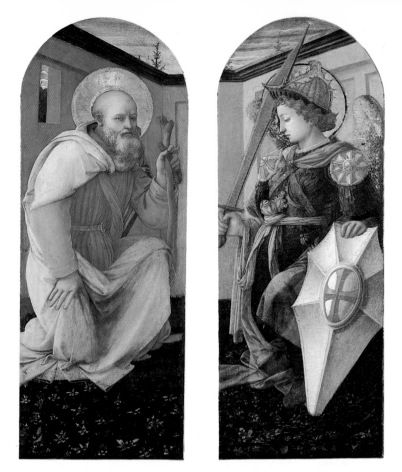

15. FRA FILIPPO LIPPI
St. Anthony Abbot and the
Archangel Michael (left-
and right-hand wings of
triptych for Alfonso of
Aragon), 1457-58. Tempera
on masonite (transferred from
panel), each wing: 32 x 11¾"
(81.3 x 29.8 cm). Cleveland
Museum of Art.

When Giovanni de' Medici
commissioned this triptych
for Alfonso of Aragon, he
made sure that the gift was
appropriate. The two saints
on the wings – the scholarly
St. Anthony Abbot (on the
left) and the warrior
Archangel Michael (on the
right) – were patron saints of
Alfonso, while an *Adoration
of the Child*, depicted on the
central panel (now lost), was
one of the king's favourite
devotional images. Alfonso
greatly esteemed the work
and placed it in his chapel in
the Castel Nuovo.

Gifts – from medals, illuminated manuscripts, and paintings, to
thoroughbred horses, finely wrought armour, and heavy embroi-
dered cloth – were carefully tailored to the rank and taste of the
recipient. When Giovanni de' Medici (son of Cosimo) wanted
to please the pious Alfonso of Aragon he sent him a triptych by
Florence's leading artist, Fra Filippo Lippi (FIG. 15). Spending on
such dignified buildings as churches, monasteries, and palaces
likewise had to do them "honor," and the decoration had to be
suitable to their location and function. Ostentation in the wrong
context was condemned.

The quality and durability of artistic materials also had to be
on a par with the religious or secular importance of the setting.
The fineness of the colors used in painted decorations and man-
uscript illumination was always stipulated by the patron: gold
and ultramarine (a deep violet-blue – the most expensive pig-
ment of all) were used unstintingly in palace and chapel decora-
tion. In Pisanello of Verona's (Antonio Pisano, c. 1415-c. 1455)

unfinished fresco cycle in the Palazzo del Corte, Mantua, a slightly raised layer of paste (known as *pastiglia*), etched with decorative designs and coated with imitation gold and silver leaf, was used to describe the heralds' brocades and the knights' dazzling weaponry and armour. Punched designs were used to imitate chain-mail (FIG. 16). The materials would have seemed expensive, while the uneven surface of the raised and punched areas amplified the glittering effect by catching and reflecting the light. The correlation between material fabric and social fabric (silk and velvet brocades were a mark of rank, coarse cloth a sign of poverty) also applied to the grind and richness of pigments. Courts such as Mantua relied on their agents in Venice to supply them with the choicest colors and media – including, in the case of Mantegna's *Pallas Expelling the Vices*, the most "perfect," quick-drying varnish.

Inexpensive materials such as wood could be made into lavish furnishings worthy of a princely chapel or palace by being gilded, intricately carved, or used in exquisite *intarsie* (marquetry panels). The inlaid wood designs often depicted perspective views of towns, so that they were ennobled by their connection with the liberal arts of mathematics and geometry. Stucco decoration (a type of moulded plaster) was also prized if it was elaborate and gilded. Imported stone was more expensive and prestigious than local stone: Ercole d'Este of Ferrara used finest-quality Carrara marble (from Tuscany) extensively in his Palazzo del Corte. Mantua and Ferrara had no local source of stone, and the

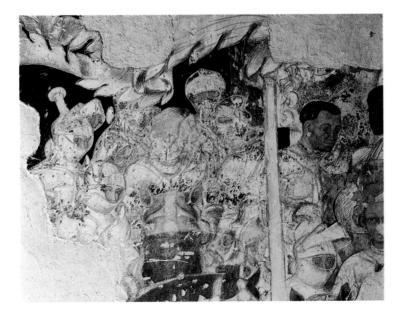

16. PISANELLO
Unfinished decoration in the Palazzo Ducale, Mantua (detail of a group of knights), 1447-48. Fresco with punched decoration.

The knights' chain-mail would originally have been coated with silver leaf.

majority of buildings were in brick. This made buildings like Ferrara's Palazzo dei Diamanti all the more impressive, with its marble faceted in the shape of diamonds and its corners faced in *pietra d'Istria* (Istrian stone).

Side by side with a general sense of what was appropriate to circumstance and status went an increasing emphasis on specifically princely notions of decorum and dignity. During the fifteenth century, numerous treatises on "The Prince" were written, underlining the traditional virtues of piety, justice, fortitude, prudence, temperance, magnanimity, and liberality. Two occur with a new frequency: the imperial virtues of clemency and – most significant of all – *maiestate* (majesty). The ultimate expression of a prince's dignity and authority, *maiestate* endowed his speech with eloquence; his dress and bearing with becoming modesty and gravity. Pontano advises the prince neither to drink intemperately, eat gluttonously, walk jerkily, guffaw with laughter, nor toss his head nervously "like a whinnying horse." Speech should be neither rash nor impulsive, but carefully adapted to the situation at hand. An understanding of the fifteenth-century notion of *maiestate* – in essence, the outward display of inner dignity – is central to a study of courtly art in which the presence of the prince, his consort, and entourage (comprising courtiers in the earthly sphere, angels and patron saints in the sacred sphere) is so pervasive a feature. Dignity is reflected not only in the dress, gestures, and poses of the painted figures, but also in the temperate manner in which the painter composes his pictures and deploys his colors.

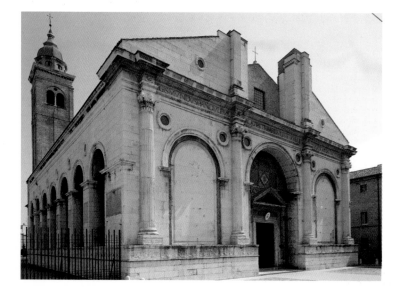

17. LEON BATTISTA ALBERTI Facade of the Tempio Malatestiano, begun late 1453, left incomplete in 1468. San Francesco, Rimini.

Alberti's so-called *tempio,* or temple, encases the medieval brick-built church of San Francesco in a "classical" shell of marble, porphyry, and Istrian stone. The facade borrows the form of the Arch of Augustus in Rimini and would have been crowned with a great dome inspired partly by the Roman Pantheon (never begun). Sigismondo Malatesta created the temple in fulfilment of a vow he had made in 1450 while embroiled in "the Italian war" (this fact is emblazoned across the frieze of the facade). Greek inscriptions on the side walls relate that "victorious on account of the deeds that he had courageously and successfully accomplished, [he] set up this temple with due magnificence and expense to God immortal and to the city..."

18. AGOSTINO DI DUCCIO
Luna, c. 1451-53. Marble
relief. "Chapel of the
Planets," Tempio
Malatestiano, San Francesco,
Rimini.

The Florentine Agostino di
Duccio (1418-1481) and the
Veronese Matteo de' Pasti
(c. 1420-1490) were
responsible for the lavish
interior decoration of the
Tempio Malatestiano: the
former is described as the
"stone-cutter," the latter as
the "architect." This graceful
figure is from a chapel
towards the east end of the
church, which features the
planets and signs of the
zodiac. Other chapels are
adorned with figures of the
Holy Fathers, Virtues, Liberal
Arts, Sibyls, and the Muses
(female inspirers of the arts).
Roberto Valturio, in his *De Re
Militari* (dedicated to
Sigismondo Malatesta),
praised the sophisticated
appeal of the figural reliefs:
"These representations – not
only because of the
knowledge of the appearance
of the figures, whose
characteristics you, the most
intelligent and un-
questionably the most
distinguished ruler of our
time, have taken from the
secret depths of philosophy –
are especially able to attract
learned viewers, who are
almost entirely different from
the common run of people."

Alberti, in his Latin treatise *On Painting* (*De Pictura*: 1435), dedicated to Gianfrancesco Gonzaga of Mantua, advised the artist who sought dignity above all in his narrative to represent very few figures "... for as paucity of words imparts majesty to a prince, provided his thoughts and orders are understood, so the presence of only the strictly necessary number of bodies confers dignity on a picture." Majesty is not to be found in material splendor alone (which is why Alberti cautions the painter who makes excessive use of gold), but in ancient rhetorical virtues of clarity, order, and decorum. This shift in emphasis explains why the rigorously controlled art of Andrea Mantegna, Piero della Francesca, and Alberti himself is just as expressive of contemporary court ideals as the profusely detailed and richly ornamented art that is more often associated with the courts.

The revival of notions of dignity and decorum was closely tied to the reading of classical texts. In artistic theory the inspiration came from Cicero's and Quintilian's treatises on rhetoric; in architecture the return to ancient ideals was stimulated by the discovery in 1414 of Vitruvius's Latin treatise *On Architecture* (*De Architectura*, first century BC). The Vitruvian orders of columns (Doric, Ionic, Corinthian) were seen as expressions of social as well as aesthetic order and were used with strict decorum to identify buildings of status. Alfonso of Aragon's humanist secretary, Antonio Panormita, reports that the king used Vitruvius as his bible when rebuilding the Castel Nuovo. His grandson, Alfonso II, had the architect Francesco di Giorgio translate the treatise expressly for him. The classical language of architecture

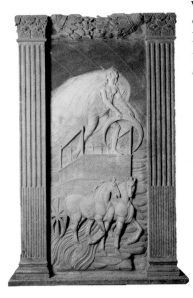

was increasingly preferred by the courts to the more "modern" Franco-German Gothic style (although Milan retained a preference for Gothic, mixed with Lombard Romanesque). Alberti's treatise *On Architecture* was aimed at a fresh generation of humanist-educated princes and encouraged them to adopt the new vocabulary of architectural forms. His own buildings for the Malatesta rulers at Rimini (FIG. 17) and the Gonzaga family of Mantua incorporated such elements as classical temple fronts and triumphal arches into the facades.

Sculptural ornament was just as important as classical canons of proportion in giving a building its elevated social identity. Even the orders of columns and pilasters were treated by fifteenth-century architects as ornamental rather than structural elements. Buildings of status, said Alberti, "should be as magnificent in sculpture and skill as money allowed," and even more so if their function was public rather than private. He advised his wealthy and high-ranking patrons to observe decorum, but to "overspend slightly on ornament" rather than err on the side of plainness. Alberti's own unfinished Tempio Malatestiano (a princely mausoleum) would have been embellished with figural sculpture, reliefs, and all'antica (antique-style) garlands in addition to the porphyry panels that surround the main door. The interior was adorned with exquisite sculptural reliefs, rich in cultural references (FIG. 18). For Sigismondo Malatesta, the intellectual authenticity of the decoration added to its elitist appeal.

The same rules of decorum were applied to internal fresco decoration. For the public state rooms of a city palace historical subjects of a didactic nature were preferred. "Lives of famous men" were very popular, as were scenes of battle and triumph. For the private and recreational rooms of a princely villa the themes could be more informal and pleasurable; they could even verge on the erotic. These rooms were often designed to entertain the viewer in much the same way as the courtly diversions they depict. They featured hunting and hawking expeditions, card and ball games (FIG. 19), scenes of courtly flirtation, tales from popular novelle, and included portraits of favourite dwarfs and *buffoni* – indispensable in banishing princely boredom and melancholy. Some minor rooms were decorated with repetitive wallpaper-like motifs; others were whitewashed (the court artist even oversaw these).

Decoration of the less accessible and more distinguished semi-private rooms in the main princely residence was usually more sophisticated. These chambers were not designed with just the prince's own enjoyment in mind, nor were their splendid interiors ever seen by the vast majority of his subjects. The decoration's chief aim, as has been shown in much recent literature, was to impress visiting princes, ambassadors, agents, and diplomats,

19. Maestro dei Giochi Borromeo
The Game of Ball (detail), c. 1440s-50s. Fresco. Palazzo Borromeo, Milan.

20. LIMBOURG BROTHERS
January from the *Très Riches Heures du Duc de Berry*,
1413-16. Ink and body colour (gouache) on fine vellum,
page: 11½ x 8½" (29 x 21 cm). Musée Condé, Chantilly.

This calendar illustration from the Burgundian Duc de Berry's
famous Book of Hours shows the ceremonial use of tapestries
and wall hangings: here a red silk canopy embroidered with
golden fleurs de lys hangs above the banqueting table, while a
splendid chivalric tapestry of the Trojan War serves as a
landscape backdrop to the feasting and ritual gift-giving.

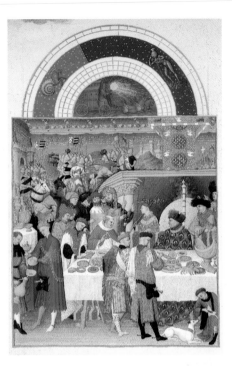

21. ARRAS WORKSHOP (?)
The Devonshire Hunting Tapestries: *Falconry* (detail),
c. 1430s-1440s. Tapestry. Victoria and Albert Museum, London.

Hunting murals in Italian palaces and castles were often based,
both stylistically and thematically, on similar scenes in
northern tapestries and miniatures. Here a courtship episode –
very much like that in a 1444 fresco in the Castello della
Manta (Saluzzo, Piedmont) – is inserted into the colorful
falconry pageant.

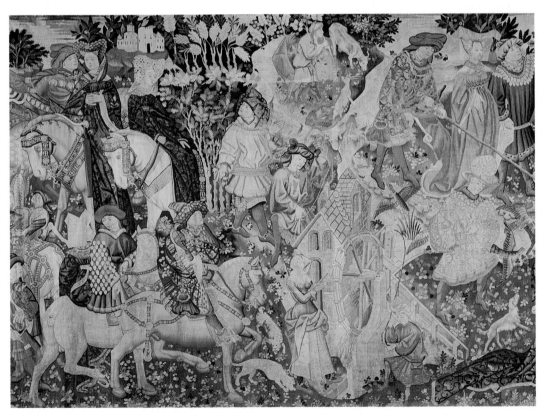

22. Pesaro ceramic workshop Floor tiles, c. 1492-94. Tin-glazed earthenware tiles, 9½ x 9½" (24 x 24 cm). Victoria and Albert Museum, London

from Italian as well as overseas courts. As a mark of esteem, and in a bid to impress, these foreign dignitaries were allowed into the private bedrooms (*camere*) and innermost audience rooms (usually situated on the *piano nobile* – the first floor above ground level). The *studiolo* – an intimate room which the prince used as his haven of quiet, his study, and as a place for artistic recreation – was also an important showpiece. It was usually decorated with favourite paintings, fine marquetry paneling, and adorned with choice *objets d'art*.

Tapestries, the most costly items of furnishing, often decorated spacious public halls and banqueting suites. The expensive gold, silk, and silver threads used in their designs contributed greatly to their immense appeal and investment value. They helped to keep out draughts as well, and were portable, so that they could be brought out on special occasions and transferred between apartments or residences (FIG. 20). Embroidered silk hangings and lengths of valuable cloth were also hung around the walls. Many fresco decorations faithfully imitated the subject-matter and decorative stylizations of northern tapestries (FIG. 21) to create an impression of warmth and splendor. Hunting frescoes recently uncovered in the castle of the *condottiere* Bartolomeo Colleoni at Bergamo even include painted metal hooks and a painted fringe of threads. Others imitate the texture and patterning of sumptuous brocades, using paint and *pastiglia*. Paint had the advantage of being relatively cheap: Duke Borso d'Este spent 9,000 ducats on a sumptuous set of Flemish tapestries and 800 ducats on an exceptionally large fresco cycle in the Schifanoia palace. Frescoes suffered, however, from their relative permanence in an age where rooms were forever being adapted to different purposes. For example, Pisanello's chivalric scenes adorning a great hall in the Palazzo del Corte at Mantua were badly damaged when the room was turned into a temporary kitchen for the marquis's nephew, Niccolò d'Este.

Where practicable, secular rooms and private chapels displayed the prince's and his consort's personal emblem or coat of arms, as well as inscriptions detailing honors and titles. Alfonso I of Naples had over 200,000 Spanish-Moorish tiles made for his Castel Nuovo decorated with his arms and devices. Isabella d'Este, wife of Francesco Gonzaga, decorated her studiolo with maiolica tiles bearing Gonzaga emblems (FIG. 22), and the ceiling of her *grotta* (a small cavern-like room that housed her collection of antiquities) was adorned with her favourite musical device and motto. The presence of the ruler's coat of arms, however, does not necessarily mean that a work was commissioned by him

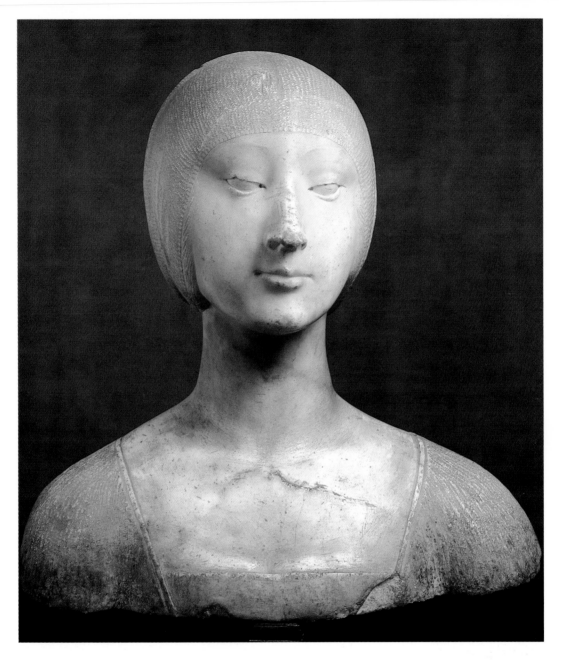

23. FRANCESCO LAURANA
Bust of Eleonora of Aragon (?), 1484-91(?). Marble, height 17″ (43 cm). Galleria Nazionale della Sicilia, Palermo.

This exquisite bust, with its pure simplified lines and almost Etruscan stylization of features, is probably a portrait of Eleonora of Aragon (d. 1405), Sicilian princess and wife of the Lord of Sciacca. The bust seems to have been commissioned by her husband's descendants sometime towards the end of the fifteenth century and housed in the Castello Nuovo of Sciacca until the family died out: it was then placed on Eleonora's tomb in the Sicilian monastery of Santa Maria del Bosco – an institution to which she had been devoted in life.

24. FRANCESCO ROSSELLI
(attributed) Tavola Strozzi:
Ferrante I in the Bay of
Naples after the Battle of
Ischia, July 1465, 1472-73.
Tempera on panel, 32³/₈" x 8'
(82 cm x 2.4 m). Museo di
Capodimonte, Naples.

This sweeping view of Naples
focuses on Alfonso's
formidable Castel Nuovo and
the Torre di S. Vincenzo (to
the left of the jetty). The artist
has been so precise that one
can distinguish between the
tufa stone of the Torre dell'
Oro (one of the five rounded
towers of the Castel Nuovo),
which gives it its golden-
yellow appearance, and the
grey trachyte (another type of
stone), of the other towers.

or her. Favourites were granted the use of their patron's arms or personal emblem as a mark of privilege, and used them in the decorations they commissioned. Gifts were often embellished with the recipient's arms or heraldic devices as a mark of respect and political allegiance.

Portraits had a special role to play at court. They were regularly presented as diplomatic gifts, enabling a ruling family to maintain a high political profile, and were also used to reassure friends, relations, and allies as to the health and well-being of individual members. In an age where marriage was one of the most important and effective ways of cementing political and military alliances or of forging new ones, the court painter took on an onerous responsibility. He was often sent to the court of the potential bride to make a portrait "from life" so that her suitability might not be ruled out on aesthetic grounds. Francesco Laurana's life-sized portrait busts of the Aragon princesses were made either to commemorate their betrothals or their deaths, or as dynastic memorials (FIG. 23). The prince and his consort also loved to be surrounded by images of themselves and their favourites, including horses and dogs. Giorgio Vasari records in

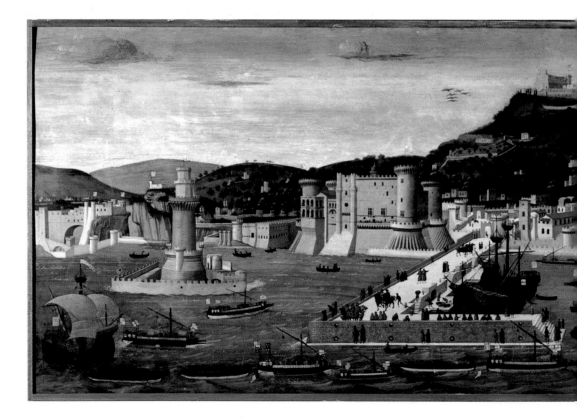

his *Lives of the Artists* (*Le Vite de'Più Eccelenti Pittori, Scultori ed Architettori*, 1550, revised 1568) that the Mantuan court painter Franscesco Bonsignori painted such a lifelike image of a dog presented to Francesco Gonzaga by the Ottoman Emperor that Francesco's dog attacked the painting, having a natural antipathy to Turks! Group portraits, including dwarfs and advisers, were used to reinforce the rigid hierarchy of court life.

Portrait painters were expected to tread the tightrope between creating a faithful representation *al naturale* and observing the propriety of the sitter's status and dignity. Emperor Maximilian I, depicted by the Milanese court artist Ambrogio de' Predis, was unhappy with most of his portraits: "Anyone who can paint a big nose comes to offer us his services." The portraitist himself was expected to exhibit some of the social graces, since he spent a good deal of time in the company of his noble sitters. The artist Baldassare d'Este's claims to be one of Borso d'Este's numerous brothers won him a privileged position at the Ferrarese court. Borso recommended him to Galeazzo Maria Sforza of Milan as "a suitable and respectable kind of person and also because he is good at his craft." Galeazzo Maria

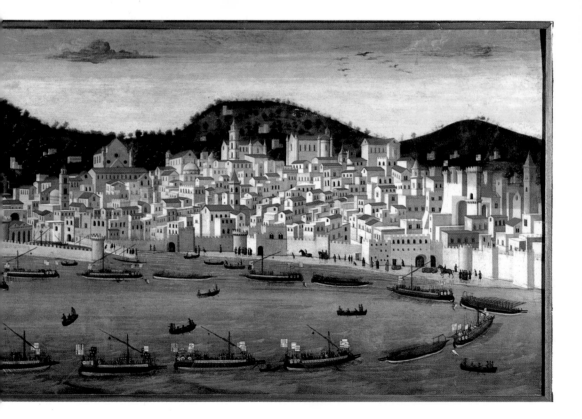

later acquired Baldassare's full-length portrait of Borso after the latter's death. He used it as a role model: "We have always striven to imitate his attire as most praiseworthy and truly befitting for a prince ..."

Other types of painting valued by rulers were dictated by fashions in subject-matter. Paintings of countries and cities were commissioned and collected throughout the fifteenth century, because, according to Vasari, they were "a novelty in the Flemish manner." Francesco Gonzaga expressed interest in buying a panel of Venice by Jacopo Bellini, commissioned Genoa from Gentile Bellini, and asked Giovanni Bellini to paint him Paris for a room of cities he was planning (in the late 1490s). Giovanni Bellini declined on the grounds that he had never seen Paris, and so was asked to paint whatever he liked. Eleonora of Aragon commissioned a painted map of Naples (her birthplace) as a present for one of her daughters. The so-called Tavola Strozzi, which commemorates the victorious return of the galleons of Ferrante I of Naples, is one of the finest surviving examples of such views (FIG. 24). It was a gift to Ferrante from the wealthy Florentine banker Filippo Strozzi, who was keen to extend his profitable business relationship with the Neapolitan king.

Painted decoration had to function within a rigid budgetary framework. Borso d'Este paid the painters who decorated the Room of the Months (Sala dei Mesi) in the Palazzo Schifanoia by the square foot; Galeazzo Maria Sforza's advisers calculated cost according to materials, labor, and the number of figures depicted. Alberti's recommendation that painters try to paint on a large rather than a small scale was not just to do with stylistic concerns: it delivered the artist better financial rewards and the patron greater prestige. This has to be measured against the aristocratic taste for small portable works of art, which were more expressive of the idea of ownership and had real monetary value. Hand-held objects like cameos, engraved gems in intricate gold settings, statuettes or cast medals, were very popular and, as a bonus, could also be used to secure loans. Portrait medals in the classical style were greatly prized and promoted by the courts, promising their subjects fame and even immortality. Sigismondo Malatesta of Rimini had medals of himself and his mistress embedded in the fabric of his buildings – over 240 have since been discovered (FIGS. 25 and 26). Alfonso of Aragon and Galeazzo Maria Sforza also had a tremendous

25. MATTEO DE' PASTI
Medal of Sigismondo Pandolfo Malatesta (obverse), 1450-51. Bronze, diameter 3⅛″ (8 cm). Museo Civico, Rimini.

enthusiasm for saintly relics – not only as a focus for piety and ritual but also because of the "magnificence" of their jeweled gold and silver caskets.

Skill came to be assessed not only according to technical merit in handling costly materials, but also in terms of the artist's *maniera* (individual style), reputation, organizational abilities, speed at expediting a panel or fresco, industriousness, and – a quality that seems to have been increasingly prized – the artist's powers of imaginative invention. When Ludovico Sforza wanted to hire the best painters working in the Florentine milieu, he asked his ambassador to send him details of the highest-rated artists, together with an assessment of their various styles. The virtues of the four artists recommended to him – Sandro Botticelli, Pietro Perugino, Domenico Ghirlandaio, and Filippino Lippi – were reinforced by the information that they had all decorated Lorenzo de' Medici's country villa, and all but one had been part of the exclusive team working for Sixtus IV in the Sistine Chapel in Rome. Ludovico's initiative was in marked contrast to the practice of his elder brother Galeazzo Maria, who invited artists to submit competitive tenders, balancing questions of experience and competence against his desire to get the work done at the cheapest price and at the greatest possible speed. In Galeazzo Maria's Milan, where artists usually worked in teams, the ability of artists to subordinate their personal styles to an overall *maniera* was also highly valued.

The court painter Giovanni Santi, in his chronicle of 1495 dedicated to Duke Guidobaldo of Urbino, singles out the Gonzaga's court artist Andrea Mantegna for praise according to precise categories that reflect the skills most valued in court circles at the time. First on the list is "drawing," "which is the true foundation of painting"; then comes "invention," which engenders truth, grace, and beauty. Both these are important to the designer, for good draughtsmanship was the key to an artist's success at court. Next on Santi's list comes "diligence," which is needed to master technical difficulties like the manipulation of color (here Santi mentions the Flemish oil technique of Jan van Eyck and Roger van der Weyden), foreshortening, and perspective. The artist must be well versed in arithmetic and geometry (the foundations of architecture), and skilled in imparting movement to figures as well as showing them in relief (the province of sculpture). These skills are all valued because they "deceive the eye" into thinking things are made by nature rather than art.

26. MATTEO DE' PASTI Medal of Isotta degli Atti (obverse), 1453. Bronze, diameter 3¼" (8.2 cm). Museo Civico, Rimini.

Sigismondo married Isotta, daughter of a Riminese merchant, in around 1456, although this medal bears the date 1446 (the year that Isotta became his mistress – his second wife died three years later). Medals of the famous beauty were so plentiful that they were owned by several ordinary citizens, and the tower of San Giovanni in Senigallia, whose foundations were filled with them, was known as the Isotteo.

The Court Artist

Early artists' biographers have given a romantic gloss to the profession of court artist: King Robert of Naples granting Giotto di Bondone the privilege of including himself in a palace fresco cycle of famous men; Charles V of Spain graciously picking up Titian's brush after the artist had dropped it to the floor; Leonardo breathing his last in the arms of King Francis I of France, whom he served in his last years. The truth for the overwhelming majority of court artists in the period we are discussing was rather more mundane. At table, where the court hierarchy was at its most rigid and defined, the artist was seated with the tailors, cobblers, musicians, upholsterers, barbers and other members of the *stipendiari* (salaried household).

Nevertheless, court artists did have the power to rise within the court structure. The title of *familiaris* was usually bestowed on those who were regarded as members of the prince's or his consort's inner household. Painters, because they worked within the court complex, were sometimes awarded this favour of privileged familiarity; sculptors and architects were usually given different rewards and incentives. Among the painters who were given this title were Master Jacomart (Jaime Baço – c. 1413-1461) and Leonardo da Besozzo at the court of Naples, and Pisanello, Mantegna, and Antico at Mantua (FIG. 27). The distinguished Brescian artist Vincenzo Foppa was one of the few artists to be made a *familiaris* at the Milanese court, although he didn't work primarily for the duke. In his case, the title went with certain privileges that allowed him to live, work, and move freely around the territory and to gain citizenship of the duchy's second city, Pavia, where he had already lived for twelve years.

There were real advantages to working at court, though enthusiasm for permanent positions had to be balanced against severe restrictions of freedom. A guaranteed salary – in theory, if not always in practice – was offered in return for the painter's services. This covered the living expenses of the painter and his family, travel expenses, and living quarters. Artists were usually accommodated in the palace, although the most celebrated or long-serving were given the gift of a house or the funds to build one. Both Mantegna and Giulio Romano built their own *palazzi* in Mantua (FIG. 28). Besides material comforts and security some artists were provided with "delightful commodities," such as a garden and vineyard. There were also clothing allowances and gifts of livery so that the artist could dress in the manner befitting a courtier. Rulers might provide dowries for the

painter's daughters and pay for physicians when he or his family fell ill. As a *familiaris* the artist was also granted exemption from taxes.

In return, the artist was expected to serve the prince in whatever capacity was required of him. His salary was a reward for his *virtù* – his special talent – and a way of encouraging it to flower. There was no fixed standard for salaries; they were entirely dependent on the prince's discretion and, in many cases, the officials who controlled court expenditure. Pisanello was paid 400 ducats a year at the court of Naples, Cosimo Tura 60 ducats a year at Ferrara. Documents record some of the financial hardship endured by artists who were on the receiving end of regular court cost-cutting exercises. Because of their lavish lifestyles, or delays in payment of *condottiere* fees, many princes had cash-flow problems. One contemporary observer punningly defined a court as a place where everything was *corto* – "in limited supply."

In aristocratic circles, however, there was a convention that talent could not be bought for cash, because it was a God-given gift. The artist's salary was to enable him to live and work; it

27. ANDREA MANTEGNA
Self-portrait concealed in foliage from the fictive pillar on the west wall of the Camera Picta. Fresco. Palazzo Ducale, Mantua, 1465-74.

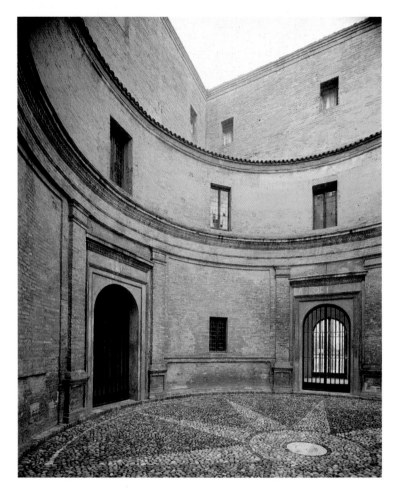

was not a payment for the art he produced. In 1449 Sigismondo
Malatesta of Rimini promised a Florentine master who agreed to
enter his services "a guaranteed annual salary, as high as he
wishes. I also promise to treat him well so that he will want to
spend his life here. Know too that his agreed allowance will be
paid punctually, even if he works solely for his own pleasure."
Artists were free, with their patron's permission, to take outside
commissions – and some were forced to by straitened circum-
stances. Completed works were therefore subject to a different
system of reward. Mantegna, for example, was granted a parcel
of land in return for the gift of "a little picture."

The artist's *virtù* could admit him to the ranks of the nobility
– and a small proportion of painters, sculptors, and architects
were knighted. Knighthoods had to be bought for cash, and the
Holy Roman Emperor Frederick III traded on the ambition of
princes and courtiers alike. Such honors were given to artists

partly as a reward and encouragement, although they were virtually meaningless in terms of improving their standard of living. The stablemaster in Pietro Aretino's play of the same name (*Il Marescalco*, 1533) satirizes the process: "This title is very suitable for someone who is rich enough and only wants a bit of reputation! ... a knight without private income is a bare wall that everyone pees against." The main reason for knighting artists seems to have been to make them worthy court diplomats. Giorgio Vasari says that Mantegna's knighthood, bought by Francesco Gonzaga, was to make him a more fitting envoy of the court when he was sent to Rome in 1488. This applied especially to artists who traveled overseas, and foreign courts were not only eager to receive these artists but to honor them themselves.

Artists took the opportunities for ennoblement very seriously and, increasingly, tried to act like gentlemen. The humanists at the courts were beginning to associate painting, sculpture, and architecture with the liberal arts – "liberal" because only a free man, a noble, could practice them. Instead of their manual skills, artists increasingly emphasized their intellectual ability (*ingegno*) and imaginative faculties (*invenzione*). Painting was associated with rhetoric, poetry, history, and philosophy, with scientific foundations in arithmetic and geometry. The plain fact that the artist worked with his hands was justified on the grounds that he worked for honor rather than for personal gain, and he took pleasure in putting his *virtù* at the patron's disposal. Thus, although the artist was a servant who had to earn his privileges, in courtly terms he freely used his talent to enhance his and his prince's prestige.

The architect was the first to free himself from the stigma of "manual" labor. In 1428 the administrator of Siena cathedral had asked the sculptor Jacopo della Quercia to track down the architect Giovanni da Siena. Jacopo explained that Giovanni was "at Ferrara, with the marquis, and is planning a very large and strong castle within the city, and is given 300 ducats a year and expenses for eight, as I know for certain ... and he is not a master with a trowel in his hand, but a planner and deviser [*ingegniere*]." At court, the architect was often artistic director and military and civic engineer rolled into one: he supervised the building of fortresses, churches, palaces, streets, and canals. He was in charge of hundreds of craftsmen, including those responsible for furnishings and fittings, who followed his plans or worked to the court painter's designs. Surprisingly, the position of court architect-engineer was not one that an artisan was

specifically trained for. He learned his skill as a stonemason or sculptor (the Lombard sculptor Amadeo), or as a painter and expert draughtsman (Donato Bramante).

Large sculptures in bronze and marble were expensive and prestigious (bronze was ten times more costly than marble), but the sculptor did not usually enjoy the status of the architect or the privileges of the court painter. Giancristoforo Romano, an accomplished courtier, and Guido Mazzoni, described by the French king as a painter-illuminator, are notable exceptions. Sculpture's uneasy status was partly due to the dirty, noisy manual nature of the sculptor's work, which meant that he did not reside in the palace. Much of the sculptor or goldsmith's most valued craftsmanship (in gold, silver, and bronze) was melted down when required by the treasury. The sculptor also had to be especially sensitive to the patron's demands, because many of his works were destined for public places. Funerary and equestrian monuments, which included sculpted portraits and details of costume, were rigorously supervised. A mistake could mean that, rather than guaranteeing fame and immortality, a monument could become an object of popular ridicule. The Florentine sculptor and goldsmith Lorenzo Ghiberti relates that while he was working for Lord Malatesta at Pesaro, his "mind was largely

29. RUBINETTO DI FRANCIA *The Lamentation* (after a cartoon by Cosimo Tura), 1474-75. Wool, silk, gold, and silver, 3'2¾" x 6'10½" (97 cm x 2 m). Thyssen-Bornemisza collection, Lugano.

Tura's dramatic *Lamentation* (inspired by Roger van der Weyden) includes portraits of the young Ercole d'Este of Ferrara (St. John) and his new wife Eleonora of Aragon. Tura's cartoon was woven into a tapestry by Rubinetto di Francia, and given an illusionistic jeweled frame. Ercole used it as an altar cloth, prized for its precious threads as much as its imagery. A replica exists, made by a northern tapestry-maker at the Ferrarese court, probably to serve as a religious or diplomatic gift.

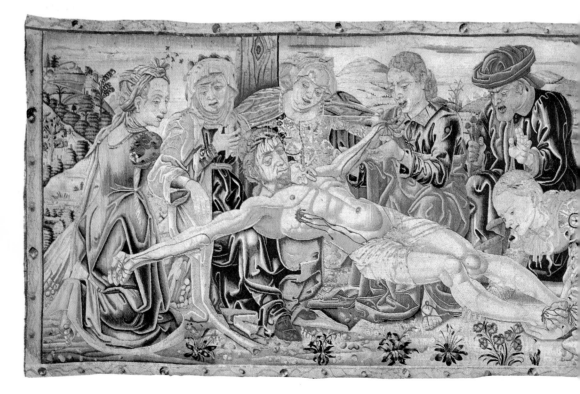

directed to painting ... because the company I was with was always showing me the honor and advantage to be had from it."

Court painters were used very much as interior designers, drafting and visualizing designs for a patron or an appointed intermediary. A team of craftsmen and suppliers was put at their disposal. Borso d'Este's court artist Cosimo Tura painted frescoes for Este palaces, executed panels of the Muses and decorative sculpture for the Este villas of Belfiore and Belriguardo, painted the organ shutters in Ferrara's cathedral, designed Flemish-style tapestries (FIG. 29) and woven seat-back covers, and made models for goldsmiths and silversmiths. For public entertainments and state occasions painters worked feverishly, designing pennants, standards, festival costumes, horse caparisons, masks, festive arches, jousting equipment, sugar confections, and all manner of ephemeral decoration. Vasari has left us a vivid picture of Perino del Vaga at the papal court, "being obliged to draw day and night in order to keep up with whatever had to be done in the palace ... and he was constantly surrounded by a host of sculptors, stucco artists, woodcarvers, tailors, embroiderers, painters, goldsmiths and the like, so he never had an hour's peace."

The courts used diplomatic channels to secure information about artists' works and activities in other centers, negotiate terms, and sometimes lure them to permanent positions at court. Ambassadors and envoys also supervised works commissioned from "outside" and organized their transportation to their final destination (linen canvas was often used for such works, so that they could be wrapped round rods en route). Commercial agents soon began to act as intermediaries, as well: merchants with their networks of business connections realized there were good profits to be made. Vasari relates that a Leonardo was purchased by a merchant for 100 ducats and sold to the Duke of Milan for three times that amount. Less distrusted by both parties were the court agents and humanist advisers.

Once at court, artists were meant to keep in line with trends in other courts and cities. Early on, artists were sponsored to journey abroad and train with celebrated masters so that they could bring back something of their special trade and, in the words of Federico II Gonzaga, "attain the perfection we hope for." Rulers were particularly keen to keep abreast of artistic developments in the northern courts. Zanetto Bugatto, for example, was sponsored by the Duchess of Milan to study oil technique under Roger van der Weyden in Brussels in the early 1460s. Italian artists were also in demand abroad. Leonardo da

Vinci, Titian, and Guido Mazzoni were three such artists whose success at Italian courts brought them to the attention of foreign kings and emperors.

The way an artist was treated at court depended on the personalities of artist and ruler. An exceptionally erudite figure like Mantegna was not only a servant but also a courtier and companion, valued for his classical connoisseurship. Cardinal Francesco Gonzaga begged his father to allow Mantegna and the musician Malgise to come and stay with him in Bologna for a couple of days, to relieve the boredom: "With Andrea I will have amusement showing him some of my cameos and bronze figures and other beautiful antiquities, on which we may study and confer in company." When Mantegna refused to execute a small picture for the Duchess of Milan on the grounds that it would be more a job for a miniaturist, Marquis Francesco Gonzaga excused him on the grounds that "these recognized masters have something of the fanciful about them, and it is best to take from them what one can get." If an artist failed to develop the right social skills or seek out useful friends he could end up like the sculptor Niccolò dell'Arca, who worked in Bologna. According to the obituary written by a Dominican friar, Niccolò died in abject misery: "He was fanciful and uncivilized in his ways, and was so rough that he drove everybody off. Most of the time he was in want even of necessities, but he was thick-headed and wouldn't accept the advice of his friends."

While the artist could achieve wealth, social status, even fame through the courts (many eminent Florentines only achieved recognition in their own city through spells of court employment), there were several disadvantages to accepting a permanent position. Chief among these were the loss of personal freedom – even if the odd eccentricity was indulged – and the ability to determine one's own fate or fortune. The court artist's career was often dependent on one individual. Mantegna complained to Ludovico Gonzaga: "I have no other way to distinguish myself and no longer any hope other than Your Grace." Because the artist's works were so closely identified with his patron, he was often assumed to share the same political ideology and was sometimes accused of treachery and corruption (even paying with his life). With the death or humiliation of a ruler, or as a result of envious slander, the artist's employment could be abruptly terminated (FIG. 30). Even a change of mind, or a passing whim, could dash his hopes or see his works destroyed.

Lorenzo Ghiberti in his *Commentaries* (*Commentarii*, c. 1447-55) urges the artist to place his trust only in the Lord, who alone

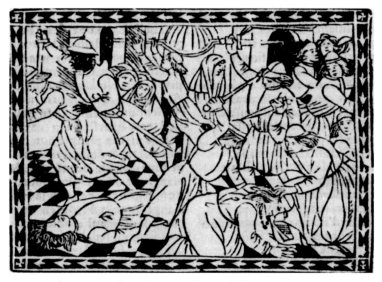

30. Title page illustration to the *Lament for Duke Galeazzo Maria Sforza*, assassinated on Christmas Day, 1476. Woodcut. Archivio Storico Civico, Milan.

governs heaven and earth, and rely on his own *virtù* rather than become a slave to fortune. He relates the story of the German sculptor Gusmin, who "saw the work he had done with such love and skill destroyed for the Duke's public requirements." In a passage of almost biblical intensity Ghiberti sets forth his anti-court creed:

> He who is well taught in all things is not alone nor a wanderer in the lands of others when he has lost familiar and necessary things and is in need of friends, being a citizen in every city and able to despise hardships of fortune without fear, never a prisoner in fortresses, but only in bodily infirmity ...

The court artist's dependency has to be weighed against the freedom from craftsman's status that the courts helped painters, architects, and sculptors to realize. In this sense, the artist was very much like the *condottiere*-prince of a small aspirational court. He was prince of his own patch (Raphael was assiduously courted by lesser artists), but was also a servant to others who wielded far greater power. But his "prostitution in service" enabled him to gain a measure of prestige and a degree of financial independence. He could even make himself so valued that his services came to be regarded as indispensable. Once a prince recognized this state of mutual dependency, the court became the unlikely setting for the artist's social and creative emancipation.

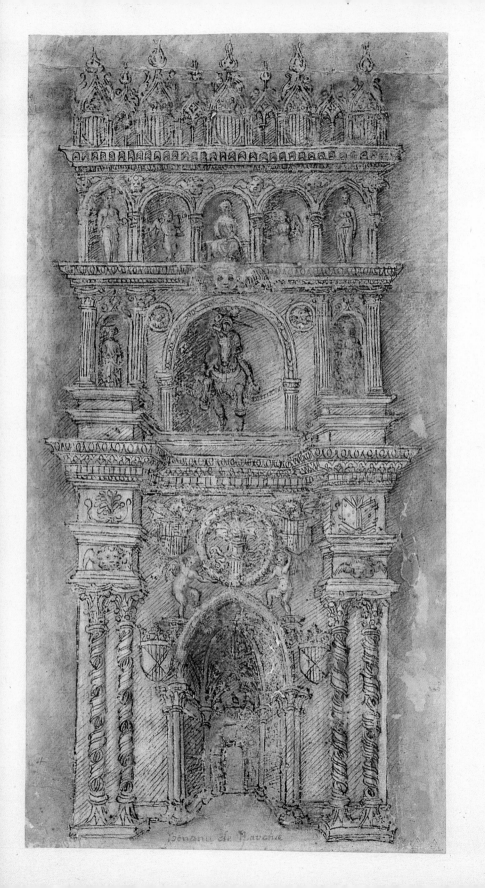

Giovanni da Ravenna

Piety and Propaganda: Naples under Alfonso of Aragon

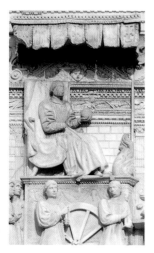

31. CIRCLE OF PISANELLO
Design for a decorative archway, n.d. Pen in brown ink, over black chalk and brown wash, 12¹/₄ x 6¹/₂"
(31.1 x 16.2 cm). Museum Boymans van Beuningen, Rotterdam.

In the mid–1440s King Alfonso of Aragon was asked to arbitrate in a bitter wrangle between two of the most illustrious humanists of the age: Lorenzo Valla, his secretary, and Antonio Panormita, his Sicilian favourite. Valla, according to his version of events, had been asked by the king's counsellor, Giovanni Carafa, to compose verses for a painted decoration on the Castel Capuano. The verses were to adorn the scrolls of four painted virtues surrounding a splendid portrait of the armoured king on horseback. The unfortunate artist was just about to paint Valla's words on to the scrolls – with the people milling around, craning to read them – when Panormita appeared and "made the man nervous about painting such 'crude' verses [as Antonio put it] in his splendid painting, and on a site specially chosen for the painter's as well as the king's glory. He told him only to wait a day or two and he, Antonio, would produce verses truly worthy of the house of Carafa and the Castel Capuano and the portrait of a king." Over a week later, Panormita produced his verses, Valla finished his, and each gathered around him a set of supporters. In the end, Carafa sent the two humanists to King Alfonso. The king, whose powers of diplomacy have been greatly praised by historians, said "both sets of verses seemed very nice." As a result, neither set was completed,

and the figures representing Prudence, Justice, Charity/Liberality, and Temperance/Fortitude were left to speak for themselves.

This episode gives us an idea of the complex role played by art at court. First, the decoration was "arranged" by an intermediary – a leading courtier anxious to bring honor to his own "house" as well as satisfy the king's general expectations of such a scheme. The site chosen, the Castel Capuano, was the busiest place in the city of Naples; so the chivalric portrait of the king in contemporary armour was designed to impress the Neapolitan populace at large and be worthy of its prestigious location. Prominent inscriptions – "flatteries," as Valla derisively termed Panormita's efforts – were intended to make the king's virtues abundantly clear to his Italian subjects. The painter was not consulted about the textual detail. This task was left to the king's humanist secretary, who was accustomed to having a hand in such schemes: Valla mentions that he took care to present his verses so that they could be put in the same order as the painter wanted to place his figures. The king's role in this particular commission is minimal – he is even noncommittal when called upon to act as "referee."

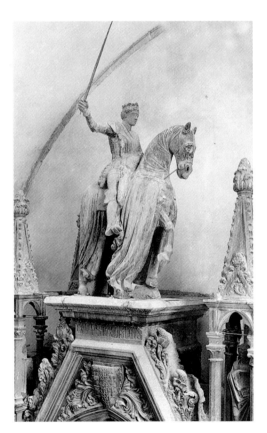

32. Andrea and Marco di Nofri da Firenze
Funeral Monument of King Ladislao, 1428 (detail of the equestrian statue of the king at its crest). Marble, height 60′ (18 m). San Giovanni a Carbonara, Naples.

The Capuano project reveals the public face of art at Alfonso's court. It finds strong echoes in a drawing of a decorative archway for Alfonso (FIG. 31) and also in a grandiose tomb commissioned by the king's Angevin (Anjou) predecessor Giovanna II (ruled 1414-1435) in honor of her brother King Ladislao (FIG. 32). Both feature imposing equestrian monuments of armoured kings, as well as classical-style figures personifying the virtues. The tomb includes other statuary – Queen Giovanna, her brother, and their parents, apostles and saints among them – and is embellished with verses by Lorenzo Valla. By continuing in this vein, Alfonso and his close advisers were adopting the successful vocabulary of regal propaganda, with its blending of chivalric and antique styles, portraits and allegorical figures, and use of edifying inscriptions. Through artistic continuity, the king was also stressing the legitimacy of his claim to the Neapolitan throne. Giovanna had adopted Alfonso as her heir after he had successfully put down an uprising against her, only to change her mind in favour

of the French duke René d'Anjou (1409-1480). When René suc-
ceeded to the throne, Alfonso went to war to wrest Naples from
him by force.

On 26 February 1443, Alfonso of Aragon (1396-1458) made
his triumphal entry into the city of Naples, following his defeat
of René's Angevin army. Already king of Aragon, Catalonia,
Sicily, Sardinia, Valencia, and Majorca, Alfonso had finally real-
ized an ambition that had involved him in a relentless twenty-
year campaign. The new king of Naples (ruled 1442-1458) was to
spend the remainder of his years there, transforming his south-
ern Italian kingdom into one of the main cultural and commer-
cial centers of the peninsula and fashioning it into the jewel of
his Mediterranean empire. As his rule progressed, he shifted his
attention from Spain to the Italian peninsula, hoping to unite
Naples with the country's other great power, Milan, and
become ruler of all Italy.

All the nationalities living and working in the bustling com-
mercial port of Naples were represented in Alfonso's magnificent
triumphal procession. Priests led the way, followed by the Flo-
rentine contingent, whose floats featured allegorical figures and
an actor dressed as the emperor Julius Caesar (theirs were the
only displays created in the *all'antica* style). Then came the Cata-
lans, followed by a float bearing the Arthurian Siege Perilous,
flanked by the Virtues Justice, Fortitude, Prudence, Faith, and
Charity (who tossed coins to the crowds). The Siege Perilous
(dangerous chair) was one of Alfonso's favourite devices: only
the knight who was pure of heart, chaste, and invincible (Sir
Galahad, who accomplished the quest for the Holy Grail) could
sit in this chair at the Round Table without being burnt by its
searing flames. Alfonso's gilded triumphal car was decked out as
a turreted fortress and a small Siege Perilous was on fire at the
foot of his throne. Alfonso himself appeared resplendent in
crimson and gold brocade, wearing the collar of the Order of
the Lily (with its golden griffin pendant) and carrying the scep-
tre and orb. Following in the king's wake were the court lumi-
naries, military captains, foreign ambassadors, local barons,
knights, bishops, and humanists (including Valla and Panor-
mita). Alfonso dismounted at the cathedral, where a marble tri-
umphal arch was under construction. (A decade later, the arch
was to be moved to the gates of Alfonso's great fort, the Castel
Nuovo.)

Alfonso brought with him court painters and architects from
his native Spain. His first Neapolitan commission was entrusted
to the Valencian painter Jacomart, whom the king had sum-

33. MASTER OF THE TRIUMPH OF DEATH
The Triumph of Death, 1441-46. Fresco transferred to canvas, 19' 8" x 21' 1" (5.9 x 6.4 m).
Galleria Regionale, Palermo.

This fresco, with its dynamic figure of Death, represents people from every strata of society: the poor on the left; an emperor, pope, and leading religious figures prostrate at the feet of Death's horse in the center; and nobles and courtiers on the right, dressed in the latest Burgundian fashions. The painter has included himself and possibly his assistant on the extreme left, holding painting tools and mahlstick.

Piety and Propaganda: Naples under Alfonso of Aragon

moned to Italy in October 1440 while he was encamped outside Naples. Jacomart, the son of the king's tailor, was otherwise engaged in religious commissions in Valencia, but eventually arrived in June 1442, at the time of the third siege of Naples. Not long after his triumphant conquest, Alfonso had Jacomart paint a retable for a classical-style chapel, which he immediately erected on the Campo Vecchio, marking the spot where he and his troops had encamped outside the city. Here Alfonso had had a divine apparition: the Virgin Mary had appeared to him as he slept and inspired him with the idea of entering Naples secretly through one of the city's ancient aqueducts. Accordingly, in Jacomart's altarpiece the Virgin is seen appearing to the king in all her tender majesty. The artist, whom the king referred to as "faithful, familiar and our chamber painter," presented the work personally to Alfonso at the Castel Capuano. It was one of the king's most prized pieces of art, and was carried aloft in the annual processions that commemorated his entrance into the city. The altarpiece was destroyed, along with the chapel, in the sixteenth century; if it had survived it would have provided a vivid illustration of Alfonso's very Spanish combination of devout religiosity and militarism.

Unfortunately, most of the paintings and murals commissioned by Alfonso have been lost or demolished, which partly explains the neglect of Naples by the majority of Renaissance scholars. The state archives were laid waste at the end of World War II, so that most documents concerning commissions and purchases no longer exist. From the surviving archive material, we learn that the Catalan sculptor-architect Guillem Sagrera had arrived in Naples by 1447, summoned to work on the rebuilding of the fort of Castel Nuovo. Leonardo Molinari da Besozzo, who worked for the previous Angevin regime, was Alfonso's foremost court painter in 1449 and served the king until 1458. He frescoed the walls of the king's palaces and churches, illuminated his charters and books, and decorated his armour. Leonardo was one of three painters who decorated 920 standards and banners for the banquet celebrating the birth of Alfonso's grandson. Perinetto da Benevento was also given a stream of commissions, including a cycle of frescoes illustrating the Seven Joys of the Virgin. Leonardo and Perinetto both worked in the monumental tradition of Giotto and Pietro Cavallini (whose Neapolitan works had made the city famous in the fourteenth century).

Fortunately, one outstanding fresco associated with Alfonso's patronage survives: *The Triumph of Death* (FIG. 33) from the Palazzo Sclafani in Sicily. The old ruined palace had been

restored as a hospital, under Alfonso's authority, and the south wall of its wide courtyard frescoed with this macabre scene. The anonymous artist has been identified with the circle of Pisanello or the brothers Zavattari, who worked on fresco cycles for Alfonso's close ally Filippo Maria Visconti of Milan. Recently, scholars have suggested that it may be the work of the Sicilian artist Gaspare Pesaro (c. 1400-1461), who illuminated books for King Alfonso in 1438. Whatever its authorship, the fresco eloquently expresses the multicultural flavour of art in the Neapolitan/Sicilian kingdom. Its blending of French, Sienese, Lombard, Sicilian, Burgundian, and Spanish elements is also typical of the refined International Gothic style that was then so popular in court circles.

34. THE CRESPI
King Alfonso and his Court attending Mass from the Libro d'Ore di Alfonso I, completed 1442. British Library, London.

Jacomart's "International" style was very much a product of the Valencian school: formal, graceful, and of considerable decorative splendor. It conforms with what we know about Alfonso's taste in devotional images. He wanted gentle spiritual works with pleasing decorative qualities, coupled with agreeable naturalistic detail: gorgeous brocades, painted sculptural decoration, and sparkling jewels alongside graceful and realistic figures. These preferences are reflected in the religious ornaments Alfonso collected; according to Giovanni Pontano (*De Magnificentia*) he "outstripped all the kings of that age, both in acquiring and exhibiting the things used in the Mass and for the adornment of priests, and in regard to statues of the male and female saints, of which he possessed many, including the twelve apostles made of silver" (FIG. 34). The only other record we have of Jacomart working for Alfonso in Italy is a commission of 1447 to paint shields and emblems on about twenty royal standards. The artist was summoned to Tivoli, where the king was about to launch his assault on Florence, and given the commission on the battlefield. Thereafter, Jacomart seems to have fulfilled the role of court painter to Alfonso in Valencia.

Jacomart's work was also influenced by the Flemish style and technique that were then fashionable in Spain, and which Alfonso had long admired. The king's previous court artist, Louis Dalmau, is more representative of this aspect of Alfonso's

personal artistic taste. In 1431, as king of Valencia, Alfonso had sent Louis Dalmau to Flanders together with the tapestry-maker Guillem d'Uxelles, so that Dalmau could learn how to design tapestry cartoons in the Flemish manner. He would have arrived just in time to see the completion and public exhibition of Hubert and Jan van Eyck's Ghent Altarpiece. On his return nearly five years later, he painted works inspired by the Netherlandish masters.

In Italy, the king's taste for works with a Hispanic-Flemish flavour continued unabated. At the same time as Jacomart was working on his Italian retable, the king acquired his first Jan van Eyck painting. He had ordered his bailiff-general in Valencia, Berenguer Mercader, to find one for him. Subject-matter was unimportant; the king, like Isabella d'Este at the close of the century, simply wanted to own a work by this leading master. Mercader accordingly commissioned a Valencian merchant to hunt one down in Flanders. The merchant found a *St. George and the Dragon* on sale at Bruges, and arranged for it to be shipped to Barcelona, from where it was dispatched to Naples in 1444. The painting has since been lost, but its qualities were enthusiastically described by the sixteenth-century writer Pietro Summonte in a famous letter of 1524. It included a landscape with a small figure of the rescued princess, a distant town and view of the sea, as well as a bravura detail, typical of van Eyck's mastery: the dragon, fatally wounded in the mouth with a long spear, was reflected in the armoured left leg of St. George. The subject was especially appropriate to Alfonso: his Catalan burial chapel at the Monastery of Poblet in Spain (built after 1442) was dedicated to the saint, whom he had adopted as protector on his Naples campaign.

Bartolomeo Fazio, who was resident in Naples from 1444, has left us a valuable description of another of the van Eyck masterpieces owned by Alfonso. Fazio acted as the king's personal secretary and historian, and in 1456 dedicated his short book *On Famous Men* (*De Viris Illustribus*) to Alfonso. It includes a chapter on painters, which discusses those whom he considers the best of the period. They are Jan van Eyck and Roger van der Weyden, Pisanello (who was employed at the Aragonese court), and Gentile da Fabriano (d. 1428), who had worked for Pandolfo Malatesta at Brescia (decorating a chapel from 1414 to 1419), the papal court in Rome, and in Florence. All four painters worked for courtly patrons and the three who were still alive were associated with King Alfonso of Aragon. Three sculptors are also singled out for praise (although "out of the multitude of sculp-

tors few are famous") – all of whom are Florentines. Among them is Donatello, who was greatly admired by Alfonso. A surviving letter written to the Doge of Venice in 1452 shows that Alfonso was interested in having Donatello make an equestrian monument for his tomb, in the manner of his ancestor King Ladislao.

Fazio declares that "Van Eyck has been judged the leading painter of our time." This judgment probably reflects the opinion of Alfonso and his close circle of humanists, who debated literary, philosophical, theological, and probably artistic questions in the *ora del libro*, the king's regular literary forum. Later, these meetings were given the formal status of an academy, presided over by the lively and witty Panormita. On such occasions, scholars were invited to put forward and defend an argument, producing supporting texts and examples from antiquity, in an atmosphere of fierce rivalry. After the ritual demolition of each other's arguments, fruit and wine were served. Fazio's text accordingly supports his assertion by alluding to van Eyck's learning, both in geometry and in "letters": "He is thought for this reason to have discovered many things about the properties of colors recorded by the ancients and learned by him from reading Pliny and other authors." Fazio's fellow humanists would have recognized the prototype – for this is how the classical author Pliny described Apelles, the favourite painter of Alexander the Great.

For his first example, Fazio takes a remarkable picture in the private apartments of King Alfonso at Castel Nuovo, in which there is a St. Jerome "like a living being in a library done with rare art: for if you move away from it a little it seems that it recedes inwards and that it has complete books laid open in it, while if you go near, it is evident that just their main features are there." On an outer panel are portrayed Battista Lomellini and "the woman whom he loved". "Between them, as if through a chink in the wall, falls a ray of sun that you would take to be real sunlight." This triptych was originally painted for the Genoese worthy Battista Lomellini, who may have sold it to Alfonso some time after the peace with Genoa was negotiated in 1444. Alfonso also owned a Van Eyck *Adoration of the Magi*, which adorned the altar of the chapel of St. Barbara in his palace of Castel Nuovo.

Fazio also talks about another Flemish artist much admired in court circles: Roger van der Weyden (FIG. 35). He discusses the artist's works in

35. ROGER VAN DER WEYDEN *Deposition*, c. 1435. Oil on panel, 7′2½″ x 8′7″ (2.2 x 2.6 m). Prado, Madrid.

Detail showing the figure of Mary Magdalene. The works of the Netherlandish painters were admired as much for their emotional intensity as they were for the painter's skill.

Italy, including a painting of a woman in her bath in Genoa (now lost) and another painting in the private apartments of Leonello d'Este of Ferrara. This was a triptych, whose central panels showed "Christ brought down from the cross, Mary His Mother, Mary Magdalen, and Joseph, their grief and tears so represented, you would not think them other than real." Fazio continues: "His also are the famous tapestry pictures in the possession of King Alfonso ... [in which] you may easily distinguish a variety of feelings and passions in keeping with the variety of the action." These decorated the great Sala del Trionfo in the Castel Nuovo, providing a splendid backdrop to the comings and goings of court and a focus for Alfonso's celebrated piety.

The taste for Flemish art in early fifteenth-century Naples had already been fostered by Alfonso's rival, René d'Anjou – who had briefly ruled Naples from 1438 to 1442. René was himself reputed to be a highly accomplished artist (although this may be humanist exaggeration) and, according to Pietro Summonte's letter, had made a study of Flemish painting. The

36. COLANTONIO
St. Jerome in his Study, lower panel of the altarpiece of San Lorenzo, c. 1444-45. Panel, 4′ x 5′ (1.2 x 1.5 m). Museo Capodimonte, Naples.

Colantonio employs dramatic *trompe l'oeil* effects to display his mastery of Eyckian illusion. The casual disorder of the stacked volumes and the minute description of the study's paraphernalia, including the small viol-shaped case containing Jerome's folding reading glasses, reveal not only the painter's skill but also his ingenuity in devising such opportunities for displaying it.

French king shared this enthusiasm with the Neapolitan painter Colantonio, who, according to some writers, might have been instructed in the newly refined Flemish oil technique by the king himself. Colantonio's *St. Jerome in his Study* (FIG. 36) shows his masterful assimilation of Flemish ideas, and may bear some resemblance to the Lomellini triptych. Some critics have suggested that Alfonso commissioned this work in around 1444, and have commented on its debt to Van Eyck, the young French master Fouquet (who may have passed through Naples at this time), and to the court painter, Jacomart.

While Alfonso prized Netherlandish panel paintings as images for his private pleasure and devotional contemplation, his patronage of art in Italy concentrated on the public sphere. There were cogent political reasons for this. Alfonso was a Spaniard who had to justify his claim to Italian territory: after the death in 1447 of his only Italian allies, Pope Eugenius IV and the Duke of Milan, Filippo Maria Visconti, he had to use all his diplomatic abilities to gain recognition from the Florentine and Venetian powers. He also had to win over the feuding Neapolitan barons, many of whom had supported and continued to uphold the French Angevin claim to the throne. He exacerbated their hostility by appointing Catalan and Castilian dignitaries to most of the leading positions at court: one of his favourites, the Castilian master chamberlain Don Inigo de Avalos (immortalized in a Pisanello medal), was granted the duties on food exports for life. In an act of conciliation, Alfonso "the Magnanimous" increased the barons' privileges and invested many with considerable power – thereby storing up problems for his successor. The machinery of government was adapted to the Spanish model, while court customs and ceremony were predominantly Catalan. More emphatically, the language spoken at court was Catalan and Castilian, where it had previously been French. Borso d'Este of Ferrara later frankly informed Alfonso: "in this kingdom you are not at all loved; on the contrary, you are hated."

But Alfonso was a shrewd, highly literate man, who knew the value of successful political propaganda. The development of a finely tuned language, both visual and verbal, that would communicate his political ideology to the native aristocracy as well as his Italian princely allies and rivals was a major factor in the shaping of his artistic policy. Spanish architects and artists worked on the interior of Alfonso's palace at Castel Nuovo, harmonizing the decoration with the character of Alfonso's interior court. Flemish musicians were brought to Naples because they

were internationally recognized as the finest, as were Flemish panel paintings and tapestries (hung round the walls in the main halls). In addition, several of the most famous Italian humanists were invited to Naples, not only because they fed Alfonso's love of literature and fascination with the world of antiquity, but also and more importantly because they could translate his political ideology into the fashionable humanist idiom and record his deeds for posterity.

Valla provided the most important service, proving in 1440 that *The Donation of Constantine* – the historic text on which rested papal right to rule Italian territories – was a fake. Fazio wrote a treatise *On Human Happiness* and a laudatory history of Alfonso's reign. Panormita also wrote a biography, *On the Sayings and Deeds of King Alfonso*, which associated the king with the Spanish-born Roman emperors, Trajan and Hadrian. Both emperors were then regarded as the "best" in a Christian sense, alongside Marcus Aurelius. Hadrian, like Alfonso, had had a passion for hunting and had made it an imperial sport in the middle of the second century AD. One of Alfonso's medals (by Pisanello) portrays the Neapolitan king as "intrepid hunter." Busts of the

37. Roundel with portrait of Caesar or Trajan (detail from the left-hand pedestal of the triumphal arch of King Alfonso of Aragon), mid-1450s. Castel Nuovo, Naples.

This fine profile bust is based on Roman coins.

two Hispanic emperors adorned a stairway in the Castel Nuovo, while the sculpture of the triumphal arch of Castel Nuovo glorifies its patron's reign in the same way as that of the Arch of Trajan at Benevento.

In the visual sphere, Alfonso's key to establishing his own legitimacy in Italian eyes was a language based largely on that of ancient Imperial Rome. Not only had Spaniards ruled Italy as emperors and kings, but southern Italy and Sicily had once been ruled by the Holy Roman Emperor Frederick II of Hohenstaufen (1198-1250). Frederick was a shining example to Alfonso – a poet, warrior, astute politician, and an exceptionally generous patron of the arts, who had cultivated a reputation for liberality. Frederick had appropriated the imperial imagery of Augustus, striking medals in the antique style and even erecting a triumphal arch in Capua. His symbol of the eagle perched over its prey was later adopted by Alfonso in his own medal *all'antica* as a symbol of liberality. The eagle – most powerful and warlike of birds – was also magnanimous to those who respected his sovereignty, sharing with them the remains of his prey.

But Alfonso's interest in imperial imagery was a real and personal one, as well. On every day of his Neapolitan campaign he had been inspired by pages from his copy of Julius Caesar's *Commentaries* – and humanists read out stirring passages of Livy (as well as chivalric romances) to his troops on the battlefield. He collected ancient coins, particularly those bearing Caesar's profile, and venerated them almost as if they were sacred objects. His famous library included the writings of Cicero, Livy, Caesar, Seneca, and Aristotle, which he perused while sitting in a wide window-seat overlooking the Bay of Naples. His quasi-religious attitude to the remnants of Roman civilization was easily explained by his humanist courtiers. The ancient emperors served as moral exemplars, spurring on Alfonso to virtue and glory (FIG. 37). Thus a bone from the arm of Livy, acquired from the Venetians, was cherished like a holy relic. At the end of Alfonso's reign, the Mantuan sculptor and goldsmith Cristoforo di Geremia (c. 1430-1476) portrayed Alfonso on a medal, clad in an authentic classical cuirass and being crowned by Mars and Bellona – god and goddess of war (FIG. 38).

Pisanello was able to satisfy Alfonso's educated delight in both humanist and chivalric images. He was brought to Naples at the end of 1448, and in February 1449 was appointed a member of the king's household and given a generous salary of 400 ducats. The decree of February 1449 confirming Pisanello's privileges makes it clear that Alfonso knew of the artist's outstand-

ing achievements, and suggests that Pisanello may have already produced designs for him:

> Seeing therefore that we had heard, from the reports of many, of the multitude of outstanding and virtually divine qualities of Pisano's matchless art both in painting and bronze sculpture, we came to admire first and foremost his singular talent and art. But when we had actually seen and recognized those qualities for ourselves, we were fired with enthusiasm and affection for him...

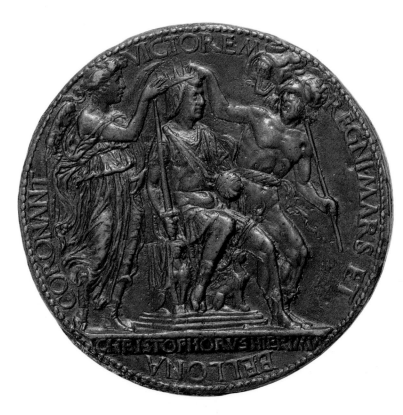

38. CRISTOFORO DI GEREMIA
Medal of Alfonso of Aragon (reverse), c. 1458. Bronze, diameter 3″ (7.7 cm). Victoria and Albert Museum, London.

The inscription reads "Mars and Bellona crown the victor of the realm." Unusually, Alfonso's entire figure is shown. He holds the sword of justice, the orb of imperial power, and his throne is decorated with sphinxes (signifying wisdom). The figures are so skillfully compressed into the circular space that they seem to be sculpted in the round rather than carved. The obverse features a powerfully naturalistic portrait-bust of the elderly king (in the style of Roman statuary). He is shown wearing a breastplate decorated with winged *putti*, a nereid riding a centaur, and a Medusa head.

One of these "reports" may have come from Filippo Maria Visconti of Milan, whose castle at Pavia boasted frescoes by Pisanello and whose medal was also fashioned by the Veronese artist. Alfonso's close relationship with the Milanese duke dated from 1435, when he had been captured by Genoese troops in the battle of Ponza and handed over as Filippo Maria's prisoner. The Visconti duke entertained the king more as a friend than a foe, and Alfonso seized the opportunity of persuading Filippo of the benefits of Aragonese rule in Naples. As a result, both men signed an accord of mutual co-operation and military alliance

that lasted until Filippo Maria's death. In Pier Candido Decembrio's life of Filippo Maria Visconti, he states that although the duke "did not wish to be painted by anyone, he was nevertheless portrayed by the excellent Pisanello."

In commissioning a medal of himself by Pisanello (c. 1441), Filippo Maria was following a fashion that had been established at the northern court of Ferrara. The ruler of Ferrara at that time, Leonello d'Este, was himself a passionate antiquarian, who surrounded himself with leading humanist scholars. These included Guarino da Verona, the teacher of Fazio, and Leon Battista Alberti. Pisanello shared his patron's interests: he seems to have made detailed drawings of classical sculpture while working in Rome (although only one such drawing is definitively attributed to him) and, like Leonello, collected Roman coins. In 1444, when Alfonso's illegitimate daughter Maria of Aragon became the second wife of Leonello d'Este, the latter had a Pisanello medal struck specially for the occasion. The letters on the obverse of the medal, above Leonello's head (GE R AR), have been interpreted as standing for GENER REGIS ARAGONUM – declaring that Leonello is now related to the Aragonese king.

When Alfonso had his own medal designed by Pisanello in 1449, it was on a much larger scale, worthy of the king of a great empire, not just the prince of a small state (FIGS. 39 and 40). Alfonso is shown in classical profile, as befits a military general and ruler, wearing contemporary armour. To his left is his crested helmet, embellished with an open book, and to the right his crown and the date of the medal. The inscription reads DIVUS ALPHONSUS REX above, and TRIUMPHATOR ET PACIFICUS below. The use of the word DIVUS – holy – associates Alfonso with the early Roman emperors, several of whom were deified after their deaths. The king is celebrated as both military victor and peacemaker – hence the combination of arms and letters in the helmet motif.

On the reverse, Alfonso decided to have Pisanello depict an allegory of Liberality. A reputation for *liberalità* enhanced the king's regal prestige, and spoke of his piety (which took the form of lavish religious donations) and love for his people. It was an ancient imperial virtue, associated with the Emperor Augustus, as well as a political tool. Pontano claimed that the king's generosity made him "famous and loved"; the truth was rather different. The vast sums that Alfonso spent on his literary and artistic enterprises (20,000 ducats a year on humanists,

39. PISANELLO
Medal of Alfonso of Aragon (obverse), 1449. Cast bronze, diameter 4³/₈" (11 cm). Victoria and Albert Museum, London.

The pleasure derived from medals such as Pisanello's had much to do with their physical character as hand-held objects: the smoothness and coloration of the bronze, their satisfying weight and roundness, and the "feel" of the relief carving.

40. PISANELLO
Medal of Alfonso of Aragon (reverse), 1449. Victoria and Albert Museum, London.

according to his biographer Vespasiano da Bisticci – clearly an exaggeration – and 250,000 ducats on the structural renovation of an old Angevin castle, restyled as the Castel Nuovo) were financed by local taxes and money from his Spanish kingdoms, which greatly resented Alfonso's heavy investment in Naples. Some of the spending was vital: Castel Nuovo had been damaged in the siege and needed almost total rebuilding, but Alfonso made it into one of the most ostentatiously lavish of royal palaces (FIG. 41). As a defensive structure it was formidable, with immense round towers, massive ravelins and ditches of up to thirty yards across. He also built new fortresses – at Gaeta up the coast (at a cost of about 30,000 ducats), and at Castellammare di Stabia on the Bay of Naples.

Alfonso's interest in the medal can also be related to his fondness for heraldic-style devices in the French and English chivalric traditions. These devices, which were used as a mark of the ruler's personal identity or denoted membership of an order of knighthood, consisted of a symbolic or allegorical design, with a motto devised to help explain the imagery's esoteric significance

41. FRANCESCO ROSSELLI (attributed) Tavola Strozzi: Ferrante I in the Bay of Naples after the Battle of Ischia, July 1465, 1472-73. Tempera on panel, 32³/₈" x 8' (82 cm x 2.4 m). Museo di Capodimonte, Naples.

Detail showing Alfonso of Aragon's palace, the Castel Nuovo.

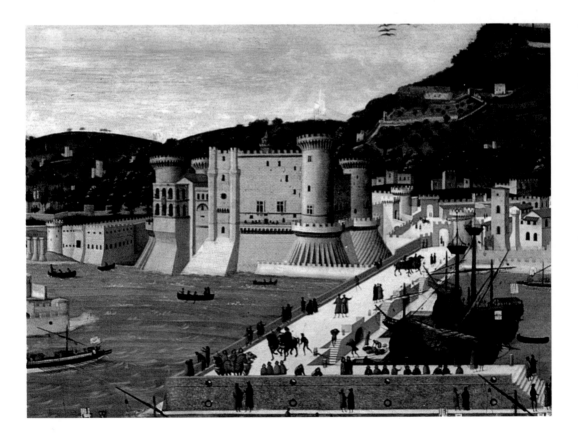

(FIG. 42). Alfonso belonged to the Order of the Lily and the Order of the Golden Fleece and his legitimized son Ferrante founded the famous Order of the Ermine. The combination of emblematic picture and explanatory inscription is a feature of the reverses of the new *all'antica* medals of Leonello and Alfonso. Like the devices, which the ruler conferred on his court favourites for their personal use, medals in the antique style were often given as marks of attachment to humanists and court favourites. The medal was moreover a better propaganda vehicle: the images were individually tailored, and the message could be more blatant.

Above 42. Pisanello *Design for an Aragonese Cloth* with the device and motto *Guarden Les Forces,* 1449. Brown wash, charcoal and pen, 8¼ x 5⅞" (21 x 15 cm). Louvre, Paris.

The reverse of the sheet bears two sketches of the bust of Alfonso for his medal of 1449. The tree in the center, growing from rock, is a symbol of enduring strength.

One of the prime motivations for Alfonso's patronage of the medal was that he believed it to be among the best vehicles for preserving his image for posterity. Ancient coins, after all, were the most prolific testament to the great emperors of antiquity. Guarino da Verona, in a letter of 1447 to Alfonso, claimed that painting and statues were not the best ways of guaranteeing fame, because they were neither portable nor "labeled." Images accompanied by inscriptions, on the other hand, left no confusion in the mind of the viewer and were of great help to historians. A letter from the Greek humanist Manuel Chrysoloras, written from Rome in 1411, was in the possession of Guarino da Verona (Manuel's Italian pupil) at this time, and had been widely circulated in humanist circles. It included a detailed description of

Right 43. Triumphal arch of King Alfonso of Aragon, 1453-58 and 1465-71. Castel Nuovo, Naples.

Alfonso's marble triumphal arch, framed by the massive towers of the Castel Nuovo, represents the sculptural and architectural achievements of two Iberians, two Dalmatians, two Lombards, a Roman, two Pisans, and a sculptor trained in Florence. Fazio described it as "of magnificent structure and workmanship, second to nothing in the world."

triumphal arches erected in commemoration of [Roman] triumphs and solemn procession – which included representations of the subject races with the generals triumphing over them, and the chariot and the quadrigae and the charioteers and bodyguards, and the captains following after and the booty carried before them – one can see all this in these figures as if really alive, and know what each is through the inscriptions there.

Chrysoloras regarded the reliefs on these great arches as "a complete and accurate history – or rather not a history so much as an exhibition, so to speak, and manifestation of everything that existed anywhere at that time." Alfonso was intensely interested in history and there were keen debates on historiography

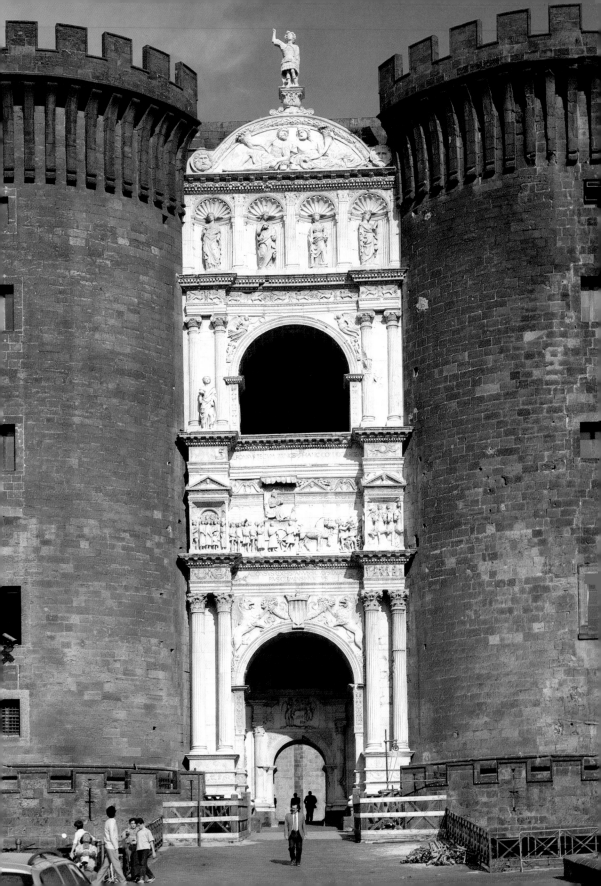

in Neapolitan circles. History, as the Florentine humanist Leonardo Bruni put it in around 1405, "affords to citizens and monarchs lessons of incitement or warning in the ordering of public policy. From history also we draw our store of examples of moral precepts." History, in the humanist sense, was almost indistinguishable from political propaganda, and for Alfonso public art was a selective and self-laudatory exhibition of the history he was creating. Chrysoloras also saw Rome's great monuments as evidence of the rulers' "wealth of gold and creative power, their artistic sense, as well as their greatness and majesty, their sensibility for lofty things and their love of beauty." Pisanello's prime duty on his appointment in 1449 was to create *monumentia insignia* – sculptural monuments that would immortalize Alfonso's qualities and deeds.

Many Pisanellesque designs have been associated with the sculptural decoration on Alfonso's great triumphal arch – made from "whitest marble" – erected at the entrance to the Castel Nuovo (FIG. 43). Work began in 1453, with the distinguished Dalmatian architect Onofrio di Giordano (who had a reputation as an expert in classical antiquities) appointed as its chief designer. The respected sculptor Pietro di Milano arrived in Naples from Dalmatia in July, and began carving reliefs on the lower arch with his assistants Francesco Laurana and Paolo Romano. Overseeing the figural sculpture was the eminent Catalan figure-carver Pere Joan who, with Guillem Sagrera, was also responsible for much of the interior decoration of the Castel Nuovo. While Sagrera was concentrating exclusively on his flamboyantly Gothic Sala dei Baroni inside (FIG. 44), the Italian sculptors were vigorously carving sumptuous *all'antica* vases with lilies and classical griffins (both symbols of the Order of the Lily), as well as *putti* carrying garlands, centaurs, and scenes from the voyages of Hercules.

The triumphal frieze (FIG. 45) was executed by, among others, two of Rome's leading sculptors, Isaia da Pisa and Andrea dell'Aquila (who were paid 356 ducats between them). As in Alfonso's actual triumph of 1443, which the frieze commemorates, the

44. GUILLEM SAGRERA
Vault of the Sala dei Baroni, 1455-57. Castel Nuovo, Naples.

This Gothic vault, made at the same time as the castle's "classical" triumphal arch, is based on Catalan models. It is of an overwhelmingly impressive scale – reaching to over 90 feet (28 m) high. Originally the rib junctions were decorated with the coats of arms of Alfonso's territories.

45. PIETRO DA MILANO AND
OTHERS
The Triumphal Cortége (detail
from the triumphal arch of
King Alfonso of Aragon),
1455-58. Castel Nuovo,
Naples.

Work on the triumphal frieze
was divided between Pietro
da Milano and Francesco
Laurana (left-hand side) and
Isaia da Pisa and Domenico
Gagini (right-hand side).
Gagini, who came from a
family of sculptors working in
the Genoese milieu,
contributed the exuberant
group of trumpeters and
musicians (far right), while
Isaia da Pisa probably created
the authentically classical
quadriga guided by Victory.
Pietro da Milano sculpted the
strongly individualized
dignitaries behind the
triumphal car, leaving
Francesco Laurana to portray
the hieratic figure of Alfonso.
The monumental heraldic
griffins below, associated
with designs by Pisanello,
have been attributed to Pietro
da Milano (left) and
Francesco Laurana (right).

mantle of the defeated René is draped over the back of the Siege
Perilous. Powerful sculptural groups in the pavilions either side
include the Tunisian ambassador and his entourage and the for-
midable Neapolitan barons. Alfonso was never officially
crowned king; this honor was gained by his illegitimate son and
heir Ferrante. Ferrante is shown as heir apparent in an internal
relief on the lower arch (FIG. 46) which was made during his
reign in 1465. His severely damaged coronation relief, which
adorns the inner arch (executed in 1465), bears the inscription: "I
succeeded to my father's kingdom having been thoroughly
tested, and received the robe and holy crown of the realm." The
"tests" to which Ferrante alludes are vividly illustrated on the
bronze doors made for the arch by the Umbrian Guglielmo Lo
Monaco in the 1470s (FIG. 47). These show Ferrante's victory
over the rebellious barons in 1462, the dramatic attempt on his

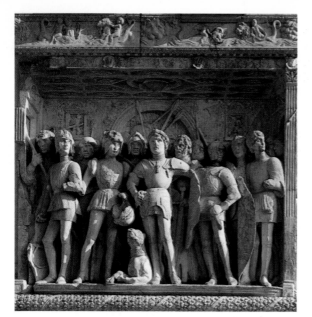

46. ANDREA DELL' AQUILA (?)
Ferrante and His Court
(detail from the triumphal
arch of King Alfonso of
Aragon: lower arch, inner
left-hand bas relief),1465.

The authorship of this relief
has been variously attributed
to two sculptors who worked
with Donatello: Andrea dell'
Aquila, who was a member
of the great sculptor's
Florentine workshop, and
the Pisan Antonio di Chellini,
who assisted Donatello in
Padua. Ferrante is shown in
the center, flanked by his
favourites, with rows of
soldiers shown in profile
stretching out behind him.
Above, a recessed strip
sectioned by Aragonese
emblems (including the
Siege Perilous and an open
book) is surmounted by a
lyrical, flowing frieze of
nereids and sea monsters.

life of 1460 and his defeat of René d'Anjou's troops in the battles of Accadia and Troia (Ferrante's victory is celebrated in the Tavola Strozzi – see FIG. 24, page 32). Bartolomeo Fazio probably devised the program and his Latin verses accompany the six scenes teeming with incident and a multitude of figures. The style is reminiscent of contemporary miniatures (with heraldic borders around each "field") and also the classical reliefs that wind round the triumphal columns of Trajan and Marcus Aurelius in Rome.

Ferrante's doors provide the final flourish to his father's majestic classical arch. Like the relief sculpture around them, the bronze panels describe episodes from recent history and at the same time rewrite them in grandiose and celebratory terms. The inscription *ALPHONSUS REX ... ITALICUS* above the triumphal frieze on the upper arch is a fitting tribute to King Alfonso's lofty imperial ambitions. Yet with Alfonso of Aragon, as with several other rulers of the period, the private enjoyment derived from painting and sculpture was often just as important as the public glory and political advantage to be had from them. The two spheres, private and public, were clearly distinguished from one another in contemporary orations. Thus the humanist Gianozzo Manetti in his speech of 1445 (celebrating the visit of Emperor Frederick III) praised Alfonso's private moral virtues (piety, continence, and devotion to art and learning) as distinct from his public regal qualities (justice, courage, gravity, liberality, and magnificence). Alfonso's letter of 22 March 1446, written to Cardinal Aquilea in grateful acknowledgment of some personal gifts he had just received, provides a suitable postscript to the monumental impression left by the Castel Nuovo arch:

I tell you, Sir, that when the first statue and the paintings arrived I was out hunting and did not return until sunset. I had not eaten all day, but nonetheless I was determined to satisfy the soul's desires before the body's, and I looked at the works without delay. I assure you that they are so perfect, especially the sculpture – which every day when I look at it delights me as if for the first time.

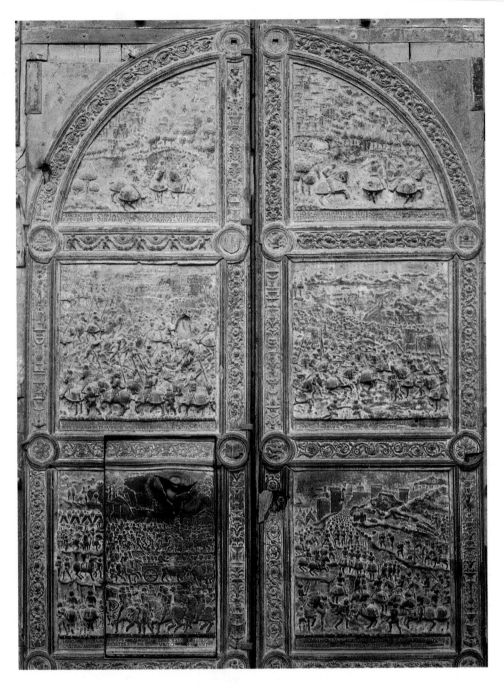

47. GUGLIELMO LO MONACO Bronze doors of the Castel Nuovo, c. 1474-77. Palazzo Reale, Naples.

Guglielmo had been variously employed at the Aragonese court making metal bombards, clocks, bronze cannon, and a bell for the Castel Nuovo. His portrait, along with that of Bartolomeo Fazio, appears in one of the doors' small roundels. Ironically, a cannon ball (fired by a Genoese galleon in the war against the French of 1495) is embedded in the lower left-hand panel, which depicts the retreating Angevin army.

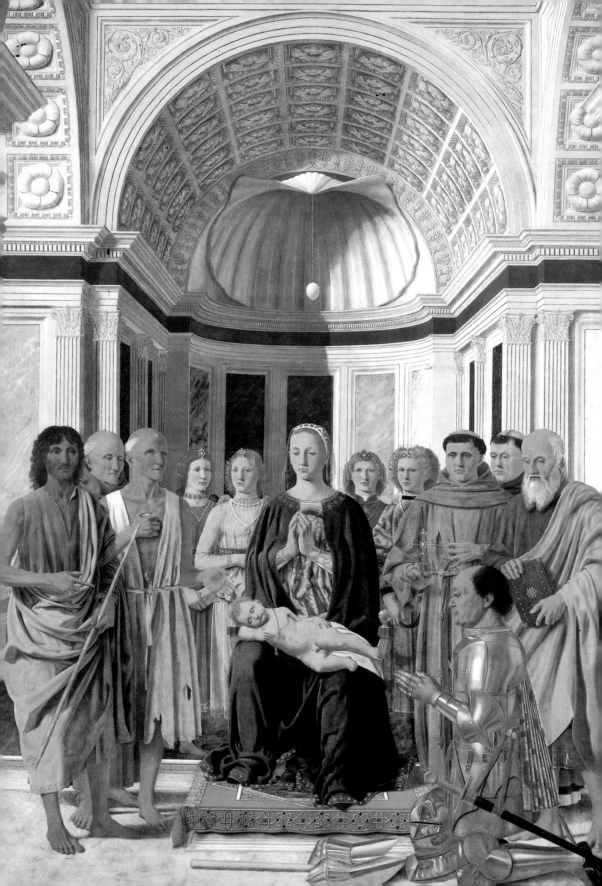

THREE

Arms and Letters: Urbino under Federico da Montefeltro

48. Piero della Francesca
The Brera Altarpiece (Pala
Montefeltro) c. 1472 (retouched
by Pedro Berruguete in 1476).
Oil on panel, 8′ 3¹/₄″ x 5′8″
(2.5 x 1.7 m). Brera, Milan.

The distribution of light in
Piero's altarpiece is one of the
panel's great novelties. The
matte texture of stone, scallop
shell, and egg are wonderfully
suggested, while the alternating
colors of the marble panels are
echoed in the richer color chords
of the draperies. The archi-
tecture and light (shining from
behind the figures) may have
mirrored the painting's intended
setting: possibly the round
tempietto in the "Pasquino"
courtyard of the palace (never
built) which was to serve as
Federico's mausoleum.

Federico da Montefeltro's patronage of the arts contributed
enormously to Urbino's status as the ideal Renaissance
court. A small hill-town with no cultural history to speak
of, Urbino was transformed in a relatively short period into a
fair-sized principality and a center of considerable artistic impor-
tance. In his treatise of 1510, the humanist Paolo Cortese
described Federico and Cosimo de' Medici as the two greatest
artistic patrons of the fifteenth century, while Baldassare Cas-
tiglione's *Book of the Courtier* (*Libro del Cortegiano*, 1528) vividly
evoked the enlightened and cultivated atmosphere of Urbino
under Federico's son Guidobaldo, singling out Federico's palace
and library for special praise. Vespasiano da Bisticci, the Floren-
tine agent who furnished the library with over half of its manu-
scripts, celebrated Federico's supreme abilities as a patron and a
military commander. For him, Federico represented the Christ-
ian ideal of the active and contemplative life. Through arms and
learning Federico achieved the wealth and stability that allowed
him to devote the latter half of his reign to the pursuit of his
princely ambitions. The imagery of his serenely harmonious
palace at Urbino alludes to the civilizing arts of peace made pos-
sible by the prudent conduct of war.

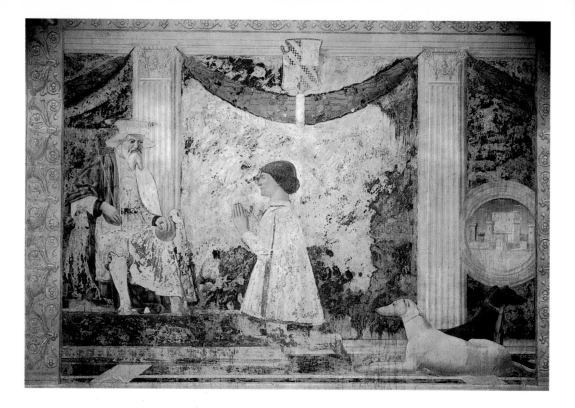

Federico (1420-1482) was first and foremost one of the most successful *condottieri* of his age. He was variously employed by most of the major states of Italy, particularly the papacy, and inflated his fees in line with his burgeoning prestige. By 1467, he was earning 60,000 ducats a year as a peacetime retainer, and 80,000 when he took up arms (the paymaster was Francesco Sforza of Milan). At the time of his death he was contracted for the huge sum of 165,000 ducats. He had gained his military expertise under the tutelage of the famous general Niccolò Piccinino, but he was also proud of another aspect of his education. As a boy hostage, he had spent two years in Mantua, where he was taught at the famous humanist school of Vittorino da Feltre alongside the Gonzaga children. Here he was introduced to the broadest humanist curriculum, learning Latin, astronomy, athletics, music, mathematics, and geometry. Vittorino also instilled in him the virtues of self-discipline and restraint that were to remain with him all his life. Using the immense earnings from warfare that he built up over the first twenty years of his rule, Federico established a large court of his own and, from 1468, invested more money in art and architecture than any other Italian ruler.

Besides his keen appreciation of sculpture and architecture (a common theme of princely patronage), Federico had several more complex motivations for spending on the arts on such a large scale. First and foremost, he had an urgent need to assert the legitimacy of his succession and to promote himself as a prince of incorruptible Christian virtue. At the same time, art was used to advertise his military prowess and propagate his image as a just and benevolent ruler. Another key theme was the celebration of the Montefeltro dynasty – Federico's paternity was the subject of much speculation and it was many years before his wife bore him an heir. The "magnificent" scale of his patronage was also designed to win him esteem both at home and among the kings and princes whom he regarded as his equals as well as his employers.

The recurrent qualities of much of the art commissioned by Federico are clarity, order, and dignity. Vespasiano, in his biography of Federico (1498), highlights the ruler's rigid self-control – a quality that seems to permeate the lucid and carefully articulated artistic imagery with which Federico and his advisers surrounded themselves. The painters, sculptors, and architects who gave visual expression to the themes of Federico's rule include Piero della Francesca (c. 1410-20-1492), Luciano Laurana(1420-25-1479) and Melozzo da Forlì (1438-1494). Their pure and harmonious styles are often thought to reflect the radiant spirit of Federico's Urbino. The problem with this notion is that it ignores the fact that these artists – all imported by the court – worked in a similar idiom for other cities and rulers. Piero della Francesca, for example, worked at the courts of Ferrara and Rimini, producing among other works the serene votive fresco of Sigismondo Malatesta kneeling before his patron saint (FIG. 49). Sigismondo's character, however, was the antithesis of Federico's: he was as capricious as Federico was measured and shrewd. Yet Sigismondo's notorious *mobilitas* – restlessness and changeability – find no place in Piero's calm, immutable Riminese portrait.

While Piero's is in essence a local style (he came from nearby Borgo San Sepolcro), his learned application of the new perspective technique and his delight in creating "real" architectural settings seem to have been keenly encouraged at the Montefeltro court. Federico surrounded himself with artists who shared his own fascination with architectural space and light. According to Vespasiano, Federico was actively involved in the designs of his own buildings, particularly his palace, although his role may have been more that of well-informed dilettante than pro-

49. PIERO DELLA FRANCESCA *St. Sigismund Venerated by Sigismondo Malatesta,* 1451. Detached fresco and tempera, 8'5⅝" x 11'4⅜" (2.5 x 3.4 m). San Francesco, Rimini.

Piero's large fresco is still displayed above the door of the "Cell of the Relics" in the Tempio Malatestiano (see FIG. 17). The fresco and the holy relics were originally designed to be seen from the adjacent chapel of St. Sigismund, through a window specially cut into the wall. Both Piero's portrait of Sigismondo (with the dark, "frowning eyes" that Pius II despised) and the roundel depicting Sigismondo's massive fortified castle (Castel Sismondo) seem to have served as models for Matteo de' Pasti's medals of the Riminese lord (see FIGS. 25 and 26).

tagonist. He shared this enthusiasm with his chief adviser Otta-viano Ubaldini, who probably played a key role in supervising artistic commissions and, as sole regent, oversaw the architect Francesco di Giorgio's work after Federico's death. Many of the painters and painter-architects employed by the court were pre-occupied with the perspective articulation of space on a two-dimensional surface or its translation into graciously propor-tioned three-dimensional forms. The reflective brilliance of sun-lit surfaces and the saturated color of forms in shadow were described in the newly refined oil technique, which Piero had mastered by the 1460s. Federico's appreciation of the oil medium led him to hire as court artist a Flemish painter who specialized in *colorire* (coloring in oils): he was the only Italian ruler to do this. Justus of Ghent was brought from Flanders (he is last docu-mented there in 1466) and was joined by the Spaniard Pedro Berruguete.

Federico's palace interior is unusual in its use of natural light, while its forms find echoes in Piero and Melozzo's painted archi-tecture. Two jewel-like chapels, constructed around 1474, are reminiscent of the cool temple interior of Piero's Brera Altar-piece (see FIG. 48, page 67). In both painting and chapels, the sense of balance is achieved through gently alternating chromatic chords as well as pure geometric relationships (FIG. 50). It has always been thought that Piero was involved in the design of the architectural interior of the palace, but his contribution has never been clearly identified. In these adjoining barrel-vaulted rooms, the architectural language of Alberti (a regular visitor to Urbino) is imbued with an intimacy and coloristic beauty that links it to the artists working in the Urbino milieu. Each room has a classi-cal order of columns framing an "altar" niche. The complemen-tary mingling of Christian and humanist references (the two chapels are positioned directly beneath Federico's *studiolo*) is reflected in the function of the two rooms: one is dedicated to the Holy Ghost, the other to Apollo, Pallas, and the Muses.

The dignity and prestige conferred by humanist learning were as important to Federico as they were to his fellow *condot-tiere*-prince, Ludovico Gonzaga, Marquis of Mantua. In a dis-patch of 1461, Federico complained to Ludovico that their employers treated them like "peasants" and yet expected to be well served. The implication that they were common soldiers driven by mercenary motives, rather than nobles inspired by deeds of ancient valour, played a large part in their promotion of themselves as humanist princes. Their reputation rested as much on their *fede* (faith) – it was crucial to be taken as men of their

50. Cappella del Perdono, c. 1474. Palazzo Ducale, Urbino.

This intimate chapel, with its frieze by the Venetian Ambrogio Barocci, was used to house Federico's precious relics. Its companion chapel was decorated with paintings of the Muses by Giovanni Santi and Timoteo Viti.

word – as in the wielding of arms. Federico's humanist credentials and princely "magnificence" were proudly exhibited in the form of an impressive and hastily assembled library – containing, as Castiglione recorded, "a large number of the most beautiful and rarest manuscripts in Greek, Latin and Hebrew, all of which [Federico] had illuminated with gold and silver ..." Teams of scribes and illuminators were housed within the court: the less wealthy Alessandro Sforza, in neighbouring Pesaro, had to use the talents of those employed at other centers. Federico's library included a lavishly illustrated bible bound in gold brocade, a deluxe Dante's *Divine Comedy*, and some beautiful presentation manuscripts (among them a treatise by Francesco di Giorgio and Piero della Francesca's *On the Perspective of Painting*). The splendor of such princely libraries is vividly evoked in Melozzo da Forlì's painting celebrating the library of Sixtus IV (FIG. 51).

The catalogue of Federico's library reflects his own preference for military treatises and ancient military history (Livy was read

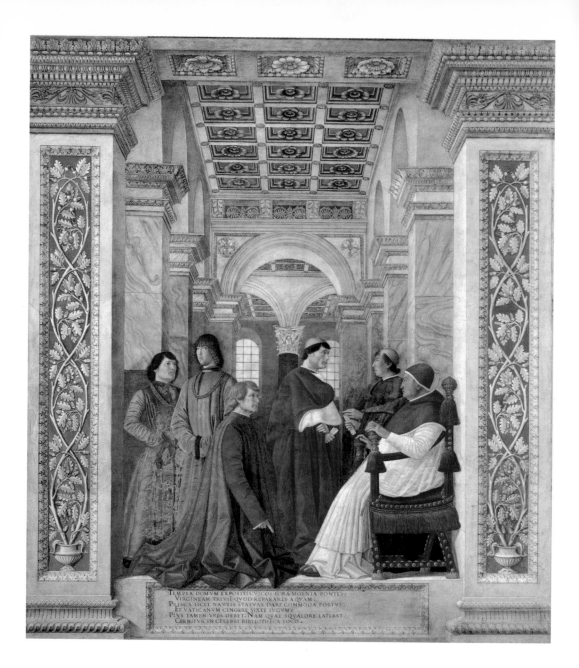

TEMPLA DOMVM EXPOSITIS·VICOS·FORA·MOENIA·PONTES·
VIRGINEAM·TRIVII·QVOD·REPARARIS·AQVAM·
PRISCA·LICET·NAVTIS·STATVAS·DARE·COMMODA·PORTVS·
ET·VATICANVM·CINGERE·SIXTE·IVGVM·
PLVS·TAMEN·VRBS·DEBET·NAM·QVAE·SQVALORE·LATEBAT·
CERNITVR·IN·CELEBRI·BIBLIOTHECA·LOCO·

to him in Latin nearly every day) and his interest in scientific and philosophical subjects. The library itself, a modest but airy room, was situated on the ground floor of the palace. It may have originally been decorated with a series of paintings of the liberal arts. They showed Federico and other leading courtiers paying homage to female personifications of the individual disciplines, and being honored for their own intellectual accomplishments

(FIG. 52). The librarian's duties, detailed in Guidobaldo's time, included displaying the books to people of learning or authority and politely pointing out the "beauty, characteristics, lettering, and miniatures in the work involved." Ignorant and inquisitive people were only to be given a glance of these treasures – unless, that is, they were people of "power and influence."

This emphasis on beautiful decoration contrasts markedly with the attitudes of Leonello d'Este and the Gonzaga, whose libraries had been painstakingly built up on the advice of leading humanists. In 1444, Gianfrancesco Gonzaga had written in a letter to an agent seeking out Greek manuscripts in Constantinople: "We don't care whether they are decorated or in exquisite lettering so long as they are accurate." Ludovico Gonzaga shared his father's perfectionist zeal. Federico's attitude, on the other hand, is very much that of the educated parvenu. The Florentine humanist Angelo Poliziano declared that many of the transcriptions in the Urbino library were rather poor. Yet there was no denying the library's comprehensiveness. Vespasiano relates how he and the duke went through the library's catalogue just before Federico set off for the siege of Ferrara. In comparing it with the catalogues of the papal library in the Vatican, the Medici library in San Marco, and the great university libraries of Pavia and Oxford, he records with an exuberant flourish: "all had defects or doubles; all, that is, except his."

Federico's initial patronage of the arts was relatively conventional. The bare remnants of a mural decoration in his palace (dated around 1450-55 and attributed to Giovanni Boccati) portrayed giant figures of famous men-at-arms (*uomini illustri*) in imaginary classical armour. The first architect of his palace was a Florentine, Maso di Bartolomeo, a pupil and collaborator of Cosimo de' Medici's architect, Michelozzo. Maso di Bartolomeo built the section of the palace known as the "Palazzetto dell Iole," which in typical dynastic mode incorporated the princely residence of Federico's ancestors. The Florentine sculptor Luca della Robbia was also briefly in Urbino, making a maiolica relief for the Dominicans for the portal of the church of San Domenico, which Federico himself financed. Cosimo de' Medici had no doubt been asked by Federico to recommend the best Florentine artisans. By 1465, however, when at the height of his powers, Federico was looking for a new architect and complaining that there was a dearth of Florentine talent. As a result, Luciano Laurana was brought from Alessandro Sforza's court in Pesaro with the permission of Ludovico Gonzaga (who had loaned him out temporarily).

51. MELOZZO DA FORLI *Sixtus IV, his Nephews and Platina*, 1480-81. Detached fresco, 12'2¼" x 10'2½" (3.7 x 3.1 m). Vatican, Rome.

This towering fresco originally adorned the wall of Pope Sixtus IV's Vatican library. Platina, the humanist librarian, is shown kneeling at the pope's feet, pointing at the inscription that praises Sixtus's rebuilding of Rome and celebrates the library as one of Sixtus's supreme achievements. The fresco would have been seen by courtiers and public alike, for the library was the first to open its doors to the people. Melozzo's powerful manipulation of perspective space and incisive portraiture evoke both the splendor and naked ambition of the papal court.

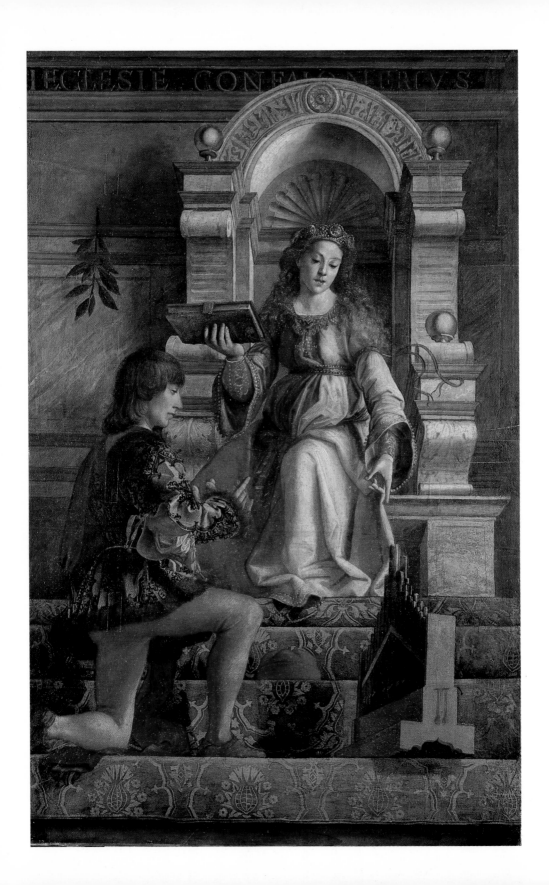

It was Laurana's contributions (c. 1466-72), and perhaps more emphatically those of Francesco di Giorgio (from c. 1476), that transformed the palace into the very symbol of Urbino: Castiglione described it as a "city in the form of a palace." In this respect, it shares the characteristics of a painted panel of an "ideal city" (perhaps intended to hang above a door in one of the interior rooms) that is sometimes attributed to the circle of Alberti (FIG. 53). This is one of three such panels that explore the potential of the new Vitruvian architectural vocabulary. The classical orders and carved ornament identify the elevated social status of the buildings and at the same time imply a sense of civic order that comes from good government. The patent letter of 1468 confirming Laurana's appointment as artistic director of the palace states that the skill of an architect is held in exceptional esteem, because it is grounded in the noble liberal arts of arithmetic and geometry. Laurana was given the funds and authority to direct and orchestrate every aspect of construction and decoration, from the stonecutters, sculptors, and intarsia workers to the palace's administrative agents. This was done in close liaison with Federico, despite his frequent absences on condottiere business.

The Urbino palace (FIG. 54) is the greatest of the many beautiful palaces that Federico built throughout his territory. Built into the hillside yet opening on to the city's main square, the palace is defensive but also accessible. Laurana's and Francesco di Giorgio's contributions include a central facade, with graceful towers framing a three-storey loggia, a broad staircase leading up to the *piano nobile,* or main floor, and a spacious inner courtyard with a wide colonnade of remarkably pure proportions (FIG. 55). Unlike Sigismondo Malatesta's nearby Castel Sismondo, which was an aggressive statement of power on Lombard-Emilian lines (FIG. 56), Federico's palace is an eloquent symbol of his peacetime ambitions. The sculptural exterior and interior decoration of the palace and the marquetry furnishings have been attributed to Lombard, Venetian, and Florentine masters. Two of the outstanding contributors were the Tuscan Domenico Rosselli and the Venetian sculptor Ambrogio Barocci (FIG. 57), who had access to designs used in Milan and Pavia. Between Laurana's departure in 1472 and the Sienese Francesco di Giorgio's appointment as palace architect (c. 1476), Ambrogio may have temporarily been in charge.

Because Federico built the palace virtually afresh, he was able to organize it around his own needs and those of his extensive household. All the audience rooms were situated on the *piano*

52. JUSTUS OF GHENT (?) Music, c. 1476. Panel, 5′1½″ x 3′2⅛″ (1.5 m x 97 cm). National Gallery, London.

Only four pictures from the series on the Liberal Arts are known, and two of these were destroyed in 1945. The fine quality of the paintings and sophistication of their perspective design (they are designed to be viewed from below) have led some critics to associate them with the hand of Melozzo da Forlì (active in Urbino between 1465 and 1476). Federico himself appears in the panel devoted to Dialectic (known through an old photograph) and a running inscription across the backgrounds of all four refers to his titles. It is uncertain whether they were designed for the library of the palace at Urbino, or another of Federico's palaces (perhaps that at Gubbio).

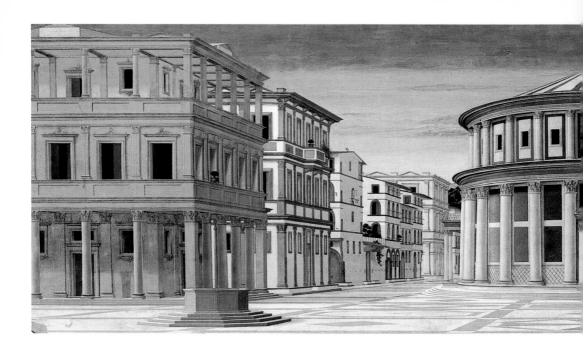

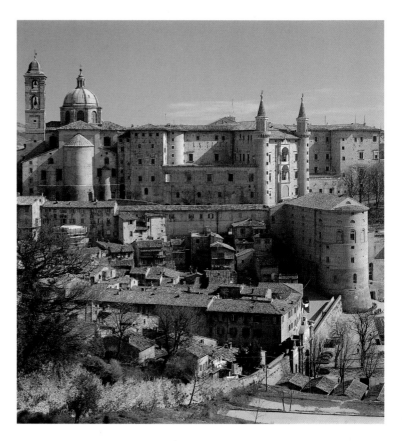

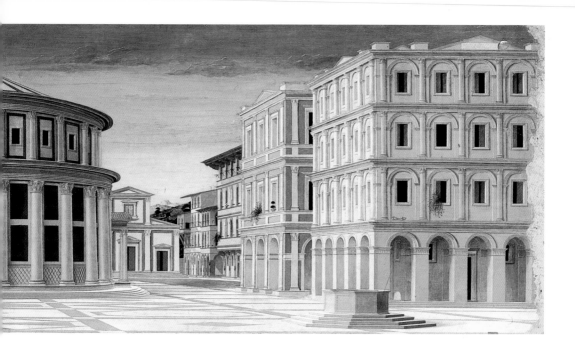

nobile, which was reached from the light and gracious stairway rising up from near the entrance loggia. Also on this floor were Federico's suite of private rooms, which were connected with the *studiolo*, the chapel, a delightful secret garden, and an airy loggia with views over rolling countryside. The ease of communication between private apartments and those that housed his staff, as well as the beauty of the interior furnishings, made the palace a model of elegance and comfort. The unusually large windows allowed light to flood into the rooms, bringing out the warmth and color of the different shades of wood in the *intarsia* panels and the brilliance of the gilded stucco ceilings. There were also practical innovations like Francesco di Giorgio's smokeless fireplaces (which had greatly impressed Federico Gonzaga) crowned with carved chimneypieces. Baccio Pontelli, the architect and *intarsia* designer who worked with Francesco di Giorgio from 1479 to 1481, sent designs of the palace to Florence's Lorenzo de' Medici at the latter's request.

The room that has attracted most scholarly interest is the *studiolo* (FIG. 58), created largely after Federico was made duke in 1474 (a similar room was made slightly later at Federico's palace at Gubbio). Situated between the main audience chamber and the duke's private apartments, it served a dual purpose. It was here that Federico found time for his scholarly pursuits, and here that he showed visiting dignitaries the "magnificence" and

Above 53. ANONYMOUS *The Ideal City*, last quarter of fifteenth century. Oil on panel, 26⅝" x 7' 10½" (67.5 cm x 2.4 m). Galleria Nazionale delle Marche, Urbino.

The palaces, temple, basilica, and geometric marble pavement of this "ideal" city have been created with ruler and compass. This panel, along with two similar "ideal" views in museums in Baltimore and Berlin, may have been painted partly as a demonstration of Brunelleschi's and Alberti's one-point perspective technique. The only parallel to these three visionary architectural views is found in the *intarsia* door panels, made between 1474 and 1482, of Federico's Urbino apartments.

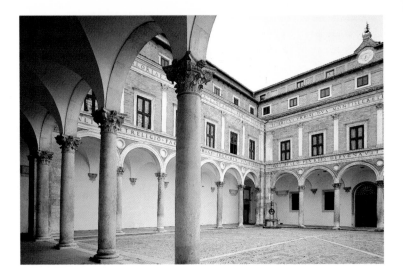

55. Courtyard (*Cortile d'onore*) of the Palazzo Ducale, Urbino.

56. MATTEO DE' PASTI Medal of Sigismondo Malatesta (reverse) 1450-51. Bronze, diameter 3¹/₈" (8 cm). Museo Civico, Rimini.

Castles appear in courtly works of art as symbols of territorial power. Pier Rossi, the lord of Parma, had the vault of the Camera d'Oro in his castle of Torchiara frescoed with the twenty castles of his domain, while Costanzo Sforza's fortress of Gardara is prominently depicted in Giovanni Bellini's Pesaro Altarpiece (a parallel to Sigismondo's use of his castle in a devotional context).

moral themes of his rule. The lower walls are still clothed in illusionistic *intarsie* of the most outstanding craftsmanship, while the upper portion was originally hung with twenty-eight portraits by Justus of Ghent of famous learned men (FIG. 59). Federico's *studiolo* was probably inspired by other princely examples, in particular Piero de' Medici's *studietto* in the new Palazzo Medici on the Via Larga (now in the Via Cavour) in Florence. The emblems, portraits, and objects depicted display the scholarly and Christian accomplishments that underline the military and dynastic achievements trumpeted throughout the decoration. Federico is portrayed in one intarsia as the embodiment of the cardinal virtues and as harbinger of peace (with a downward-pointing spear).

The dignity and order of Federico's "beautiful and worthy dwelling" were intended to do honor "to the status and praiseworthy reputation of our ancestors as well as our own rank and position" (Laurana's 1468 patent of appointment). The path to power, however, had not been a straight or unsullied one. Federico was born illegitimate ("according to Italian custom bastards commonly rule," remarked Pope Pius II dryly in his *Commentaries*), although he was legitimized in 1424. Pius II even reported the rumour that Federico was not the son of Count Guidantonio of Urbino, but had been fathered by the famous captain Ubaldini della Carda and substituted for the ruler's child at birth (though the passage was later deleted from the published version of the *Commentaries*). Federico only came to power when his half-

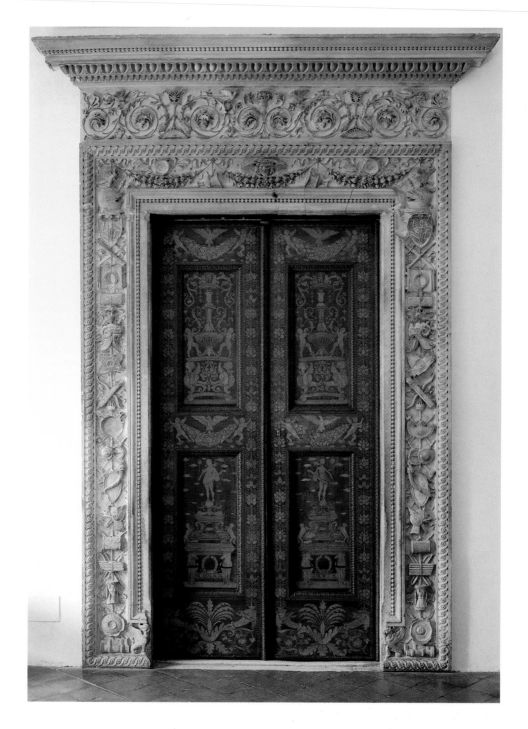

57. AMBROGIO BAROCCI AND GIANCRISTOFORO ROMANO (?)
Portal with war trophies (*Porta della guerra*). Iole suite, Palazzo Ducale, Urbino.

This imposing door stands at the head of the staircase "of honor."

Arms and Letters: Urbino under Federico da Montefeltro 79

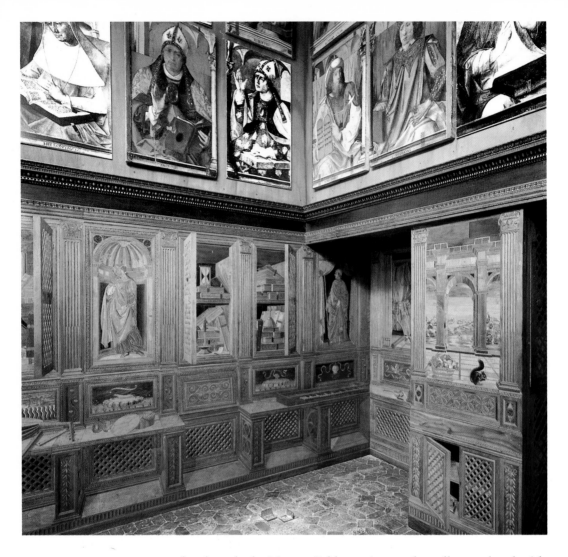

58. The *studiolo*, c. 1472-76.
Palazzo Ducale, Urbino.

The remarkable *intarsia* decoration (possibly created from designs by Sandro Botticelli and Francesco di Giorgio) includes illusionistic cupboards left open to display their contents, a landscape panorama, armour, devices, and titles. Many of these glorify Federico's accomplishments; others, like the basket of fruit, are there simply to delight the viewer.

brother, the legitimate Oddantonio, was brutally murdered with a pruning hook.

Oddantonio, who had become papal vicar of Urbino on his father's death (21 February 1443), was created Duke of Urbino in April 1443 at the age of sixteen. He had proceeded to impose heavy taxes on his people and lead a life of reckless debauchery. Within a year he had inspired near-universal hatred. At the time of Oddantonio's murder at the hands of his own subjects, the twenty-two-year-old Federico was in Pesaro, defending the city against Sigismondo Malatesta of Rimini. The following day Federico returned to Urbino with his troops, but was not allowed to re-enter the city until he had acquiesced to conditions imposed by the people. His ready agreement to grant an

amnesty to the assassins and those who had rampaged through the palace led to persistent rumours, fuelled by Sigismondo Malatesta, that Federico himself had headed the conspiracy to murder his brother – allegations he always vigorously denied.

Federico's problems at his succession were pressing ones. The state coffers were empty, and almost immediately he had to put down a plot by his own people to overthrow him. Added to this, Federico was penalized for his part in the secret sale of Pesaro (a papal vicariate), being excommunicated by Pope Eugenius IV in 1446. Eugenius's successor, Nicholas V, remedied the situation in 1447 and recognized Federico as Count of Urbino. From this time onwards, Federico settled into a period of relatively stable rule, assiduously building up valuable relations with courts and republics throughout the peninsula. In the interests of peace and security, he employed Francesco di Giorgio as architect and defence expert, committing about 200,000 ducats to the construction of a network of forts throughout the Urbino territories (FIG. 60). His most pressing priority, however, was to win the loyalty of his subjects. This he did through a policy of low taxation (his mercenary wages meant that he did not need to generate funds through taxes), the establishment of ecclesiastical foundations,

Above 59. JUSTUS OF GHENT (AND PEDRO BERRUGUETE?) *Plato* (from a series of *Uomini illustri*) c. 1475. Panel, 39⅞ x 27¼" (101 x 69 cm). Louvre, Paris.

The *studiolo's* learned men (half of which are now in the Louvre) included Vittorino da Feltre (Federico's tutor) and Pope Pius II (his ally).

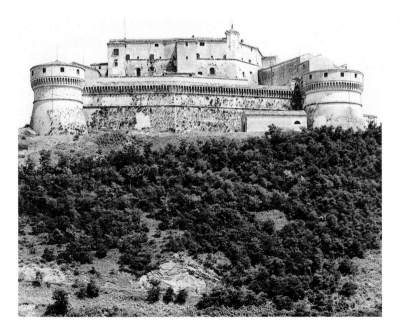

Left 60. FRANCESCO DI GIORGIO MARTINI Fort of Rocca San Leo, near Urbino, 1476-78.

The diversity of Francesco di Giorgio's achievements can be seen by comparing this building with the candelabrum incorporating Federico's emblems (FIG. 64). The famous Sienese designed over seventy fortresses in the Urbino region.

and, in the last twenty years of his rule, through a display of "magnificence" designed to stimulate civic pride and spread his honor abroad.

The beginning of the great period of Federico's art patronage falls shortly after the final humiliation of his arch-rival Sigismondo Malatesta (1417-1468), who had ruled in Rimini since 1432. Ever since Federico had arranged the sale of Pesaro in 1444 (Galeazzo Malatesta sold it to Francesco Sforza, with whom Federico formed an alliance) the bitter rivalry between the two neighbouring rulers had degenerated into violent enmity. The continuous feud reached a climax when Sigismondo Malatesta rashly took on the might of Pius II's papal state, in a last-ditch attempt to free Rimini from papal interference. Federico was employed by the papacy to fight the "impious house of Malatesta" and its representative Sigismondo, whom the Pope uniquely canonized to hell. In the midst of the war, Federico briefly sided with Sigismondo, who, with typical bravado, had a deluxe copy of Roberto Valturio's military treatise *On Military Matters* (*De Re Militari*: written about 1450 and published in 1472) presented to his rival. Valturio's treatise on the art of war promoted Sigismondo as the exemplary modern prince and general, the only one worthy to be classified amongst the ancients. Many of the military reliefs that later decorated the interior of Federico's palace were taken from its woodcut illustrations (attributed to the artist Matteo de' Pasti). After Sigismondo's defeat, Federico was the beneficiary of much of the Malatesta's forfeited territory. Urbino was now nearly three times its former size.

In 1464, the Pope granted Federico the right that the citizens of Urbino had previously denied him: to pass on the rule of Urbino to his legitimate son. Federico's first wife had been barren, though he had fathered several illegitimate children. His second wife, Battista Sforza (daughter of Alessandro Sforza of Pesaro), bore him eight girls in succession. Then, at the ninth attempt, she bore him an heir – Guidobaldo (FIG. 61). A few months later, Federico and his troops – in the pay of the Florentine republic – put down the revolt of Volterra (June 1472), a subject-town of the Florentines. As a mark of gratitude, the city of Florence staged a triumphal entry for the *condottiere*. The Mantuan ambassador in Urbino reported back to the Gonzaga, detailing one of the lavish gifts the Florentines sent to Federico: "A gilded silver helmet, with

61. JUSTUS OF GHENT
The Communion of the Apostles, 1472-74. Panel, 9'5" x 10'6" (2.8 x 3.1 m). Galleria Nazionale delle Marche, Urbino.

Detail showing Battista and the infant Guidobaldo.

enamels, valued, as is said, at 500 ducats. The crest is Hercules, club in hand, and under him the griffin, the arms of the people of Volterra, bound as a symbol of victory." The helmet was made by one of Florence's leading artists, the goldsmith Antonio del Pollaiuolo.

The gift of a solid silver helmet had bitter-sweet connotations for Federico. He had lost his right eye and the bridge of his nose had been shattered when he had been foolhardy enough to leave his helmet visor open in a joust. This incident (related by Giovanni Santi in his rhyming chronicle), besides leaving permanent physical scars, caused Federico eternal remorse. He saw it as a direct punishment from God for having impulsively placed an oak sprig in the open visor as a token of love for a young mistress whom he had seduced in a blasted oak. When his legitimized son Buonconte died of the plague in 1458, Federico still felt that he was atoning for his youthful sins. A Florentine miniature showing Federico as the victor of Volterra shows him from his right side but unscarred. In his official, large-scale portraits he is decorously shown facing to the left.

Federico's victory celebrations were abruptly curtailed in July by the tragic death of Battista Sforza, who had never recovered from Guidobaldo's birth. The two events inspired Federico to commission several works that were either devoted to her memory or to the recent military victory, which he dedicated to his late wife in her honor. In around 1472 he commissioned a double portrait of himself and his wife from Piero della Francesca (FIG. 62). The two panels may have originally been in the form of a diptych (hinged so that they opened and closed like a book), with the bust-length portraits on the outside and two scenes of allegorical triumph on the inside (see FIG. 7, page 13). The coupling of aristocratic profile portraits with allegorical emblems is similar to that found in contemporary medals. There are even accompanying inscriptions written in the same perfect humanist hand that appears along the base of Piero's Riminese fresco.

While Sigismondo chose to have his castle portrayed alongside him, Federico and Battista's profiles are set against a shimmering landscape that implies the infinite extent of their domain (although there are no direct topographical references). The landscape, with a walled city and little boats gliding on radiant expanses of water, is painted in the manner of Van Eyck, and is echoed in the continuous panoramic landscapes on the reverse panels. Battista's pale profile – probably taken from her death mask – reveals a luminous intelligence set off by the lustre of her pearls. A highly cultured woman, she was deeply revered by

Following pages
62. PIERO DELLA FRANCESCA *Diptych with Portraits of Federico da Montefeltro and Battista Sforza*, c. 1472. Oil on panel, each panel: 18⅝ x 13⅛" (47 x 33 cm). Uffizi, Florence.

These profile portraits are beautifully contrasted: the dead Battista's fine blonde hair and porcelain skin are set against the dark, wiry hair and sanguine complexion of Federico; her finery is rendered all the more splendid by comparison with his sober red attire. The timeless landscapes against which they are silhouetted heighten the poignant message of their juxtaposition. Battista's valley is filled with shadows, which in Federico's panel are softly dispersed by the moist early morning light. It is possible that Federico chose the portable diptych format so that he could carry the portrait of his late wife with him when he journeyed from palace to palace.

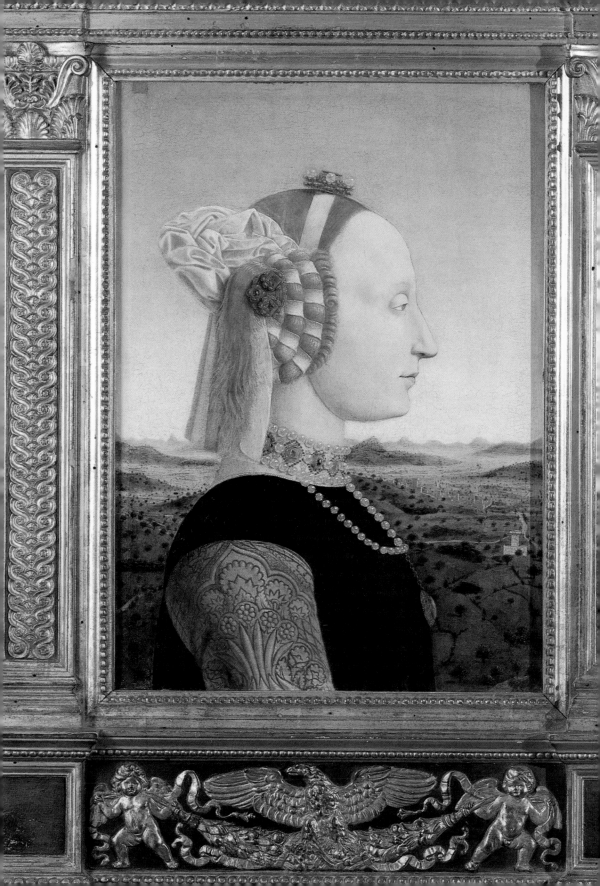

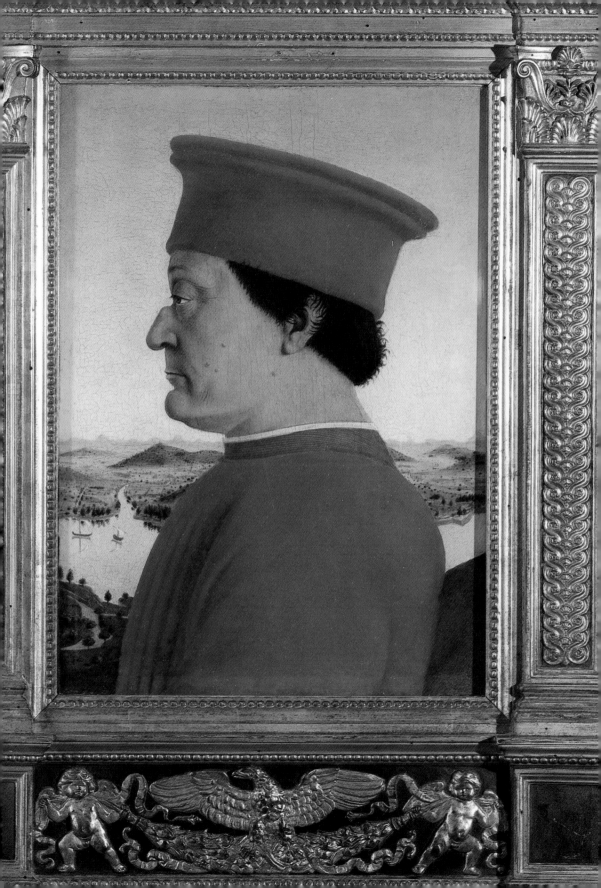

63. PIERO DELLA FRANCESCA
The Brera Altarpiece (Pala
Montefeltro) c. 1472
(retouched by Pedro
Berruguete in 1476). Oil on
panel, 8′ 3¼″ x 5′8″ (2.5 x
1.7 m). Brera, Milan.

Detail showing the kneeling
Federico da Montefeltro

64. FRANCESCO DI GIORGIO
MARTINI (attributed)
Candelabrum, c. 1476.
Gilded bronze, height 5′3⅝″
(1.6 m). Museo Diocesano
Albani, Urbino.

This enormous candelabrum
was presented to Urbino
cathedral by Federico da
Montefeltro for use in the
Easter liturgy. It is decorated
with symbols of the
resurrected Christ as well as
the duke's heraldic emblems
and chivalric honours. The
gift of the piece may have
coincided with the duke's
decision to rebuild the
cathedral – Francesco di
Giorgio was made cathedral
architect from 1476.

Federico. The ideals of dignity, decency, and modesty outlined in Alberti's *On Painting* are followed to the letter in the manner of Federico's portrayal. Alberti had given the example of Apelles, who "painted the portrait of Antigonus only from the side of his face away from his bad eye": Piero's portrait of Federico observes "decency" in precisely this way. Alberti also relates that the ancient painters, "when painting kings who had some physical defect, did not wish this to appear to have been overlooked, but they corrected it as far as possible while still maintaining the likeness." Piero does not attempt completely to disguise Federico's disfigurement, realizing that this adds to the impression of naturalism.

Like Sigismondo, Federico was to realize the propaganda value of a strong, recognizable likeness. Piero's formidable portrait was to be used as a model by medallists and manuscript illuminators throughout Federico's reign. The enmity between Federico and Sigismondo seems to have played some part in the restrained visual image that Federico preferred for himself. Both men had things in common: they were extremely able *condottieri* and erudite rulers: Sigismondo was one of the most naturally gifted and eloquent men of his day, with his *mobilitas* also expressing itself in an exceptionally quick and agile intelligence. Sigismondo's undisguised acts of immorality and hot-headed impetuosity, however, served to underline Federico's moral rectitude and coolly deliberate character. Vespasiano da Bisticci's *Life* describes Federico as "naturally choleric" in temperament, although "after a long time he managed to control this, on every occasion being a reconciliator for his people." His passion for clear organization and insistence on the highest standards of hygiene are reflected in a unique list (the *Ordini et offici*) detailing the duties and structure of his household. Later Giovanni Pontano, in his treatise *On Prudence* (*De Prudentia*, around 1499), singled out Federico as leading an exemplary "prudent life."

A second portrait by Piero of Federico, using the same cartoon as the diptych portrait, is included in the so-called Brera Altarpiece, dating from about 1472 (see FIG. 48, page 67). The altarpiece was later hung in Federico's burial church of San Bernardino (begun by Francesco di Giorgio shortly after the duke's death). It is probably first and foremost a votive work, celebrating Federico's victory in Volterra. The Virgin sits solemnly on a dais in the center, with the Christ Child laid across her lap. Her rich brocade robe and modest veil seem to identify her with Battista. Indeed, originally, her headdress was adorned with a jewel very much like that worn by Battista in

the Uffizi diptych, and which seems to have been a studio prop. The angels behind her are bedecked in the splendid jewels that Piero used to display his skill in the oil technique. Federico kneels in the foreground in shining armour, his sword still strapped to his side (FIG. 63). His helmet (rippled with reflections), gauntlets, and baton of command are on the floor beside him, leaving his head bare and his hands free to pray. Suspended above the Virgin's head, at the apex of the scallop-shaped shell on the apse, is a large white ostrich egg on a slender cord. Its smooth, matte finish reveals Piero's delight in contrasting reflective and non-reflective surfaces.

The work is full of subtle symbolism and allusions. Federico kneels in front of his patron saint John the Evangelist, whose book is held in line with Federico's head – that favourite conjunction of arms and letters. On the opposite side stands Battista's patron saint, St. John the Baptist. St. Jerome, St. Francis, St. Peter Martyr, and St. Bernardino (canonized in 1450) complete the ensemble of saints. The ostrich egg has been interpreted in countless ways, but it is probably another instance of the painting's clever combining of theological and secular meanings, in keeping with the dual nature of the work. The ostrich was a personal emblem of Federico and its eggs a common ornament of churches. A candelabrum for the cathedral, probably made by Francesco di Giorgio and donated by the duke, features the same combination of sacred and secular symbols – with Fredericos emblems (including the ostrich and bombshell) arranged around its base (FIG. 64).

Piero della Francesca's main period of employment at Urbino dates from the early 1470s, although he seems to have worked for Federico periodically before this date. Giorgio Vasari mentions that he made "many paintings with extremely beautiful figures" at Urbino, most of which "came to grief during the many times that state has been troubled with war." The famous *Flagellation of Christ* (FIG. 65), dating from the late 1450s or early to mid-1460s may be the sole survivor of this type. With no clues as to the painting's original setting, or even the definitive identity of its patron, the attempts to unravel its meaning continue unabated.

The old tradition that the figures in the foreground of the picture represent Oddantonio flanked by the evil counsellors who were killed alongside him – the agents of Sigismondo Malatesta – is still hotly disputed. Other interpretations hinge on an inscription *CONVENERUNT IN UNUM*, which seems to have once been written on its frame (now

65. PIERO DELLA FRANCESCA
Flagellation of Christ, late
1450s or early to mid-1460s.
Oil and tempera on panel,
23¹/₈ x 32¹/₄" (58.4 x 81.5 cm).
Galleria Nazionale delle
Marche, Urbino.

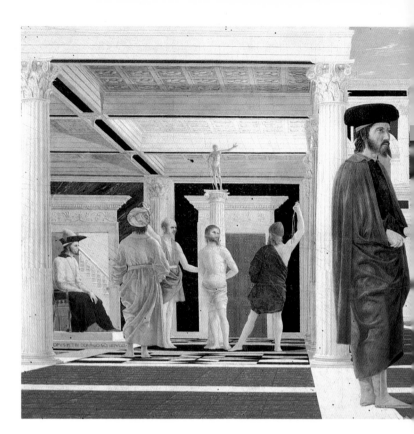

Aside from the iconographical
complexities of this small
meditative panel, the
Flagellation has attracted
much attention because of the
unusual precision of its
architectural setting. The
biblical event takes place in
Pilate's Praetorium in
Jerusalem; the flagellation
column is probably the city's
Hadrianic sun column,
marking the center of the
earth. When the perspective of
Piero's praetorium is translated
into real architecture, the
column appears on a perfectly
round porphyry disc
surrounded by geometrically
patterned Roman floor tiles.
The separation of the holy site
from the deep exterior
courtyard is emphasized by
supernatural and natural light
effects.

lost). These words were taken from the Second Psalm, "The
kings of the earth set themselves, and the rulers take counsel
together, against the Lord and against his Anointed ..." The
psalm goes on to exhort the kings ("ye judges of the earth") to
be wise and be instructed. The painting may embrace both the
Old and New Testament meanings contained in this verse.
David's psalm was interpreted as a prophecy of the conspiracy
against Christ – the three foreground figures may represent
Herod, Pilate, and the prophet David – and also as an exhorta-
tion to a holy crusade – the flagellation scene has been inter-
preted as an allegory of the church's contemporary suffering at
the hands of the Turks.

Piero's first documented visit to Urbino is in the spring of
1469. He came, all expenses paid, at the invitation of the artist
Giovanni Santi, not at the bidding of the court. Santi had been
asked to find a painter to complete an altarpiece for the Corpus
Domini confraternity, which had been begun by the Florentine
artist Paolo Uccello, who was paid for the predella panels in
1468. Piero was unable to undertake the commission and, in the
event, Justus of Ghent painted the main panel (1472-74). Its

iconography is traditional: the Last Supper is shown as an enactment of the sacrament of the Eucharist. In recognition of Federico's generous partial funding of the project, the figures of Federico, two leading courtiers (Ubaldini is one of them), and the late Battista with baby Guidobaldo are also included. Federico gestures towards a richly dressed Jew, who has been identified as Isaac, the ambassador of the Shah of Persia. Isaac, a Catholic convert, had caused a great stir when he came to Urbino in 1472 to persuade Federico to embark on a crusade against the Turks. Justus has set the action in a shadowy Romanesque interior – imbuing the architecture with sacred symbolism of a distinctly Flemish type (FIG. 66).

At the time of the altarpiece's completion, Federico's career reached its triumphant heights. In 1474 he was created Duke of Urbino in an elaborate ceremony performed by Pope Sixtus IV in Rome, and also made *gonfalonierè* (captain) of the papal forces. Later that year, he received two prestigious international honors: the Order of the Garter from Edward IV of England and the Order of the Ermine from Ferrante of Naples. Federico could now at last bask in the universal recognition of his status and look to his son to uphold the dignity of the Montefeltro dynasty. Inscriptions referring to his new titles and honors appear throughout the palace – chief among them the omni-

66. JUSTUS OF GHENT
The Communion of the Apostles, 1472-74. Panel, 9′5″ x 10′6″ (2.8 x 3.1 m). Galleria Nazionale delle Marche, Urbino.

This panel is a strange mixture of Italian and Flemish styles, techniques, and imagery. The brocaded figure, who has been identified as Isaac the converted Jew, closely resembles the Old Testament facial types of the Louvain master Dirc Bouts.

present flourish FED. DUX. His princely confidence expresses itself in the official portrait supreme, recently re-attributed from Justus of Ghent to Pedro Berruguete (FIG. 67).

The Duke is shown solemnly reading at a lectern, yet he is also dressed in armour, with his sword strapped to his side. His dignified and disfigured profile is itself a symbol of fortitude: Giovanni Pontano referred to Federico's self-deprecating jokes about his own appearance as an example of his courage. As defender of the Christian faith, Federico is ever vigilant, even when engrossed in scholarly contemplation. His prestigious chivalric honors – the Order of the Garter and the Order of the Ermine – are prominently displayed. Above the lectern is a hat encrusted with pearls – possibly the gift presented to Federico by the ambassador of the Shah of Persia. This lavish object alludes to Federico's central role in the shah's call for an international holy crusade. The fragile child leaning against Federico's reassuringly solid draped knee is his heir Guidobaldo, bearing the sceptre that signifies the continuation of the Montefeltro dynasty. It is engraved with the word *Pontifex* – an allusion to the pope's granting of the right of succession. Just as the famous men in the *studiolo* had provided Federico with moral and intellectual guidance (over half their dedicatory inscriptions mention Federico's gratitude towards them), so young Guidobaldo, radiant in his ceremonial robes, is here presented with the living example of his father.

In 1512, thirty years after the duke's death, Guidobaldo's adopted son and successor, Duke Francesco Maria della Rovere, ordered Federico's coffin to be opened up for him. His secretary, Urbano Urbani, reports that he tried repeatedly to pull a few hairs from Federico's chest but found that they still held remarkably firm. Deprived of this "relic," Francesco Maria sighed: "Why was I not born a generation earlier so that I could profit from the example of such a man?"

LIBRO PRIMO DELLA HISTORIA DELLE COSE FACTE DALLO INVICTISSIMO DVCA FRANCESCO SFORZA SCRIPTA IN LATINO DA GIOVANNI SIMONETTA ET TRADOCTA IN LINGVA FIORENTINA DA CHRISTOPHORO LANDINO FIOREN TINO.

FRAN. SFOR. VIC.

M
D.X
M
LII
IIII

PATER PATRIAE

NE TEMPI CHE LA REGINA GIOVANNA SE conda figliuola di Carlo Re regnaua:perche era suc ceduta nel regno Neapolitano a Latislao Re suo fra tello:elquale parti di uita sanza figliuoli.Alphonso Re daragona con grande armata mouendo di Cata logna uenne in Sicilia: Isola di suo Imperio.La cui uenuta excito gli huomini del Neapolitano regno a uarii fauori:& a diuersi consigli:& non con piccoli commouimenti di quel regno:Impero che Giouana Regina per molti & uarii suoi impudichi amori era caduta in soma infamia.Et desperandosi che lei femina potessi adempiere lofficio del Re:& aministrare tanto regno:fece prese marito Iacopo di Nerbona Conte di Marcia:elquale per nobilita di san gue:& belleza di corpo:ne meno per uirtu era tra Principi di Francia excel lente.Ma accorgendosi in breue che quello desideraua piu essere Re:che marito:& quella non molto stimaua:mosso da feminile leuita lo rifiuto:& priuo dogni aministratice.Questo fu cagion chel suo regno:elquale per sua natura e prono alle dissensioni & discordie:arrogendouisi e no honesti costumi della Regina: ritorno nelle antiche factioni & partialita;& comin cio ogni giorno piu a fluctuare & uacillare.Erano alcuni a quali no dispia cea la signoria della dona:perche benche il nome fussi in lei:loro niente di meno comandauano.Altri desiderauano:che Lodouico tertio Duca dangio: figliuolo di Lodouico e quale era nomato Re di Puglia:& di uiolante:nata della Reale stirpe daragonia:fussi adoptato dalla Regina.Costui poco auanti ne conforti di Martino tertio somo Pontefice:& di Sforza Attendolo excel lentissimo Duca in militare disciplina:& padre di Francesco sforza de cui egregii facti habbiamo a scriuere era uenuto a liti di Campagna:Et cogiun tosi Sforza:hauea mosso guerra alla Regina.Ma quegli che repugnauano a Lodouico:metteuano ogni industria:che Alphonso fussi adoptato in su gliuolo della Reina:accio che in Napoli fussi tal Re:che con le sue forze & di mare & di terra potessi resistere alla possa de Franciosi.Adunque in cosi uehemente contentione de baroni:& piu huomini del regno:Alphonso chia mato dalla Reina in herede & compagno del regno:diuene no solo illustre: ma anchora horribile:Et el nome Catelano elquale insino a quegli tempi no era molto noto & celebre se non a popoli maritimi:ma inuiso & odioso: comincio a crescere:& farsi chiaro.Ma & da Lodouico & da Sforza tanto ogni giorno piu erono oppressi:el Re & la Regina:che diffidandosi nelle pro prie forze:conduxono Braccio Perugino:el quale era el secondo Capitano di militia in Italia in quegli tepi co molte honoreuoli coditioni:& maxime

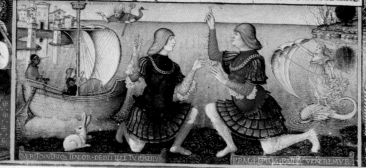

FOUR

Local Tradition and Imported Expertise: Milan and Pavia under Ludovico "Il Moro"

68. GIOVAN PIETRO BIRAGO
Frontispiece to Giovanni
Simonetta's *Sforziada*, 1490.
Bibliothéque Nationale, Paris.

This elaborate frontispiece
emphasizes Ludovico's
paternal care for his nephew,
Giangaleazzo, for this edition
was a gift to his youthful
charge. In the right-hand
border, the Moor (Ludovico)
emerges from a mulberry tree,
embracing a smaller tree
(Giangaleazzo). Their initials
IOG and *L* are correspondingly
entwined. The two are
portrayed at the bottom of the
page, with Ludovico
preaching the virtues of good
government. Behind them
Ludovico's patron saint,
Louis, blesses the ship of state
which bears Giangaleazzo
and is steered by a Moor.

round 1482, Leonardo da Vinci left Florence, where he was a member of the painters' Guild of St. Luke, to try his luck at the great court of Milan. According to one of his early biographers, he had been chosen by Lorenzo de' Medici to present Ludovico Sforza, Duke of Bari and regent of Milan (ruled 1480-1508), with the gift of a silver lyre, since he was a superb player on the instrument. Leonardo went in the company of his gifted pupil, the young musician, singer, and actor Atalante Migliorotti. Staying on in the city, Leonardo presented a remarkable letter of self-recommendation to Ludovico, listing the complete range of services he could provide and stressing his skills as a military engineer. This letter, of about 1485-86, drafted in another's hand, shows Leonardo's understanding of the priorities of a great military court; it also reveals the subtle differences between his own perceptions of a court position, colored by his Florentine background, and the realities of such employment – which rarely resulted from a direct approach of this kind.

In his letter Leonardo offered to contrive portable bridges, covered walkways and ladders, siege machinery, mortars capable of "causing great terror and confusion," sea vessels, impregnable covered chariots, catapults, mangonels, "and other machines of marvellous efficacy." Many drawings exist of the ingenious weapons he devised during his Milanese years (FIG. 69), although

69. LEONARDO DA VINCI
Design for a Ballistic Weapon, c. 1487-90.
8 x 10⅞" (20.3 x 27.5 cm).
Biblioteca Ambrosiana, Milan.

This giant catapult, capable of firing "100 pounds of stone," is tripped by lever action. An alternative spring-pivoted trigger (illustrated on the left) is released by a mallet blow.

it is not known to what extent they were used by Ludovico. At the end of his letter, he adds – almost by way of a postscript – "In times of peace I believe I can give perfect satisfaction to the equal of any other in architecture and the composition of buildings public and private; and in guiding water from one to another ... I can carry out sculpture in marble, bronze, or clay, and also I can do in painting whatever may be done, as well as any other, be he who he may." The final item is a specific suggestion: "Again, the bronze horse may be taken in hand, which is to be to the immortal glory and eternal honor of the prince your father of happy memory, and of the illustrious house of Sforza."

On his arrival, Leonardo (1452-1519) would have been struck by the huge cultural differences between republican Florence and Sforza Milan. Although a great trading and manufacturing center, Milan's character was defined more by its military ethos and aristocratic ambitions than its commercial dealings. Geographically and politically, Milan was connected as much to France and Germany across the Alps as it was to Florence and other Italian cities south of the Po Valley. The emblems adopted

by the Sforza and their Visconti predecessors boast not only of their rich Lombard heritage, but also of their imperial German and royal French and English connections. Galeazzo II Visconti (d. 1378) had married the sister of Amadeo VI of Savoy, count of the mountainous state straddling the Alps. Through Savoy, French and English chivalric culture filtered its way into Lombardy and, with the marriage of Galeazzo's children to the sons and daughters of French and English royalty, set its stamp firmly on court ideology and culture. Galeazzo's successor, Giangaleazzo (d. 1402), had expansionist ambitions: only his premature death seems to have prevented him from becoming the peninsula's overall ruler.

While both Florence and Milan used art and pageantry as expressions of "magnificence," there was a marked difference in scale and style. This had been highlighted in 1471, when Duke Galeazzo Maria (1444–1476), Ludovico's older brother and predecessor, had made his spectacular entry into Florence accompanied by his wife, Bona of Savoy, sister-in-law of the king of France. Featuring 1,250 elaborately costumed courtiers, and more than a thousand horses bedecked in caparisons of white and deep red velvet (Sforza colors) and fitted out in gold and silver, their dazzling procession had wound its way through the city to the church of Santissima Annunziata. At an estimated cost of 200,000 ducats, the spectacle far surpassed Florentine pageants and was regarded as a scandalous display of extravagance and an awesome manifestation of Sforza despotic power.

At home, Milan's vast material wealth and firm belief in the ritual trappings of power supported an immense bureaucratic network of court and state officials and a large population of local skilled artisans. The administrative core of the Sforza court was more complex than that of any other northern Italian court, let alone a republic. In Ludovico's time, its machinery took on a new sophistication: secretaries, with virtually sovereign powers, were put in charge of the key departments of law, ecclesiastical affairs, foreign policy, and finance. In theory, appointments and the day-to-day running of these departments were in their hands; in practice the duke could and did intervene whenever it was in his interests to do so. The court reached far beyond the physical confines of the ducal residences and connected court buildings. Subject towns and districts were part of the sprawling governmental network, with the duke appointing the Commissario and other high-ranking ducal civil officers. The native nobility had their own palaces and some of them were considerable patrons of art in their own right. The poet Gaspare Visconti,

70. Altar cloth, late fifteenth century. Coloured silks, gold, and silver, 35⅝" x 8'4" (90 cm x 2.5 m). Museo Poldi Pezzoli, Milan.

This silk cloth, with its delicate design showing a pelican feeding its young, is enlivened with brilliant five-pointed flames in gold and silver thread, which symbolize the holy spirit. It is probably from the church of Santa Maria delle Grazie – luxurious cloths of this type were donated as gifts by Ludovico and Beatrice.

for example, had his residence frescoed by Donato Bramante with giant figures of "men of arms."

The court was well provided with artists, stonemasons (the finest in Italy), and architect-engineers from the Lombardy region. It was also an active and voracious consumer of deluxe items from local craftsmen, purchasing exquisite engraved plate from the city's famous armourers and luxury silks, satins, and brocades, which were manufactured in Milan (FIG. 70). Ludovico combined a love of gold and precious gems, on a scale only seen in northern European courts and the Kingdom of Naples, with a sophisticated delight in such "refinements" as antique cameos, engraved carnelians, medallions, antique coins, and illuminated books. When the Medici were ousted from power in 1494, Ludovico sought to embellish his treasure-trove with all "the precious and portable things" that had been assiduously assembled by Lorenzo de' Medici.

In the early 1490s, the threshold to Ludovico Sforza's treasury in the "Rocchetta" fortress of the Castello Sforzesco was frescoed with an image of the mythological giant Argus of a hundred watchful eyes (FIG. 71). The fresco, considered to be largely by Bramante (c. 1444-1514) with the help of his Milanese follower Bramantino, is one of the most naked expressions of Sforza financial power. The custodian of the duchy's coffers stands at the head of a long corridor, shown in dramatic foreshortening, holding a club in his hand. Below him, a monochrome roundel in *bronzo finto* (imitation bronze relief) shows a sovereign presiding over the weighing of gold. In a bold subversion of the Ovidian myth, in which Argus is beheaded by Mercury, the protector of robbers, Argus seems to have emerged victorious. In his right hand there are traces of Mercury's caduceus (wand), entwined with the green vipers associated with the Sforza's Visconti predecessors (their heraldic device).

The fresco illustrates several key themes of Ludovico's patronage. First is the use of classical/imperial imagery in the promotion of Sforza ideology. Then there is the stress on stylistic continuity: Bramante's work assimilates the styles of the court's favoured artists – the Paduan/Ferrarese elements of Vincenzo Foppa's paintings, the angular mannerisms of Cristoforo and Antonio Mantegazza's sculpture – into a heroic classicizing

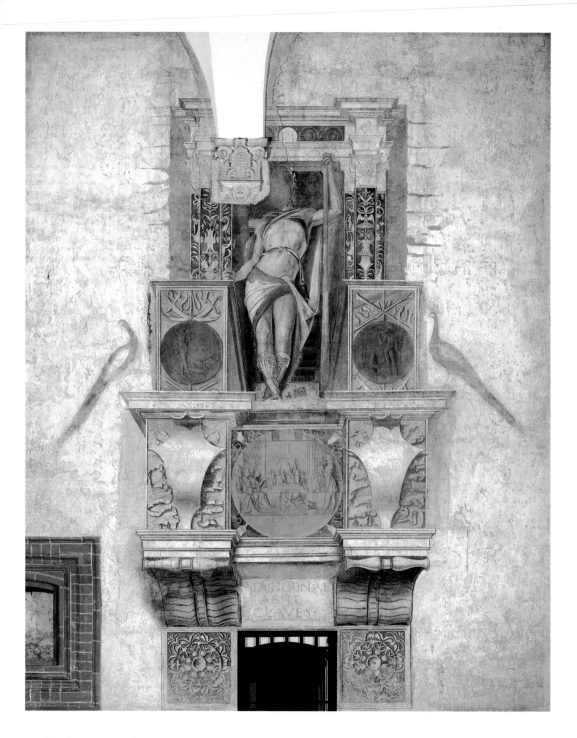

71. BRAMANTE AND BRAMANTINO
Argus, 1490-93. Fresco. Sala del Tesoro, Castello Sforzesco, Milan.

Argus's face was damaged during work on the vaulted ceiling undertaken in Ludovico's reign.

Local Tradition and Imported Expertise: Milan and Pavia under Ludovico "Il Moro" 97

vision of his own. This is paralleled by an iconographical emphasis on political continuity with the previous Visconti regime (a conscious policy up to this date). The "Argus" fresco also reveals another aspect of Sforza artistic policy: the use of *stranieri* (outsiders) to school local artists in their specialist skills, and often vice versa. The best way to learn was through collaboration, a process that came naturally to Lombard masters. Here the painter-engineer-architect Bramante of Urbino, who was renowned for his perspective expertise and illusionistic skills, collaborates with the local painter Bramantino, who was later to write his own treatise on perspective. The process was not peculiar to the court: Leonardo, in his first Milanese commission (1483) for the Confraternity of the Immaculate Conception, was contracted to work with the Milanese brothers Evangelista and Ambrogio da Predis (the latter was court painter to Ludovico).

Family connections were as important in Milan's artistic world as they were in the world of dukes and nobles. Many local artists and courtiers owed their positions at court to the fact that their parents or relatives had served there before them. The firm of Solari and sons (and sons-in-law) produced the foremost architects and sculptors during the Sforza years and monopolized work on all the major building projects. They subcontracted work to other craftsmen, transferred stone from one building to another (principally from the cathedral to the Certosa of Pavia, but also from the Castello Sforzesco), ran a profitable sideline in terracotta mouldings and sculpture, and, according to documents, invested their substantial income in the wool trade. News of contracts in the offing spread quickly through the family grapevine; Guiniforte Solari, who had inherited the position of architect of the cathedral and the great Certosa (charterhouse) from his father Giovanni, alerted his future son-in-law Giovanni Antonio Amadeo when he heard that a new sculptural facade for the Certosa was about to be commissioned (1473). Amadeo hastily formed a profit-sharing consortium with his brother-in-law Lazzaro Palazzi, Giovanni Giacomo Dolcebuono, and other eminent craftsmen and tendered for the job.

For large civic and court commissions, it was normal practice for artists to organize themselves into consortia and put in competitive bids. Thus, it was somewhat unusual for Ludovico to take up Leonardo on his offer to revive the ambitious equestrian project to his father. Ludovico would have known the stunning portrait of his mistress Cecilia Gallerani, which Leonardo made when she was about sixteen (FIG. 72), and the master's *Virgin of*

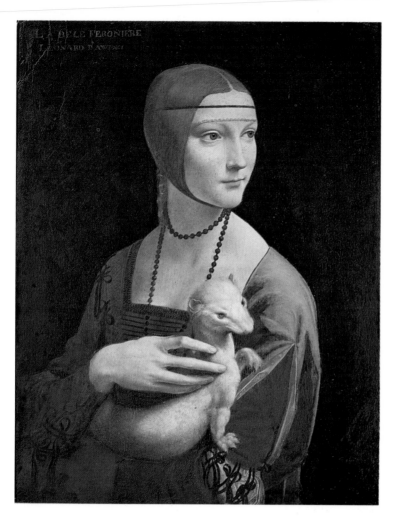

72. LEONARDO DA VINCI *Lady with an Ermine (Cecilia Gallerani)*, c. 1483-85. Oil on panel, 21 x 15½" (53.4 x 39.3 cm). Czartoryski Museum, Cracow.

Ludovico Sforza's mistress Cecilia Gallerani – daughter of a high-ranking fiscal officer and noble at the Sforza court – was a gifted writer and renowned patroness of art, literature, philosophy, and music. Her portrait by Leonardo, whom she described as "without equal," created a startling new ideal for courtly female portraiture. Isabella d'Este asked to borrow it (having heard, no doubt, of its unrivalled *grazia,* or grace) even though Cecilia modestly told her that the portrait showed her much younger and was no longer a true likeness. Instead of the conventional static profile view, Cecilia is shown turning gracefully towards the left so that her face, throat, and the curve of her shoulders are fully displayed. Her elegant hand with its long, tapering fingers caressing the sleek ermine (a pun on her name – *galē* is the Greek word for this creature) is prominently rendered, bringing a new sensuality to the pictorial form.

the Rocks altarpiece for the Confraternity of the Immaculate Conception, with its bold *chiaroscuro* (contrasts of light and dark) and *sfumato* (smoky shadows), had had a profound impact on the Milan milieu. Ludovico may even have purchased it from the confraternity and sent it as a diplomatic gift to the Emperor Maximilian. There was, however, little concrete evidence of Leonardo's sculptural or technological skills.

Correspondence dating from early 1484 with Lorenzo de' Medici in Florence reveals that Ludovico had tried to hire acknowledged experts in the art of bronze-making. The first letter expressly asks Lorenzo to send sculptors to Milan. The two most qualified artists were Andrea del Verrocchio, Leonardo's master, who was in Venice making the equestrian monument of the *condottiere* Bartolomeo Colleoni (an old enemy of the Sforza); and Antonio del Pollaiuolo, who was shortly to take up

the commission to make the bronze tomb of Pope Sixtus IV. Having failed to secure the services of either of these artists, Ludovico probably reasoned that Leonardo, who may well have been involved in the initial stages of the Colleoni project, was the next best thing. Later Ludovico seems to have had serious misgivings about entrusting Leonardo alone with such an ambitious project.

The purpose of the equestrian monument was to commemorate the founder of the Sforza dynasty, the great *condottiere* Francesco Sforza (ruled 1450-1466), who had seized power following the death of Filippo Maria Visconti (1447) and the brief Ambrosian republic. His flimsy claim to the duchy (he was married to Filippo Maria's only child, an illegitimate daughter, who had no legal claim to the dukedom) was reinforced with all the military and political skills at his command. Sforza had no aristocratic lineage – his soldier-father had adopted the name "Sforza" (force/strength) as a way of marketing the family's military expertise – yet he was to become duke of one of Italy's greatest and wealthiest powers. He surrounded himself with former comrades-in-arms, forged political and matrimonial alliances on the Italian peninsula, and together with his wife established a highly respected regime. It was for him that the Florentine architect Filarete fancifully created the ideal city of "Sforzinda" (FIG. 73).

The equestrian monument was dreamed up after Francesco's death by his extravagant and dissolute son Duke Galeazzo Maria Sforza – a great patron of the arts and, in particular, of music. In November 1473, the Commissario of ducal works, Bartolomeo Gadio, was set the task of finding an artist to execute the life-sized bronze. Having scoured the local talent and found none that was practiced in "bronze-making," the Commissario was instructed to look further afield. Galeazzo Maria had good reason to commemorate the first Sforza duke in this way. Emperor Frederick III had still not recognized the legitimacy of Sforza rule, even though Galeazzo was willing to pay 300,000 ducats for a kingdom. Galeazzo Maria's brutal murder put paid to the project until it was revived by his younger brother in the 1480s.

On Galeazzo's assassination, his wife Bona of Savoy took over as regent until their son Giangaleazzo came of age. But Galeazzo Maria's brothers had ambitions of their own. In 1479, Ludovico and the short-lived Sforza Maria ousted Bona from power. In 1480 Ludovico established himself as regent of Milan and its territories, ostensibly ruling on behalf of the boy Giangaleazzo. The resuscitation of the monumental equestrian mon-

73. FILARETE
Castello of "Sforzinda" from the *Treatise on Architecture*, 1461-62. Biblioteca Nazionale, Florence.

ument can be seen in the context of Ludovico's own claim to the dukedom as son of Francesco Sforza, as opposed to Giangaleazzo's bid as grandson. Giovanni Simonetta's Latin biography of Francesco (the *Sforziada*), which had been written during Galeazzo Maria's reign, was printed by the hundreds by Ludovico in 1482. The new regent, who had a humanist training, was not a military man. Under the protective shadow of a colossal equestrian monument embodying Sforza might, Ludovico believed he could manipulate foreign powers though diplomacy and the quickness of his intellect.

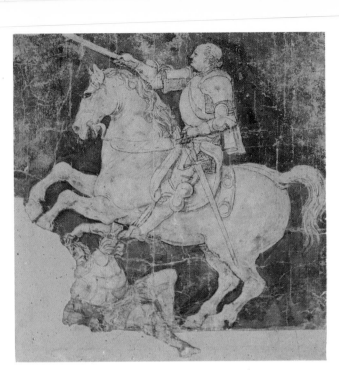

Leonardo seems to have begun making drawings for the Sforza monument shortly after his letter of around 1485-86. Initially the design featured a horse rearing above a fallen foe, an image of singular vigor and dynamism, but of immense technical difficulty as far as bronze casting was concerned. As the project evolved, it metamorphosed from a life-sized memorial into a political colossus and technological marvel – the statue Ludovico planned was to be more than 23 feet (7 m) high and weigh approximately 158,000 pounds (72,000 kg). By 1489 Leonardo had been commissioned to make a model, but it seems that Ludovico was already experiencing doubts as to whether such a complex design could be cast successfully, or carried out singlehandedly. This attitude has to be set against Leonardo's rather Florentine belief in the individual *tour de force*. At this point, Lorenzo de' Medici received a fresh letter stating that since Ludovico wanted something "superlative" he would like to be sent an artist or two "apt in such work." Antonio del Pollaiuolo's two drawings for the monument probably date from this time (FIG. 74). By April 1490, however, Leonardo had rethought his design, using the antique equestrian monument in Milan's second city, Pavia, as his starting point. He was attracted by its marvellous sense of movement – "the trot almost has the quality of a free horse."

Leonardo combined ancient Lombard inspiration with detailed examination and measurement of horses in the stables of

74. ANTONIO DEL POLLAIUOLO *Design for Equestrian Monument to Francesco Sforza*, c. 1489. Pen and wash, 8¼ x 8⅜" (20.8 x 21.7 cm). Staatliche Graphische Sammlung, Munich.

Pollaiuolo's design uses the combination of rearing horse and fallen soldier (to support the horse's forelegs). The trampled victim is shown in an ostentatiously complex pose, with his head thrown backwards and his leg trailing over the side of the pedestal.

75. LEONARDO DA VINCI
Design for a Casting Pit for the Sforza Horse, c. 1493.
Biblioteca Nacional, Madrid.

The main sketch on this page of Leonardo's notes shows the casting pit from above (looking down on the underbelly of the outer mould of the horse), abutted by two rectangular and two circular multiple furnaces. These were originally designed to melt down bronze for cannon. The lower sketch shows how the horse is to be cast upside down, with molten bronze poured through tubes into the neck and body cavities.

his main Milanese patron, Ludovico's captain and future son-in-law Galeazzo Sanseverino, as well as another noble in the upper echelons of the Sforza court, Mariolo de' Guiscardi (whose palace Leonardo designed). A colossal clay model was made, which was still in Leonardo's studio in the Corte Vecchia at the time of the marriage of Ludovico's niece to the Emperor Maximilian in November 1493. Moulds were ready, a special casting pit had been designed (FIG. 75), and the model was even packed for transportation. A year later, bronze assigned to Leonardo for the casting of the monument was given to Duke Ercole d'Este of Ferrara, who urgently needed it to make cannons. The monument was never to be cast or erected on its intended site – the ravelin opposite the entrance to the Sforza castle. In 1495, Ludovico was forced to pawn 150,000 ducats' worth of jewels to secure a loan from the Venetians for a third of the amount. By 1497, Leonardo was despairing about the "delay" in progress on the horse. A letter from this time complains about lack of funds, suggesting that while Leonardo was paid for work done for the duke, he was not a regular, salaried member of the ducal household.

In about 1497, Leonardo drafted another extraordinary letter for a patron or high-placed friend to send in their own name. This was addressed to the Commissario of Buildings in the subject territory of Piacenza, where bronze doors were being planned for the Duomo. By this time, Leonardo had learned something about how commissions – both civic and ducal – operated in the duchy. The letter shows Leonardo's frustration with the system of favours filtering down from the court, and the reliance on "inferior and coarse" local men. The frontrunners for the job are dismissed because they are not trained in bronze-making: "This one is a potter, that one a maker of cuirasses, this one is a bell-founder, another a bell-ringer, and one is even a bombardier." Worst of all, among the contenders is someone in the duke's service who has been bragging that he

can pull favours from the duke's Farmer of Customs, having served as his "gossip." Leonardo's own credentials are based on the fact that he is the Florentine artist "of the horse of Duke Francesco in bronze." Artistic merit and reputation, as Leonardo now realized, were not always of prime consideration.

While Leonardo did not at this date have many prestigious ducal commissions to his name, he was clearly much employed and valued in court circles. A master of musical improvisation, he seems to have looked for similar opportunities to improvise in his artistic and intellectual life. Castiglione's idealized portrait of court life in his *Book of the Courtier* (*Libro del Cortegiano*, 1528) shows that the ability to ad-lib was one of the most prized: to be quick-witted, provide effortless conversation, and contrive new and unexpected delights. Leonardo was master of such courtly diversions, devising visual and verbal jokes, complex allegories, new musical instruments, mathematical conundrums, and amazing technical contraptions. Ludovico's court was particularly fond of abstruse symbolism and intellectual puzzles (FIG. 76). One little masterpiece of the art of the pun is a sentence, devised by Leonardo, which contains five plays on the word *moro* (moor), Ludovico's nickname (derived from his second name, "Mauro," or from his dark complexion). The major visual outlets for this talent were the spectacular theatrical pageants that Leonardo helped to mount.

In January 1490, the court poet Bernardino Bellincioni praised "the great brilliance and skill" of the scenic devices made by Leonardo for a performance of his poetic drama *Paradiso*. The theatrical extravaganza was staged in the Castello Sforzesco in honor of the marriage of Giangaleazzo to Isabella of Aragon, and included revolving planets set within a gleaming orb of gold. The following year, Leonardo was involved with numerous other artists in the pageantry that accompanied the wedding of Ludovico to Beatrice d'Este on 17 January 1491 in Pavia. His fantastic contrivance was staged in the palace of Galeazzo Sanseverino. One of the duke's secretaries described Leonardo's "wonderful steed ... all covered with gold scales which the artist has colored like peacock eyes." The peacock decoration, Leonardo wrote, signified "the beauty which results from the graciousness coming from he who serves well." More lasting decoration for the newly

76. GIOVAN PIETRO BIRAGO
Frontispiece to Giovanni Simonetta's *Sforziada*, 1490. Bibliothéque Nationale, Paris.

Detail showing Giangaleazzo and his Moorish pilot (Ludovico) in the ship of state.

weds was provided by two leading Lombard artists, Bernardo Zenale and Bernardino Butinone, who under Giangaleazzo's instructions decorated the Sala della Balla of the Castello Sforzesco in Milan (used by Beatrice a week after the nuptials).

The marriage of Ludovico to the fifteen-and-a-half-year-old Beatrice, and the uniting of the great houses of Este and Sforza, inspired a spate of artistic commissions. From the 1490s, Ludovico embarked on a series of important projects, designed to reaffirm his links with the Visconti, stress the independence of the Sforza dynasty, and rival the achievements of rulers like Lorenzo de' Medici and his wife's father, Duke Ercole d'Este. Two mausoleum churches became the focus of his political and artistic ambitions: the great Carthusian monastery at Pavia, known as the Certosa, which had always been intended as the burial place of the Visconti dukes; and the church of Santa Maria delle Grazie, in which Ludovico intended to house his own tomb. In both projects the distinguished court architect-engineer Amadeo took a leading role. A trained sculptor of considerable experience, Amadeo's buildings unite architectural structure with sumptuous sculptural ornament.

A grandiose tomb for Ludovico's ancestor Giangaleazzo Visconti (FIG. 77) was entrusted to the Roman sculptor, humanist, and courtier Giancristoforo Romano, who arrived in Milan around 1490. Giancristoforo had worked at Urbino and then at Ferrara, where he had become a valued member of the entourage of Beatrice d'Este. His bust of the lively and intelligent Beatrice was probably made as a gift for Ludovico when the two were betrothed. While directing work on the tomb and other antique-style sculptural decoration in the Certosa, he was also active as a singer, touring centers with Beatrice and her choir. He was in demand for his classical erudition, too: it was Giancristoforo who advised rulers in their purchase of antiquities; who inspected the newly unearthed Hellenistic masterpiece the *Laocoön* for Pope Julius II (together with Michelangelo); and who was the mouthpiece for the defence of sculpture in Castiglione's *Book of the Courtier*.

While there was no doubting Ludovico's discernment and taste in such matters, his political judgment was not so unerring. The reasoning behind the commission of the tomb was to assert the continuity of the Visconti-Sforza regimes and thus the legality of Sforza rule. Yet in commemorating Giangaleazzo, the first Duke of Milan (a title bought from the Emperor Wenceslas for 10,000 florins), Ludovico was also commemorating the Visconti on whom rested the persistent claims of the French to the duchy

of Milan. Giangaleazzo's daughter had married the son of King Charles V of France, and their grandson, the Duke of Orléans, was soon to assert his right to the Milanese state. It may be that Ludovico quickly realized the dangers of his artistic strategy, for the tomb was not placed in the prominent position originally intended for it.

Giangaleazzo Visconti's close ties with the courts of France (he himself was married to Isabella of Valois, daughter of King John II of France) had had a lasting impact on artistic patronage in the duchy. His great castle in Pavia, built by his father Galeazzo II, was furnished in the splendid style of a French château, even though it was also one of the most formidable of fortified buildings. Its walled park, which Giangaleazzo extended to over thirteen square miles, was one of the court's great delights. It was stocked with thousands of deer, partridges, and hare so that the duke and his court always returned triumphant from hunting. Here all kinds of pleasures and amusements were accommodated amidst fountains, pavilions, and spacious tree-lined avenues. With Pavia (site of the famous university and the Visconti library) as the center of his court, Giangaleazzo embarked on the building of the grand Certosa – which was to contain his mausoleum – on the border of his park. As a Pavian

77. GIANCRISTOFORO ROMANO Tomb of Giangaleazzo Visconti, 1492-94. Marble. Right arm of south transept, Certosa, Pavia.

Only the lower portion of the tomb (with the exception of the seated figures of Fame and Victory, sculpted in 1562) is attributed to Giancristoforo Romano (his name is inscribed in the cornice). The pilasters decorated with war trophies are similar to carved reliefs in the Palazzo Ducale, Urbino. There are also roundels with signs of the zodiac and a frieze of shields joined by antique garlands. The upper portion of the tomb, with scenes from Giangaleazzo's life, is the work of Benedetto Briosco and his assistants.

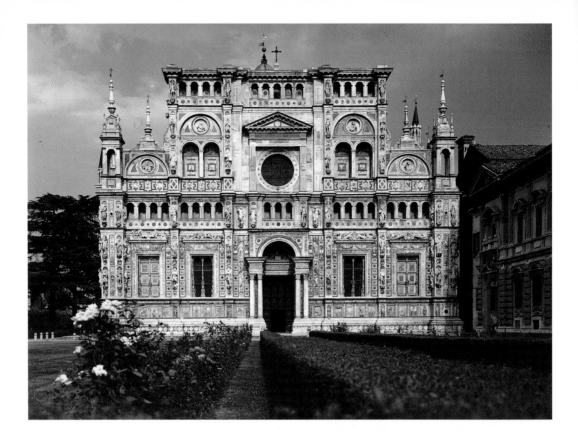

78. Facade of the Certosa, Pavia.

historian recorded, Giangaleazzo had fulfilled the archetypal princely requirements of "a palace for his residence, a garden for his sport, and a chapel for his devotions." The courtly nature of the monastery even extended to the monks' cells, which were transformed into "courtiers' " cottages with garden loggias.

Half a decade after Giangaleazzo's death, Francesco Sforza took up residence in the former's castle at Pavia. The Visconti castle at Porta Giovia in Milan, which had become a symbol of oppression under Filippo Maria Visconti, was rebuilt as the Castello Sforzesco, ostensibly as an ornament to the city rather than as a fortification against the people. The aging frescoes in Giangaleazzo's Pavian castle – with their scenes of hunts and jousts – were painstakingly restored as a mark of continuity. Francesco Sforza's urgent need to win over his subjects expressed itself in works designed to show his commitment to their spiritual, social, and economic welfare. He commissioned a vast hospital in Milan from the architect Filarete, and another in Pavia; in addition, he improved the canals and funded many new reformist churches and convents in the names of himself and his

Visconti wife. As a mark of his legitimacy and piety, he continued work on the Certosa – commissioning a new cloister and confirming the monks' historical privileges. Unlike Milan cathedral, which was largely a civic undertaking, the Certosa represented a triumphant and continuous collaboration between ducal and ecclesiastical patronage.

Under Francesco's son Galeazzo Maria, Pavia became the favoured residence of the duke and his court. The imposing castle was given a major refurbishment, with frescoes and an elaborate "chamber of mirrors." The room was an ostentatious showpiece, strategically situated next to the ducal treasury. Its exquisite mosaic floor was complemented by a stained-glass ceiling, painted with gold figures, animals, and greenery. Galeazzo Maria, who admitted to the vice of "lust" ("that [sin] I have in full perfection, for I have employed it in all the fashions and forms that one can do"), was well aware of the sensual and seductive qualities of such "magnificence" on the men and women of his court, as well as its powerful allure to visiting ambassadors and princes.

With Galeazzo Maria's approval, the monks commissioned sculptural work on the Certosa's facade. The duke favoured the Mantegazza brothers for the task; the monks preferred a team led by Amadeo. In the event, the competing sides were offered half the facade each. In late February 1474, Galeazzo Maria organized the transferral of Giangaleazzo Visconti's remains to the Certosa amid great ceremony and pomp. He was the only duke to be buried there. Galeazzo had already made plans for his own splendid mausoleum, outlined in a testament during his illness at the end of 1471. He wanted a centrally planned marble church, on the lines of Pisa's or Florence's Baptistry (a Romanesque building believed to be an ancient temple of Mars), with a bronze tomb fit for a pope, king, or emperor. The ambitious project, like the majority of his grandiose fresco schemes, was never to be realized. Assassinated by members of his own court in 1476, he was hastily placed in his father's casket at dead of night.

In 1491, besides commissioning the tomb of his great-grandfather, Ludovico determined to complete the facade of the Certosa in the most glorious manner. The remaining brick substructure was covered in Carrara marble and encrusted with the richest possible sculptural decoration in the new antique style (FIG. 78). Amadeo was placed in charge and, assisted by Dolcebuono, employed the classicizing forms and ornament that had already found favour with Ludovico and Francesco Sforza

before him. Following in the wake of Venice and Padua, Lombard workshops had been slow to embrace the new style. Filarete's crusade to get Francesco Sforza to abandon the "modern" Gothic style and embrace the antique idiom championed by Florentine masters had met with effective opposition from local craftsmen: his sophisticated *all'antica* garlands, which were to adorn the facade of the rebuilt Castello Sforzesco, were rejected by the stonemasons because they were costly, time-consuming, and "not weatherproof." By the 1490s, however, Lombard artists had accumulated an impressive repertoire of classical-style forms and motifs, taken mainly from the *all'antica* medals and plaquettes that were so popular among the ruling elite. Designs and decorative moulds were used as artistic currency, circulating freely among the major northern Italian workshops.

79. BERGOGNONE
Giangaleazzo Visconti Presenting a Model of the Certosa to the Virgin, c. 1492-94. Fresco. Half-dome at the end of the south transept, Certosa, Pavia.

The model of the Certosa shows the facade before it was encrusted with decoration in the 1490s.

Ludovico also took a keen interest in the commissioning of the Certosa's interior. Ambrogio da Fossano, called Bergognone (c. 1453-1523), a painter from the Piedmont, was put in charge of the vast co-ordination of the project. There are illusionistic mullions peopled with painted monks, choir stalls with *intarsia* work to rival that of Urbino, and frescoed ceilings painted in collaboration with his brother Bernardino. Bergognone fashioned elaborately gilded altarpieces and adorned the transepts with two dynastic frescoes: one shows Giangaleazzo Visconti, in the company of his sons Filippo Maria, Giovanni Maria, and Gabriele Maria, presenting a model of the Certosa to the Virgin (FIG. 79); the other shows the *Coronation of the Virgin*, flanked by Francesco Sforza and Ludovico himself (FIG. 80). These frescoes, which celebrate the Sforzas and the Viscontis separately but in equal measure, reveal Ludovico's confidence in the independent strength of a Sforza dynasty.

His political manoeuverings in this direction were swiftly bearing fruit. In 1493 his niece was married to the Holy Roman Emperor Maximilian – an alliance on which Ludovico had pinned all his hopes. The following year, just as Giangaleazzo reached the age of majority, he died (allegedly of consumption). With the death of Giangaleazzo, Maximilian invested Ludovico with the dukedom – the first official recognition of Sforza legitimacy. After a decent period of mourning, Ludovico was pub-

licly proclaimed duke in 1495. In May 1497, following the tragic death of Beatrice in childbirth, the Certosa was finally consecrated, an event commemorated in a relief flanking Amadeo and Dolcebuono's main doorway. Already, however, Ludovico's artistic policy had been marked by a decisive shift away from celebrating the dynasty's Visconti descent.

At the same time as he was assisting the monks on the Certosa, Ludovico was pursuing parallel plans for his own burial chapel and sacred dynastic seat. As early as 1483 he had decided to rebuild Guiniforte Solari's newly completed Dominican church of Santa Maria delle Grazie, and from March 1492 he seems to have intended it as the site of his sepulchral chapel. Very early in his reign, he had consecrated a small chapel for his private devotions in the church's grounds, made of the finest marble and embellished with family devices and sculpture of "marvellous craftsmanship" (destroyed by the French around 1500). The foundation stone of the Grazie's new choir was laid on 29 March 1492, and the Guiniforte Solari church was gradually subsumed. In 1497 Ludovico commissioned a double tomb of himself and his newly departed wife from the sculptor Cristoforo Solari (FIG. 81) which was to be placed in the new choir. A document of the same year reports that all the *peritissimi architetti* (the most expert architects) had been consulted on alterations to the Grazie and had been asked "to examine and make a model of the facade ... and to adjust the church proportionally to the great chapel [choir]." Among these experts were Bramante, Leonardo, and Amadeo. Amadeo, it seems, was made director of building operations: the brickwork and terracotta

80. BERGOGNONE
Coronation of the Virgin,
c. 1488-89. Fresco. North
transept, Certosa, Pavia.

81. Cristoforo Solari
Funerary statues of Ludovico
il Moro and Beatrice d'Este,
begun 1497. Marble.
Certosa, Pavia.

Beatrice's effigy shows her
clothed in the much-admired
costume which she wore to
mark the birth of one of her
sons. The dress alone, with its
bands of gold tissue and
crimson velvet, is thus a
symbol of the continuation of
the Sforza dynasty. Although
the marble can only hint at the
richness of the materials, her
effigy may originally have
been draped in a silken
shroud of spun gold. The
double tomb was transferred
from Santa Maria delle Grazie
to the Certosa in 1564.

decoration of the exterior bears his imprint. But the form of the
choir, with its dome and three rounded apses (FIG. 82), as well as
the airy cubic interior, with its complex numerological symbol-
ism, geometrical patterning, and skilful architectural illusionism
have all been firmly associated with Bramante (FIG. 83).

The Grazie and the Castello Sforzesco were intimately
related, forming the key buildings in an area which Ludovico
had decided to make into his personal enclosure. Lands adjacent
to the grounds of the castle, including parts of the ducal gardens
with an artificial *montagna* (hillock), were granted to the
monastery so that, as in Pavia, the ducal castle, pleasure park,
and mausoleum church were linked. Next to the castle were the
palaces of Galeazzo Sanseverino and other members of the city's
elite, while leading artists like Leonardo, Bramante, and the
medallist Caradosso resided in an artistic quarter next to the
Grazie. The parallel work on Santa Maria delle Grazie and the
Certosa illustrate the vigorous cosmopolitanism of Milan at this
time. Together these great buildings bear witness to the technical
and decorative genius of masters from Urbino, Rome, Lom-
bardy, and Tuscany.

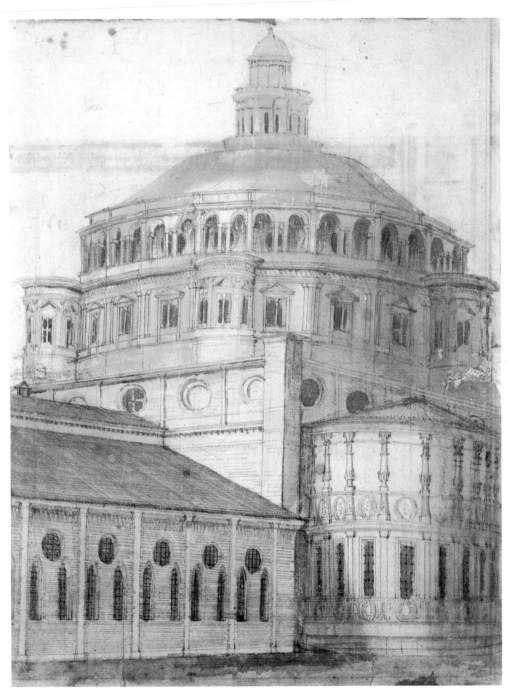

82. ANONYMOUS

View of Santa Maria delle Grazie, Milan, 16th century. Pen and sanguine (red crayon) on paper, 9½ x 13" (24.3 x 32.9 cm). Casa di Raffaello, Urbino.

This drawing, which was previously attributed to Bramante, shows Bramante's great choir apse (begun1492), towering over the modest nave of Guiniforte Solari's "old" church (dating from 1463).

Local Tradition and Imported Expertise: Milan and Pavia under Ludovico "Il Moro" **111**

83. DONATO BRAMANTE
Interior of Santa Maria delle
Grazie, Milan, looking
towards the main altar, nave
of old church from 1463,
choir apse begun 1492.

The mathematician Luca Pacioli was employed by the duke from 1496 to 1499, forming a great collaborative friendship with Leonardo and testifying to Ludovico's "singular devotion" to the church of the Grazie. Pacioli cites Leonardo's *The Last Supper* mural (FIG. 84), painted for the refectory of the church's convent, and the church's tribune as supreme evidence of this. Leonardo's famous mural further reveals the nature of the collaboration between ducal and ecclesiastical patronage. The Dominicans commissioned the work, but the duke was inevitably involved because the order enjoyed his patronage. Indeed Ludovico's involvement went much deeper than this conventional funding relationship suggests. He had a profound respect for the learned prior Vincenzo Bandello, with whom he dined in the refectory twice a week. Bandello, the court's leading theologian, devised complex iconographic schemes for the refectory and the church; together with Ludovico, he decided on the symbolic shape of Bramante's great choir. His program for the tribune's painted interior decoration, with its celestial space and rings of cherubim supporting Visconti and Sforza emblems, reflects the delight in esoteric symbolism that he and Ludovico shared.

The refectory decoration, entrusted to Leonardo and a Lombard painter, Giovanni Donato Montorfano, in 1495, reveals the same balance between theological and secular demands. In addition, there is the customary division between commissions given to *stranieri* and those given to local men. Montorfano's *Calvary* decorates the wall opposite *The Last Supper* (the kneeling figures of Beatrice and Ludovico were inserted around 1495-96 from cartoons by Leonardo). Leonardo's masterpiece, completed in 1498, combines Florentine monumentality and psychological narrative with the courtly taste for decorative vegetation, illusionistic perspective, and heraldic symbols. These latter elements appear in the three *trompe-l'oeil* lunettes above the biblical scene, painted to seem like a shadowy apse. This same Mantegnesque combination appears in north Italian manuscript illumination and in the works of Foppa, Bergognone, and Zenale (the latter apparently advised Leonardo on *The Last Supper*). The luxuri-

84. LEONARDO DA VINCI
The Last Supper (before
restoration), c. 1495-98.
Tempera and oil over ground
limestone, 15′ 1¾″ x 29′ (4.6
x 8.8 m). North wall of the
refectory of the convent,
Santa Maria delle Grazie,
Milan.

The psychological drama of
the Last Supper, with the
apostles reacting animatedly
to Christ's words that one of
them will betray him, is
increased by Leonardo's
manipulation of space and
scale. The deep painted room
in front of which the table is
set is made to seem like an
annexe of the monks' long
vaulted refectory – even
though the focus of the
perspective construction
(Christ's head) is high above
eye-level. This has the strange
effect of "elevating" the
viewer: the duke and the
abbot, sitting at their table at
the other end of the refectory,
would have felt spiritually
"uplifted" as the perspective
pulled their gaze towards
Christ's commanding figure
(painted slightly larger than
the apostles to either side).

ous garlands and foliage evoke the elaborate festive greenery that
adorned the duchy on ceremonial occasions, yet their plants and
fruits are symbolic, primarily of Christ's sacrifice (FIG. 85). The

85. LEONARDO DA VINCI
The Last Supper (after
restoration), c. 1495-98.
North wall of the refectory of
the convent, Santa Maria
delle Grazie, Milan.

Detail of the central lunette.

letters, originally in gold, celebrate Ludovico, his wife Beatrice, and his heir Massimiliano. In the large central lunette, bearing the Sforza arms (of Visconti vipers and imperial eagles), *more* (blackberries) appear among the fruit – a little pun on the nickname of "Il Moro." In contemporary poetry the name was often interwoven with references to *amore* (love); both sacred and divine.

The theme of symbolic foliage reached its apotheosis in Leonardo's decoration of a square ground-floor room in the north tower of the Castello Sforzesco, known as the Sala delle

Asse (FIG. 86). Unlike Galeazzo Maria, who had planned to have his private rooms in Pavia frescoed with portraits of himself and his family, his courtiers, and his Visconti predecessors, Ludovico characteristically chose to celebrate himself and his wife in a more esoteric way. In keeping with the secretive and exclusive atmosphere of his inner court, the emphasis was on intellectual and visual conceits rather than bawdy slapstick (one of the highlights of Galeazzo's fresco program was the portrait of his Albanian favourite, who was to be shown unhorsed with his legs in the air!) Recently it has been shown that the decoration was inspired by the duke's mulberry tree emblem, a heraldic pun on Ludovico's nickname that had been made explicit in Gaspare Visconti's play, Pasitea (written for the Milanese court around 1495-97).

In Visconti's play, a classical writer of comedies, Caecilius Status (thought to be Milanese) returns to Ludovico's Milan having heard that the city has attained glory in the shade of *un Moro* – "a mulberry tree." The patriotic tone of the play is already set: Visconti had resurrected Caecilius Status in direct competition with Ercole d'Este's revival of Plautus, the ancient Ferrarese writer of comedies. Having countered the competition from Ferrara, Visconti later informs his audience that the mulberry tree is even superior to the laurel, the emblematic tree of Lorenzo de' Medici. *Il moro* is also the Italian term for a "Moor" or black, and Ludovico had long used both

the mulberry and the moor as his favourite personal emblems. The two fuse in one extraordinary image: Giovan Pietro Birago's frontispiece for the *Sforziada* manuscript (see FIG. 68, page 93) presented by Ludovico to his nephew Giangaleazzo and published in 1490. It is possible that an adjoining private apartment in the castle, the Saletta Negra (Little Black Room), which Leonardo decorated prior to the Sala delle Asse, included allusions to the moor device.

Leonardo's marvellous arboreal room, painted in tempera, is only a pale reflection of what it once was. The branches of eighteen mulberry trees intertwine in intricate patterns like Oriental knot motifs or the osiers used in basket weaving (known as *vinci* in Italian). The trees, which bear small clusters of red fruit, grow from rocky crevices, their branches entwining around the windows and reaching to the summit of the vault. Here they encircle a gold oculus containing the joint arms of Ludovico and Beatrice d'Este. The slender gold cord weaving in and out of their leaves has been associated with the raw silk filament, "extruded ... in repeated figure of eight movements," by silkworms fed on mulberry leaves. Ludovico was actively involved in the promotion of the city's famous silk industry and had planted a grove of mulberries at his villa-farm near Vigevano. The filigree gold threads were woven into a similar interlaced design in the fashionable silk garments of Beatrice (in a pattern designed for her sister, and known as *fantasia dei vinci*). The room was completed around 1498 – the year in which Ludovico gave Leonardo a "vineyard."

While the Sala delle Asse is one of the best examples of the interweaving of allegorical themes and heraldic *fantasia* that were so popular at Ludovico's court, the Pala Sforzesca (FIG. 87) reveals an interweaving of the court's favourite artistic styles. It is a curious hybrid, with the "foreign" styles of Leonardo and, more fleetingly, Bramante, grafted on to those of the favoured Lombard masters, Ambrogio da Predis, Foppa, Zenale, Bernardino de' Conti, Bergognone, and even the brothers Mantegazza. The work, still attributed to an anonymous master, is probably dated around 1496-97 and shows the ducal family (including Ludovico's two legitimate sons) being presented to the Virgin and Child by the fathers of the church. Here the official portrait style of Ambrogio da Predis mingles with the Flemish facial types of Bergognone and Zenale; brilliant Lombardian color surrounds passages of Leonardesque *sfumato*; and a Bergognone compositional format for the fathers of the church (used in his Pavian altarpieces) is invaded by a Leonardesque Madonna and Child.

86. LEONARDO DA VINCI AND WORKSHOP
Sala delle Asse (detail of northeast wall), 1498. Tempera. Castello Sforzesco, Milan.

Leonardo's severely damaged room was substantially repainted in 1901-02, although subsequent restorations have brought details of his original to light. Above the two windows (northeast and northwest) and on the facing walls are four tablets with inscriptions. The three which are still legible commemorate the highpoints of Ludovico's reign: 1493 (the marriage of his niece to the Emperor Maximilian); 1495 (his proclamation as duke); and 1495-96 (his part in the Italian victory over the French at the Battle of Fornovo, and his journey to Maximilian's Germany to formalize an anti-French alliance). Interestingly, the festive decorations for his niece's wedding and the ducal proclamation featured hangings embroidered with mulberry trees.

A surviving document relating to the Pala Sforzesca asks for the painter to supply the duke with a detailed description of the way he intends to treat the subject. In particular, the writer wants to know how much gold and costly pigment will be used and what details of the ducal family's garments and accessories will be included. Beatrice's rich beribboned dress, with its alternating bands of gold and deep blue and black velvet, together with her braided and bejeweled hair (hanging in a long pigtail encased in cloth down her back), reveal her as a figure of high fashion in the latest style *alla castellana* (from Spain).

Work on the Pala Sforzesca is probably contemporaneous with the commission of two important altarpieces for the Certosa in 1496. Ludovico had recommended to the monks that they use two of the most eminent artists working in Florence at the time, both of whom had been favoured by Lorenzo de' Medici. The duke clearly intended to make the Certosa the artistic jewel of northern Italy, and assert Sforza leadership in the cultural arena now that the Medici were no longer in power. The demise of Florence's cultural supremacy had an ancient parallel: after the fall of Rome, Milan and Pavia had become the leading Italian cities of the Holy Roman Empire. The two "foreign" artists – Pietro Perugino and Filippino Lippi – were duly commissioned, but three years later had still not delivered their completed panels. In 1499, Ludovico wrote angrily to his ambassador in Florence, declaring that both he and the monks had been "wronged." Ludovico was forced to flee Milan shortly after this letter: he never saw Perugino's altarpiece (c. 1500-05), painted in rich, jewel-like oil colors – the only one to be delivered (its panels are now split between the Certosa and the National Gallery, London).

Ludovico's ruin was brought about by the succession of the Duke of Orléans to the French throne in 1498 (as Louis XII). The grandson of Giangaleazzo Visconti's legitimate daughter, he invaded the duchy in 1499. The impregnable Castello Sforzesco was taken without a struggle, after the castellan had accepted a bribe. Ludovico fled to Maximilian, returning from exile in 1500 only to be taken prisoner by the French. He died in captivity in 1508. Leonardo and Pacioli hastily left for Florence; Bramante and the sculptor Cristoforo Solari (who had made Ludovico and Beatrice's sepulchral monument) left for Rome. Much of the great art assembled by Ludovico was similarly dispersed after 1499. Leonardo's colossal clay horse – the symbol of Sforza strength and Ludovico's towering aspirations – was used by the French archers for target practice. Ludovico's father-in-law Ercole d'Este tried unsuccessfully to salvage the mould, so that the great "snorting" horse could be used to glorify his own regime.

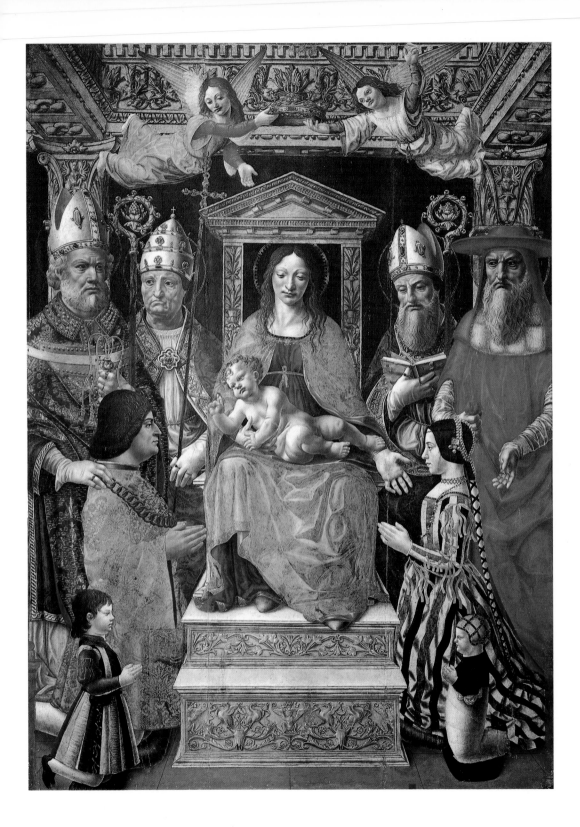

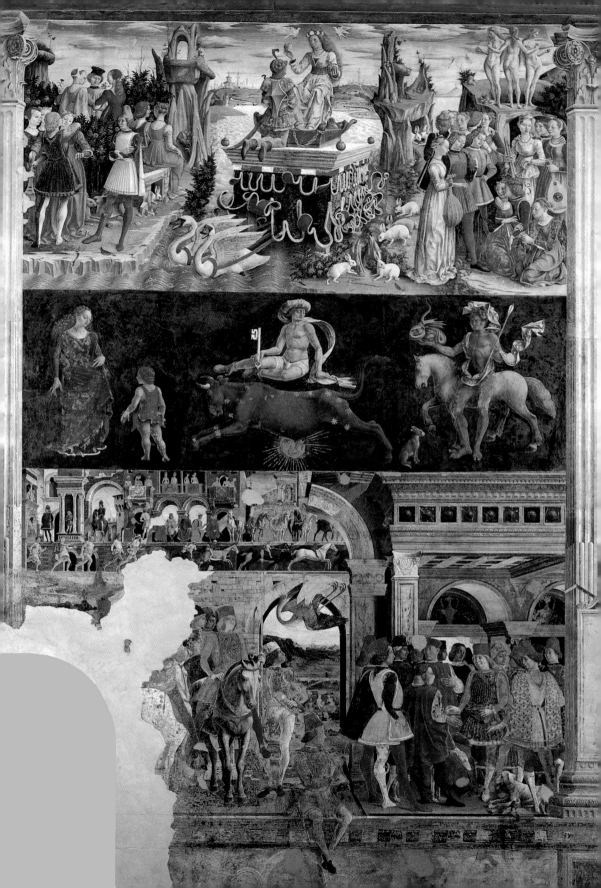

FIVE

Varieties of Pleasure: Este Ferrara

88. Francesco del Cossa
April from the east wall of the
Room of the Months, late
1460s-early 1470s. Fresco.
Palazzo Schifanoia, Ferrara.

The large Room of the
Months is completely covered
with paintings; even the
window shutters are
decorated. Each of the twelve
months depicted is divided
into three horizontal zones,
with a pageant of classical
gods and goddesses
processing through lush
landscapes on the upper
level; the zodiac sign and
three figures representing the
decans (the segments of each
month) in the middle; and the
traditional "labors" of the
months, mingled with events
in the courtly calendar, in the
lower zone. Above all, Borso
d'Este is shown, smiling and
benevolent, as creator of a
heavenly kingdom on earth.

The small principality of Ferrara, ruled by the noble Este family, developed a culture of remarkable vigour and individuality within the span of the fifteenth century. Its idiosyncratic character was shaped by strong cross-currents: aristocratic conservatism mingled with a thirst for novelty and even the bizarre; intellectual elitism flourished amid a practical realism and sense of irony bred in the *contado* (surrounding countryside). The dynamic tensions produced by these cross-currents expressed themselves in a mixture of competing styles. Thus the Ferrarese poet Boiardo used the languages of chivalric romance, the classical epic, and the Italian novella, among others, to create his irrepressible fantasy of 1484, *Orlando Innamorato*.

It has often been noted that the literature, music, and art produced at the court of Ferrara in this period share the same poetic, visual, and lyrical complexity, even though successive Este rulers had markedly different characters and styles of patronage. This is probably because the ideal of courtly recreation in all its diverse forms − intellectual, physical, theatrical, musical − lies at the very heart of Este patronage. This vein of escapism is expressed in the names of the Este country villas and summer palaces or *delizie* − places of delight. It was in these frescoed residences − Belriguardo ("beautiful outlook"), Belfiore ("beautiful flower"), Belvedere ("beautiful view"), and Palazzo Schifanoia ("escape every nuisance") − that the Este lords chose to spend most of their time.

The aristocratic ideals of the Este, drawn from codes of medieval chivalry and heraldry on the one hand, and the moral example set by classical and mythological heroes on the other, are encapsulated in the names that the *condottiere*-prince Niccolò III gave his three sons, successive rulers of Ferrara (he sired over thirty children in all). Leonello was named after the lion, heraldic king of the beasts; Borso after Sir Bors, one of the Arthurian knights on the quest for the Holy Grail; Ercole after the Greek hero Hercules. The Este derived their family name from their castle at Este, near Padua, where they had been granted land and titles by their imperial overlord. From here they expanded their territory to take in Ferrara, Modena, Reggio, and Rovigo as well as the fertile lands of the eastern Po Valley. By the time of Niccolò's death, Este rule and the nobility of the house were well established. The court poet and dramatist Ariosto (1474-1533) celebrated Este descent from Trojan princes, while Borso traced their ancestry to Charlemagne's France. In fact, the roots of the Este family tree were firmly planted in Germany.

During his brief reign (1441-1450), Leonello d'Este developed a style of patronage based on the ideals of intellectual recreation and connoisseurship. He was scholarly, pious, and compassionate, with a consuming interest in the new humanist learning as well as the visual arts. Ferrara was

89. Frontispiece to Angelo Decembrio's *De Politia Litteraria*, 1540. Biblioteca Communale Ariostea, Ferrara.

not a dukedom until Borso's time, but its aristocratic status was respected. With this in mind, Leonello cultivated an appropriate style of "magnificence" that was directed towards a discriminating and elite audience. His art commissions were governed by strong aesthetic preferences that had an influence beyond the small circle of eminent courtiers with whom he discussed them. These preferences are set out in Angelo Decembrio's imaginary dialogue of 1462, the *De Politia Litteraria* (FIG. 89), in which Leonello converses with his former teacher, Guarino da Verona, and other prominent literary figures including the poets Tito Vespasiano Strozzi (a fellow pupil of Guarino) and Feltrino (Boiardo's grandfather). The conversations are stimulated by a study of engraved gems, and range around ancient coins, sculp-

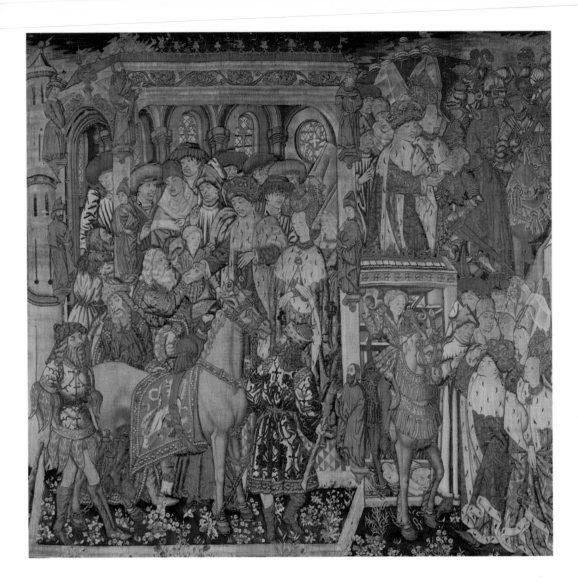

ture, and even Flemish tapestry. From these courtly arts Leonello concludes that the most admirable artistic qualities are lifelikeness and natural variety.

Leonello's asceticism and interest in realistic "accuracy" are expressed through his appreciation of the nude, for the nude is free of all sensual and concealing adornment. In his own dress he shunned opulence, though he chose the colors he wore each day according to "the positions of the stars and planets." He condemns the popular absurdities of "tapestries from Transalpine Gaul," which pander to "the extravagance of princes and the stupidity of the crowd" (FIG. 90). Leading his life in a decorous and unpretentious fashion, in keeping with a secure sense of his

90. TOURNAI WORKSHOP
Story of Alexander the Great (detail), second half of fifteenth century. Tapestry. Doria Pamphili, Rome.

Leonello owned rich Flemish tapestries, but in Decembrio's "dialogue" he criticizes their crudeness, alluding to a tapestry in which Alexander the Great's horse, Bucephalus, is depicted as "some hell-horse of Pluto's."

91. PISANELLO
Medal of Leonello d'Este
(obverse), 1441-4 4. Bronze,
diameter 4" (10.3 cm).
National Gallery of Art,
Washington. D.C.

own status, he believed the painter should not "go beyond the proper bounds of reality and fiction," but should try to match the elegant "artifice" of nature. His tastes are presented by Decembrio alongside the more fantastic preferences of his companions, which had equal appeal in court circles. Feltrino talks about the painter venturing as freely in his pictures as a poet does in his songs, painting "a gelded ram flying with wings" or a "she-goat draped in a woman's veil."

Above all, Leonello's taste is ruled by the delight he took in the "smallest works of art," like the figures on engraved gems, the head of Caesar on bronze coins, or the work of a scribe, described in an anecdote of Pliny: Homer's *Iliad* written compactly enough to be enclosed in a pair of nutshells. These are admired for their precision and intricacy of detail as well as their associations with antiquity – Ferrara did not have any ancient monuments of its own. This aspect of Leonello's taste was expressed in his patronage of the illuminator's art and, in particular, the medal – a unique courtly art form, revived in the fifteenth century largely by Leonello; he had over 10,000 specimens made. The medal also inspired the development of an aristocratic portrait style, with the sitter shown in half-bust profile.

While rulers like Sigismondo Malatesta were to use the medal in a blatantly political fashion, Leonello's message, articulated by his favourite artist Pisanello, was subtle, elegant, and veiled in symbolism. It was a message designed to be appreciated by the cultivated men who were its recipients – to stimulate ideas in the same way as the engraved gems provided the point of departure for the conversations, mixed with explanations of Greek and Latin words, in Decembrio's dialogue. This Ferrarese habit of using visual allegory or verbal conceits – even the etymology of words – to set in train a stream of associated ideas can also be seen in the fresco decoration of the Palazzo Schifanoia's Hall of the Months. It suggests that works of art in Ferrarese courtly circles, from Leonello to Isabella d'Este, often served as "conversation-pieces."

Pisanello's medals for Leonello may have been inspired by

Leon Battista Alberti, who had come as part of the papal curia to the Council of Ferrara in late 1438. The first medal, commemorating the presence at the council of the Byzantine Emperor John VIII Palaeologus, may have been commissioned by Leonello or his father Niccolò III at Alberti's suggestion. Indeed, the only Renaissance precedent is Alberti's bronze plaquette showing himself in profile in Imperial Roman style alongside his winged eye emblem. The prototypes for such imagery were ancient Roman and Greek coins, wax seals and the pastiches of antique "jewels" purchased by the Duc de Berry (and copied in gold and silver by one of his own court artists). Alberti may have seen this "jewelery" on his travels to the northern courts.

Leonello's medal, commemorating his second marriage to Maria of Aragon (Alfonso I's illegitimate daughter), is one of the least self-aggrandizing images of this type (FIGS. 91 and 92). Its reverse shows Amor, the little winged god of Love, taming the Lion (Leonello) through the powers of music. Numerous medallists inspired by Pisanello of Verona were soon active at the Ferrarese court. The Veronese Matteo de'Pasti, who illustrated manuscripts for Leonello between 1444 and 1446, made a medal of Guarino (also from Verona) in 1446. Draped in a toga, Leonello's mentor is portrayed with a blunt naturalism that reinforces the sense of his vigorous intellect. The difference in portrait style with the Pisanello medal recalls the distinction drawn by Leonello between two competition portraits made of himself by Pisanello and Jacopo Bellini: the style of one was *gracile* (slender or elegant), the other *vehemens* (powerful or violent). The Ferrarese humanists delighted in such *paragone* (comparisons).

Guarino had become Leonello's tutor in 1429, and for six years dedicated himself to the *condottiere*-prince's humanist education. To this end, he chose Caesar as the model for the young man to follow – Leonello even learned to swim because Caesar had done so. Guarino's marginal notes on Caesar's *Commentaries* draw attention to the virtues that each action of Caesar demon-

92. PISANELLO
Medal of Leonello d'Este (reverse), 1441-44. National Gallery of Art, Washington, D.C.

In the background can be seen the eagle, emblem of the Este, and a pillar featuring a mast with billowing sail (Leonello's device), both integrated into a rocky landscape.

strates, from liberality to clemency. Appropriately, Pisanello was to present Leonello with a portrait of Caesar by his own hand. Later Guarino was to set up his own school, which was to have a huge impact on the literary and intellectual thought of Ferrara in the ensuing years.

Guarino also provided the humanist program for the decoration of Leonello's *studiolo* at Belfiore. The room was to be painted with Muses by the court painter Angelo Maccagnino da Siena and his assistant Cosimo Tura (c. 1430-1495). The revival of the Muses was an elegant and erudite solution to the requirements of a courtly *studiolo*: they represent ancient ideals but are also marvellously decorative. Guarino describes the role of each muse, her symbolic attributes, and even her gestures or garments. Clio, for instance, the inspirer of history "and things that pertain to fame" is to be shown with a trumpet (symbol of fame) and a book, and clothed in draperies of shot silk.

Pisanello was greatly admired by Guarino and his circle, and his paintings were to be used in the literary exercises the tutor set himself and his pupils. These evoke the variety and "'life-likeness" of Pisanello's paintings, using appropriately florid language: .".. you equal Nature's works, whether you are depicting birds or beasts, perilous straits and calm seas; we would swear we saw the spray gleaming and heard the breakers roar ..." It has been suggested that Pisanello may have emphasized the elements of his style that would appeal to his sophisticated audience, presenting them with a visual catalogue of items and selecting some for bravura artistic display (such as a flamboyantly foreshortened figure). What is clear is that Pisanello was much sought after in courtly circles and had a considerable influence on the native Ferrarese art that was to dominate the court of Leonello's successor.

Equally important for the development of native Ferrarese art were the other talents Leonello imported. Jacopo Bellini from Venice worked for him intermittently; Alberti gave advice on the base of the equestrian monument to Leonello's father and wrote his treatise on architecture at Leonello's suggestion; Piero della Francesca, according to Vasari, painted *molte camere* (many rooms) with frescoes (c. 1449-destroyed) in the Palazzo del Corte; the French master Fouquet made a portrait of the court jester Gonella on his way through; and the Tournai master Roger van der Weyden painted an altarpiece of *The Deposition and Fall of Man* for Leonello, which was in Ferrara by 1449. Through his agent in Bruges, Leonello purchased several more works by the master, and Roger possibly visited the city in 1450

93. ROGER VAN DER WEYDEN
Deposition, c. 1435. Oil on panel, 7'2¹/₂" x 8'7" (2.2 x 2.6 m). Prado, Madrid.

Roger van der Weyden's famous panel in the Prado probably bears some resemblance to Leonello d'Este's prized *Deposition* triptych and the Passion tapestries (designed by Roger) owned by Alfonso of Aragon. Ciriaco d'Ancona was deeply impressed by the piety of Roger's works, while Bartolomeo Fazio was struck by the realistic rendering of the 'grief and tears' of the two Maries and Joseph in the Ferrarese triptych. Here, the viewer is invited to share in the intensity of religious emotion by dwelling on carefully orchestrated details; thus the hand of the swooning Virgin Mary is depicted hanging limply alongside the mutilated hand of the dead Christ.

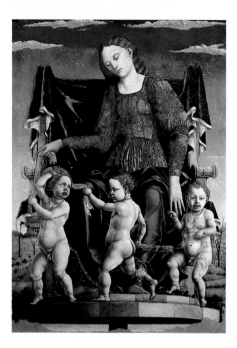

94. ANGELO MACCAGNINO
COSIMO TURA, AND ASSISTANTS
The Muse Terpsichore, c. 1450
and 1463. Tempera on panel,
46¹/₂ x 32″ (1.1 m x 81 cm).
Museo Poldi Pezzoli, Milan.

The antiquarian Ciriaco
d'Ancona, who visited Ferrara
in July 1449, saw two earlier
Muses by Angelo at the Este
family's summer residence of
Belfiore – Clio and
Melpomene. He marveled at
Angelo's skill and devotion to
the example of Roger van der
Weyden, praising the round
"shining pearls and gleaming
gems projecting from the base
of the gold-colored dais" of
Melpomene – created,
amazingly, "by smooth panels
of flat pigment." The panel of
Terpsichore, Muse of Dance,
shows a similar technical skill,
particularly in the sumptuous
red and gold brocade.

during his pilgrimage to Rome of that year. The
moving piety of Roger van der Weyden's Passion
scenes (FIG. 93), expressed through a combination of
taut stylization and unsparing observation of telling
detail, had a profound impact on artists in the
region. One of them, the young Andrea Mantegna,
painted a portrait of Leonello and his leading
adviser (lost) in 1449.

Leonello was succeeded by his brother Borso
(ruled 1450-1471), who thoroughly enjoyed all the
trappings of power. He shared his brother's love of
the arts and, in particular, illuminated books, but
revelled in all the ostentatious opulence that
Leonello had, for the most part, shunned. He wore
the most costly garments and jewelery, and spent
huge sums on entertainment and spectacle, as well
as on his horses, hounds, and falcons. In his *Com-
mentaries*, Pius II described him as a man of fine
physique and pleasing looks, who "was eloquent
and garrulous and listened to himself talking as if
he pleased himself more than his hearers." Borso decorated the
city's principal palace, the Palazzo del Corte, with rich velvet
Flemish wall hangings embroidered with the chivalric Romance
of the Rose, and (among his many building and renovation pro-
jects) had the old Palazzo Schifanoia rebuilt as a suburban
administration-cum-pleasure complex. This was shrewd politics,
for although Pius II wrote acerbically that "he desired to seem
rather than be magnificent and generous," Borso's showy
grandeur and public magnanimity raised the profile of his state.
While his artistic commissions reflect this change, particularly in
their amibitious scope and scale, their imagery has the same
lively complexity – probably due to the far-reaching influence of
Guarino's teachings and the presence of many of his pupils at
court.

Borso continued Leonello's renovation of the Este villas, and
commissioned more paintings of the Muses for the unfinished
studiolo at Belfiore. These include a painting of the Muse Terpsi-
chore by Angelo Maccagnino (FIG. 94), Thalia by Michele Pan-
nonio and Cosimo Tura's *Allegorical Figure* (FIG. 1, page 7). Major
restoration of Tura's figure has shown that he modified it exten-
sively: Tura and his assistants were active at Belfiore from 1459
to 1463, and made iconographic alterations to the other Muses as
well. His original tempera painting showed the Muse of Music,
Euterpe (the throne was assembled from organ pipes), but he

then transformed her into another figure of a more fantastic nature (possibly Calliope, the muse of eloquence and epic poetry), seated on a throne of pink and green marble embellished with leaping jeweled metallic dolphins. Tura's subsequent over-painting was done principally in van der Weyden's Netherlandish oil technique – one of the earliest Italian paintings to use it so extensively and with such a grasp of its subtleties. Tura even seems to have distinguished between the yellowing properties of different oils and the depth and richness of color achieved by the addition of resins (FIG. 95). The sophistication of his technique has led to the suggestion that he may have been advised by Roger, or that his master Angelo Maccagnino may have been sponsored by Leonello to make a study trip to the Netherlands.

The colors are of a particularly high quality: a document of 1460 records the purchase of three-and-a-half ounces of fine ultramarine blue for Tura's use at Belfiore. Tura was later to use ultramarine, at thirty-six ducats a pound, for the top layer of blue in the friezes of the duke's chapel at Belriguardo (decorated in 1469). Here blue was complemented by the other most expensive pigment, gold – used in abundant quantities in the gilded stucco reliefs. A document referring to the costs of the various pigments used in the chapel decoration shows just how expensive the ultramarine was compared to the cheaper blue pigments used in the underlayers: indigo, a dye of negligible cost; coarse azurite (German blue) at one ducat a pound; and a finer quality azurite at three ducats a pound. The amount paid to Tura for the painting of the nine religious figures in the chapel was less than the total cost of the colors. This emphasis on the best-quality colors, and a comparative undervaluing of the artist's skill, is characteristic of Borso's patronage. When Francesco del Cossa (c. 1435-c. 1477) was paid by the square foot for his work in the Palazzo Schifanoia – and his work was not distinguished from that of lesser artists – he left in disgust for Bologna.

Cosimo Tura, who worked mostly in oil, seems to have guarded his position as court artist by not sharing the secrets of his special technique (except perhaps with his chosen pupils). His rivals, such as Cossa, painted their panels in egg tempera although they tried to imitate some of his effects – particularly as regards depth and richness of color. In this sense, while the position of court painter often meant that new techniques were acquired and developed (sometimes through the sponsorship of study by a patron), the need to protect one's privileged status may also have slowed their wider dissemination. Mantegna seems to have jealously guarded his knowledge and refinement

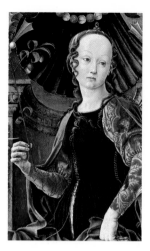

95. COSIMO TURA
Allegorical Figure (the Muse Calliope?), 1458-60. Tempera and oil on panel, 45³⁄₄ x 28" (1.1 m x 71.1 cm). National Gallery, London.

Detail showing the head of the figure and the varied textures of her costume.

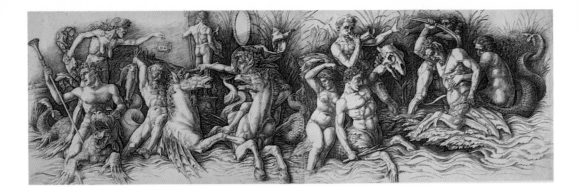

of the northern European copperplate engraving technique, which he clearly regarded as one of his unique skills (FIG. 96). He even hired a gang of ruffians to beat up a pair of rival engravers and hound them out of town .

The bizarre imagery and lyrical intensity of Tura's paintings are very much in keeping with the literary tastes of the Este court (which enjoyed the *meraviglioso* – the marvellous – in poetry and drama). Formally, his work is typical of the native Ferrarese school – with its stylized elaboration of simple forms, compression of space, high-keyed color, and abiding delight in stony, jewelled, or metallic surfaces. From Borso's time onwards, the talents of Ferrarese painters were employed extensively by the court. Their decorative and expressive mannerisms, while clearly in line with stylistic developments in northern Italy in general, were allowed to flourish vigorously under Este patronage. In this respect, the example set by Florence – so important to central Italian courts – had comparatively little impact. The Ferrarese were more interested in the affinity of painting to poetry, music, and theater, than its relation to its sister arts, sculpture and architecture. Modern scholars of Este Ferrara have stressed the influence of manuscript illumination on the painters of the court. Here, as in Lombardy, the ornamental forms and colors of miniature painting were to fuse with decorative motifs *all'antica* to create an art eminently suited to aristocratic tastes. The sources for many of these ideas are the famous workshops of Jacopo Bellini in Venice (closely associated with the Ferrarese court) and Squarcione in Padua (Mantegna's training ground).

One of Borso's greatest joys was his magnificent Bible, lavishly illustrated between 1455 and 1461 by, among others, the illuminators Taddeo Crivelli and Franco dei'Russi (FIG. 97). The artists were housed at the court's expense for the duration of the project, during which time they produced over 1,000 exquisite

96. ANDREA MANTEGNA *Battle of the Sea Gods*, 1470s. Engraving and drypoint, 11¹/₈ x 32⁵/₈″ (28.3 x 82.6 cm) overall. Duke of Devonshire Collection, Chatsworth.

Mantegna's forceful print, based on an ancient relief, uses the engraving and drypoint technique to create a dramatic interplay of light and shade, with a rich spectrum of grayish-brown tones. The "Battle" may refer to Mantegna's altercation with two rival engravers: it has been suggested that it is an allegory of envy between artists (the haggard figure of *invidia* – envy – appears upper left). Black humour powerfully conveys Mantegna's passionate concern to defend himself from the "envy" of rivals at court.

97. TADDEO CRIVELLI
Illuminated page showing the Court of Solomon, from Borso d'Este's Bible, 1455-61.
Biblioteca Estense, Modena.

Many of the illustrations of sacred stories in Borso's Bible – inspired by the illuminations of Burgundy and Provence – are really idealized visions of Borso's court. Heraldic motifs mingle with the refined images, colored in vivid blues, gold, russet, pink, green, and lavender – the hues preferred in contemporary Ferrarese painting.

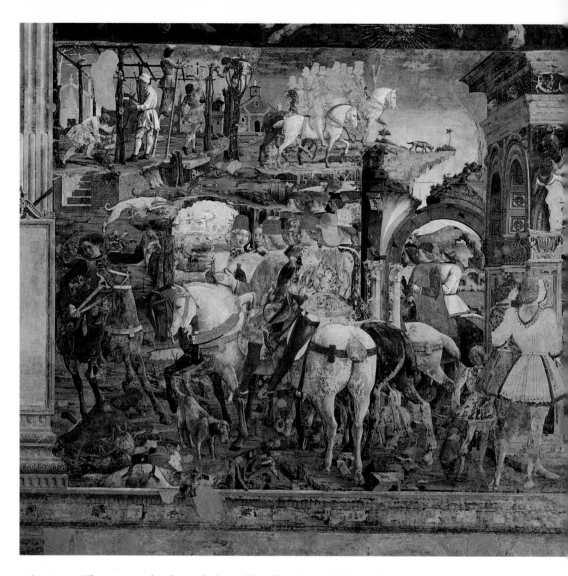

minatures. They were also loaned the richly illuminated Bible of Niccolò III, probably because Borso wanted to give them a clear idea of the luxurious splendor he was after. Niccolò's Bible had been illuminated by the great Gothic miniaturist Belbello of Pavia, whose elegant schematic forms were probably beginning to look out of date. Borso's miniaturists made the most of their perspective skills, relating the small figures to the landscape or architectural settings. Belbello's courtly style, which had been in such demand at the beginning of the century, was emphatically supplanted when he was ousted from his position in Mantua on Mantegna's recommendation by the Ferrarese miniaturist Guglielmo Giraldi.

98. FRANCESCO DEL COSSA *Borso Hunting* (detail from *March* in the lower zone of the east wall, Room of the Months). Fresco. Palazzo Schifanoia, Ferrara.

Borso and his courtiers make a second appearance on the rocky plateau above, this time proceeding in the opposite direction, followed by leaping greyhounds and hares.

The Bible, while an extremely costly manifestation of Borso's Christian piety (to the tune of 2,200 ducats), was also designed to impress through its magnificence. Far from gathering dust in the library, the Bible was displayed to visiting ambassadors, as well as being perused by the duke for his own pleasure. Towards the end of 1471, Borso had it rebound in readiness for his momentous journey to Rome, where he was to be invested with the title of Duke by the pope. That he should take such a valuable and unwieldy book – the two volumes, minus their original binding, have a combined weight of 34 pounds (15.5 kg) and measure 27 x 19¹/₂″ (67.5 x 48.6 cm) – with him on the road suggests that it functioned as a symbol of his Christian devotion and glittering prestige.

The influence of the Ferrarese manuscript tradition is seen in Borso d'Este's most famous fresco commission, the Room of the Months, in his suburban hunting palace, the Palazzo Schifanoia (see FIG. 88, page 119). The immense fresco cycle was executed in the late 1460s and early 1470s mainly by the Ferrarese Francesco del Cossa, together with a number of anonymous artists (it has recently been argued that Ercole de' Roberti's participation was restricted to possible involvement in small sections of April and May). The humanist who devised the complex program is unknown, although it has convincingly been associated with the intellectual habits of a pupil of Guarino. It celebrates the good government of Borso d'Este within a seasonal and astrological framework, such as that found in contemporary Books of Hours, and is rich in complex literary and verbal allusions. The huge room, forty by eighty feet (12 x 24.4 m), would have been used as a reception hall on semi-public occasions, as well as a delightful setting for the informal pleasures of the court. One of the most striking features of the cycle is its formal repetition: the affable features of the duke dominate every scene in the lower zone, whether he is out hunting (FIG. 98), paying his jester, dispensing justice, or enjoying the *palio* (a horse race). Another noteworthy element is the deliberate manipulation of different spatial conventions, from the decorative compression of the upper zone, featuring the triumphant classical gods, through the symbolic space of the middle zone, showing the heavenly bodies, to the airy perspective space of the lower zone, in which Borso reigns supreme. The illusory nature of this space, with its detailed colorful landscapes, is emphasized by the courtier in *April* who has swung his legs over the edge of the balustrade, which divides the painted space from "our" space.

99. ERCOLE DE' ROBERTI
The Wife of Hasdrubal and Her Children, 1480-90.
Tempera and oil on panel, 18½ x 12" (47.1 x 30.6 cm).
National Gallery of Art, Washington, D.C.

The bright colours of the panel, concentrating on the lively contrast of Este red and green, emphasize its fanciful nature and primarily decorative function.

Borso's successor Ercole I (1471-1505) was a very different personality. Coming to the position as duke, he developed a more aloof and "regal" air and a more grandiose form of patronage. He was extremely conscious of his position *vis-à-vis* other rulers in Italy, particularly the Duke of Milan (Galeazzo Maria Sforza) and the King of Naples. Having been raised from childhood at the Aragonese court, he had an impressive role model in Alfonso "the Magnanimous." He too was deeply religious, and may have consciously tried to rival Alfonso I in using piety as an expression of "magnificence." Like Alfonso, Ercole styled himself "Divus," though this was on mass-produced coins rather than on medals. While he lavished enormous sums of money on art and architecture, he was more grave and "weighty-of-purpose" than the affable and showy Borso. His princely *maiestate* was expressed through his patronage of sacred music on a magnificent scale, and later, as a concession to the populace at large, in his famous revival of classical comedy and contemporary classically inspired drama (after 1486, plays by Terence and Plautus were given full-blown theatrical staging).

In the field of sacred vocal music, Ercole d'Este immediately set out to establish one of the greatest chapel choirs in all Europe, rivaling those of the pope, the King of Naples and even the King of France. Ercole used his well-placed diplomatic agents to entice the best singers from France, Flanders, and other centers to his court, and then sent the singers themselves on recruiting trips. Papal benefices were brought into his control so that they could be used as a financial lure. This enterprise put Ercole in direct competition with Duke Galeazzo Maria Sforza, who deliberately set out to build a chapel choir that would surpass Ercole's in size and quality of repertoire. Considering his love of music, it is surprising that Galeazzo Maria was not a more active patron of dance – an art form that flourished in Ercole's Ferrara. The stylizations of Franco-Flemish polyphonic music and the courtly conventions of dance find a counterpart in the vibrant color harmonies and the rhythmic stylization of movement and gesture in some of the best court art of the period. Religious dramas and secular plays with colorful *intermezzi* (the elaborate diversions staged between acts) also encouraged the already highly developed taste for the artificial and the bizarre. This aspect can be seen especially in painted landscape settings, where there is no hint of the prosaic flatness of Ferrara's Po Valley. Instead, fantastic rocks shape themselves into "natural" architecture, showing how artful and "mannered" nature herself can be.

Continuing the family's close ties with Naples, Ercole married Ferrante I's eldest daughter Eleonora of Aragon in 1473. Three of their children – Beatrice, Isabella, and Alfonso (named after Alfonso of Aragon) – were to become important patrons of art in their own right. Eleonora herself played an unusually active role in the political and cultural affairs of court, and was regarded as a more able administrator than her husband. She shared Ercole's religious fervour and keen appreciation of music, and approved his endowment and adornment of monasteries and churches on a massive scale. Within three years of their marriage, the duke was challenged in a dramatic *coup d'état* staged by Leonello's son, Niccolò, an occasion on which Eleonora displayed great fortitude. A few years later, Ferrara's peace was shattered by a damaging war with Venice (1482-84). The city's vulnerability was ruthlessly exposed: many buildings were destroyed in the Venetian bombardment and the Villa Belfiore was burnt down. It was only after Ercole had recovered from the humiliation of defeat and the resultant economies forced upon him that he began to rebuild his reputation for "magnificence," as well as refortify Ferrara.

100. ERCOLE DE' ROBERTI *The Israelites Gathering Manna*, early 1490s. Panel transferred to canvas, 11³/₈ x 25¹/₈" (28.9 x 63.5 cm). National Gallery, London.

The major artist to enjoy Ercole's patronage was a Ferrarese painter Ercole de' Roberti (c. 1450-1496). Having worked in Bologna from 1481 to 1486, probably to escape the aftermath of the Venice/Ferrara war, Roberti returned in around 1486 and was court painter by 1487, when he is documented as receiving a stipend from the duke. Like Cosimo Tura before him, Roberti worked on all manner of commissions. From mid-1489 to early 1490, he was involved with other painters and sculptors in gilding and painting marriage chests, a triumphal car, and a matrimonial bed for the wedding of the duke's eldest daughter Isabella to Francesco Gonzaga of Mantua. This was the first of many marriage alliances made with ruling Italian families in the wake of the war. Roberti performed a similar service for the marriage of Beatrice to Ludovico Sforza and Alfonso to Anna Maria Sforza. The huge dowries that Ercole had to provide for his daughters put a considerable strain on the duchy's finances, but did not curb Ercole's spending on ambitious architectural and artistic projects. Nevertheless, Ercole, like his brothers before him, was extremely imaginative in thinking up new forms of levies and taxes. The dowry that Alfonso's second wife brought with her helped to redress the balance: Pope Alexander VI (Cesare Borgia) paid Ercole 100,000 ducats, as well as making gifts of land and valuables, to secure Lucrezia Borgia's marriage to Alfonso in 1501.

In the early 1490s, Roberti worked mainly for the duchess, decorating her apartments in the Castello Vecchio and producing small devotional pictures. Three panels showing famous women may have originally decorated one of these rooms, probably set into wainscoting or furniture. One of these, portraying the wife of Hasdrubal, provides a fitting tribute to Eleonora's own courage and virtue (FIG. 99). It is a visual equivalent of the encomiastic treatises on women written for Eleonora by the humanists at the Este court. The picture shows how successfully Roberti could adapt his style, which was often fiercely emotional, to the courtly and decorative nature of the commission. Here a harrowing subject – Hasdrubal's wife immolated herself and her children in the flames of a burning temple, rather than share in the humiliation of her husband's surrender – is treated in an almost emblematic way. Hasdrubal's wife and her children seem to dance amid the tiny curling flames, set against a stylized backdrop.

Eleonora died in 1493, and a Roberti *Pietà*, dating from around this time, may have served as her memorial. The *Pietà*, which was made for the church of San Domenico, was probably commissioned by one of the religious confraternities patronized by the duke and duchess. Funds would have been provided by the duke. The work is now known only through a copy in the

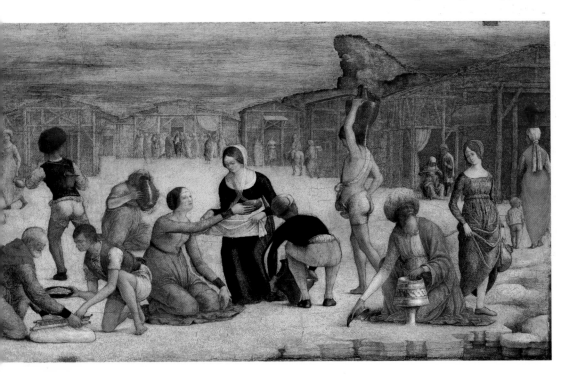

Galleria Spada, Rome. It portrays the duke and Eleonora, along with Eleonora's brother Alfonso, Duke of Calabria (later King Alfonso II of Naples) as holy witnesses of Christ's Passion. Eleonora's brother takes the role of Joseph of Arimathea, while Ercole assumes the humbler role of Nicodemus. The painting echoes the real-life Passion plays that were promoted by the duke and duchess and performed in 1481, and again in 1489, 1490, and 1491.

A small predella panel, sometimes associated with this altar-piece, reflects even more forcefully the theatrical ambience of Ercole's Ferrara. Roberti's *The Israelites Gathering Manna* (FIG. 100) appears accurately to record the stage-sets used for the classical plays mounted in the ducal palace or grand courtyard. A Ferrarese diarist describes a raised platform with five or six little painted huts, equipped with curtains instead of doors. Another small Roberti panel depicting the Last Supper, recalls another kind of drama – the Maundy Thursday suppers in which thirteen of Ferrara's poor were invited by Ercole to re-enact Christ's last meal in the sumptuous surroundings of his palace.

101. GUIDO MAZZONI
The Lamentation, c. 1484-85. Terracotta, height of Maria di Cleofa 5'4" (1.6 m). Chiesa del Gesù, Ferrara.

The Last Supper was also the subject of a spectacle staged in 1489. The duke's intimate involvement with sacred drama is made explicit in a sculptural terracotta group by Guido Mazzoni of Modena (1445-1518) for the church of Santa Maria della Rosa. Mazzoni's *Lamentation,* now in Ferrara's Gesù, probably dates from around 1484 (FIG. 101). His position at court was already well established: he was involved in making theatrical masks and props for the duke's wedding back in 1473 and a document of 1481 exempts him from paying all taxes. In Mazzoni's *Lamentation,* the

102. GUIDO MAZZONI
Joseph of Arimathea (Alfonso
II), detail from *The
Lamentation,* 1490-92.
Terracotta, height 4' (1.2 m).
Chiesa di Sant'Anna ai
Lombardi di Monteoliveto,
Naples.

The deep religiosity of
Alfonso's last years is etched
in every furrow of his face,
while his status is reflected in
the weighty richness of his
winter costume, his ring, and
his large tooled-leather purse.
A small detail, straight out of
a Flemish painting,
symbolizes his intellectual
piety: a leather case
containing a pair of folding
reading glasses protrudes
from an opening
in his coat.

life-sized figures of Ercole (as Nicodemus) and Eleonora (as Maria di Cleofa) join the five other biblical "players" grieving over the dead body of Christ. All the figures are presented in an astonishingly lifelike manner. Court decorum dictates that Ercole and Eleonora display their own grief in a dignified way − Ercole is particularly stiff and constrained. Winter garments have been chosen, because their understated opulence signifies the elevated status of the ducal couple. Ercole wears a fur hat and a wolf-skin coat, which elegantly falls open to reveal a luxurious fur lining. His gloves, one worn, the other held, are the attributes of nobility.

The use of terracotta (baked clay) − a relatively ephemeral material compared to bronze or marble (Ferrara had no local source of stone) − was common in sculptural ornament. Local terracotta adorned the remodeled facade of the Palazzo Schifanoia, complementing the brickwork and contrasting with the imposing marble portal. In life-sized figure sculpture the material took on a vivid biblical symbolism − for men are "no more than mortal clay." Sculpting in clay allowed for a fineness of detail that was comparable to the waxen images of funerary masks and the realism of Flemish portraiture, and, in the hands of masters of the stature of Mazzoni and Niccolò dell'Arca in Bologna, could mimic the texture of all manner of rich fabrics and materials. Mazzoni also made theatrical terracotta masks for the *sacre rappresentazioni* and ceremonial occasions sponsored by the Este, and was actively involved in staging feasts and public festivals. His skills were held in such esteem that he was knighted by Charles VIII of France in 1495.

Ercole's brother-in-law, who had featured in Roberti's *Pietà*, invited Mazzoni to Naples in 1489, paying all travel expenses. Here, in around 1492, Mazzoni created a Lamentation group for Alfonso's favoured church, Sant' Anna ai Lombardi di Monteoliveto. As in Roberti's *Pietà*, Alfonso is depicted in the role of Joseph of Arimathea (FIG. 102), the rich man who paid for Christ's tomb − a persona in keeping with the gifts that he showered on the church's Olivetan order, including castles, property, and valuables.

The dynastic and artistic ties between Naples and Ferrara, dating back to 1444, seem to have produced a devotional style that was eminently suited to courtly and aristocratic tastes − a "modern" idiom to rival the monumental narrative style being so

actively exported by Florence. The Neapolitan/Ferrarese idiom, with its assimilation of Spanish and Flemish elements, combined northern naturalism and technical virtuosity with decorative splendor, humanist showpieces, and elegant variety. The rich cultural interchange between the courts helped to shape the style and imagery of artists like Antonello da Messina and Giovanni Bellini (based in Venice), Andrea Mantegna, and Piero della Francesca, as well as the three great Ferrarese artists Tura, Cossa, and Roberti.

In the field of secular decoration, the Este lords seem to have commissioned more palace frescoes than any other ruling family, though very few have survived. Fortunately, Giovanni Sabadino degli Arienti's *On the Triumph of Religion* (*De Triumphis Religionis*), a treatise written in around 1497 in praise of Ercole d'Este, includes a detailed description of the interiors of the Este palaces and villas. Here, in a section devoted to "Magnificence," we find out about the splendor of rural Belriguardo (eight miles from the city), paid for with a "mountain of gold." There is a painted room with portraits of "wise men, with brief and singular moral sentences" and "an image of ancient Hercules on a green field," an obvious allusion to the modern Hercules, Ercole. That the room was intended to impress rulers who stayed there while en route to other courts is made clear by a painted plaque which records that the Duke of Milan and the ruler of Bologna were lodged there in 1493. Another room was frescoed with lively scenes of the duke "happily relaxed and natural" with all of his courtiers. In between the public and private apartments of the palace was the Sala di Psiche, painted by the court's "leading painter." Roberti is documented as working on cartoons for frescoes (almost certainly the Psyche series) at Belriguardo in February 1493, with the duke at his side all day long. Ercole's bemused secretary couldn't understand why the duke "wasted" the hours in this way, when he could be playing chess or out hawking and hunting. Clearly, Ercole's keen interest in such matters was regarded as unusual in court circles.

The Cupid and Psyche series, based on Apulieus's *The Golden Ass* (second century AD) was probably one of the most fascinating fresco cycles of the period. The comparison between the painted palace of Cupid and Ercole's Belriguardo is made explicit in Sabadino's description: it is "a palace, like this one, of marvellous beauty." The frescoes featured fantastic and delightful landscapes: Sabadino describes a dangerous mountain, grassy places and shady woods. He invites comparison with a poem by Niccolò da Coreggio (the *Innamoramento di Cupido e di Psyche*,

dedicated to Ercole's daughter Isabella) in which the same subject is "painted in light and sweet maternal verse." His continual insistence that the theme was a "moral" one "under a poetic veil" suggests that the series may have had its share of sensual delights. Another room was decorated with an openly erotic subject: the Triumphs of Hymenaeus. The enjoyment of such subjects in aristocratic circles emerges clearly in court commissions at the end of the century. Their themes are in keeping with the sensual pleasures of the gardens which surrounded such villa retreats: with their cool fountains, scent of citrus and rosemary, and licentious statuary.

Roberti was later involved in one of the numerous fresco projects at Belfiore where there were audience chambers decorated with exotic animals (the Este were often presented with such creatures as gifts), boar, bear and wolf hunts, court banquets, a pilgrimage cycle and a series commemorating the wedding of Eleonora and Ercole. The Duchess and her ladies feature prominently in the frescoes, implying that the palace housed a "ladies court." C.M. Rosenberg has suggested that the palace, ideally positioned on the edge of the city by the *barco* (hunting park), was used to lodge distinguished visitors who were passing through – leaving them with vivid images of Este hospitality.

103. Planimetric view of Ferrara, showing the "Erculean Addition," 1499. Woodcut. Biblioteca Estense, Modena.

The streets of the Addition were set at right angles to one another, with the largest avenue – the Street of Angels – being some 52 feet (16 m) wide. Part of this avenue was closed to traffic, so that the "angels" (courtiers) could use it for their promenades.

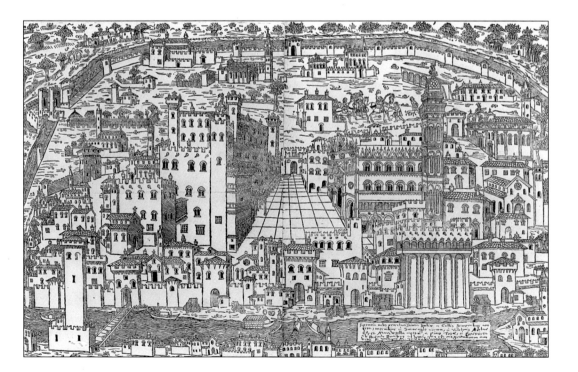

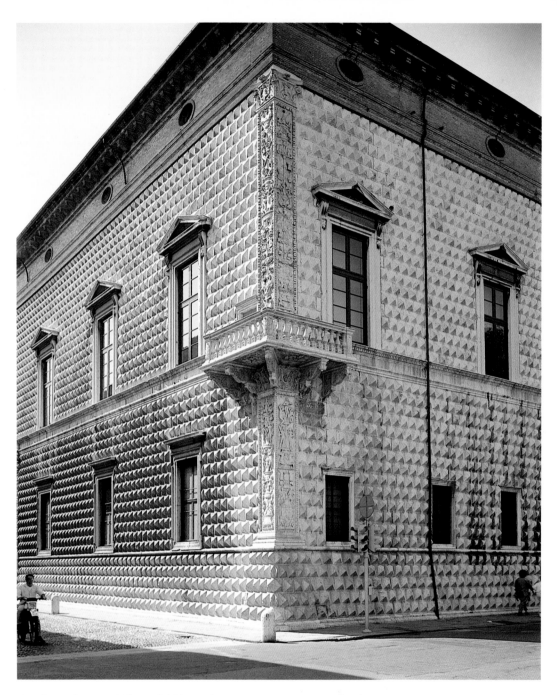

104. Biagio Rossetti Palazzo dei Diamanti, Ferrara, 1493-1504 (completed 1567).

The urban context of buildings within Ferrara's newly created suburb is emphasized by their architectural decoration. The Palazzo dei Diamanti was positioned at the crossroads of the Addition's two most prestigious streets, and so its prominent corners are faced in Istrian stone and decorated with relief carving. The effect of the jutting stone diamonds on the flank and facade is even more pronounced from this corner viewpoint.

140 *Varieties of Pleasure: Este Ferrara*

Belfiore was incorporated into the "Erculean Addition" - the vast city extension which Ercole built in the 1490s, with Biagio Rossetti (1447-1516) as its architect (FIG. 103). The Addition, along with the colossal equestrian monument of Ercole that was planned (designed by Roberti), shows most blatantly the self-aggrandizing nature of the Duke's late commissions. By building an entire new quarter to the north of the city, which more than doubled Ferrara's size, Ercole was also meeting the urgent defensive and economic needs of his capital.

By 1493 the surburban area outside the medieval town - with its monasteries, gardens, and villas bordering the great Este hunting park - had been laid out as streets and divided into parcels of building land. These were sold off to leading courtiers and other interested parties, and by 1503 there were at least twelve gracious new palaces and as many churches. One of these was Rossetti's Palazzo dei Diamanti, built by Ercole ostensibly for his brother Sigismondo in the most prestigious quarter (near the ducal residence). With its exterior covered in marble blocks faceted to look like diamonds (one of the Este emblems) it was a testimony to the duke's love of expensive materials (FIG. 104). Sabadino, in fulsome tribute to Ercole's urban transformation, wrote "for you found a Ferrara of painted brick ... and you have left it ...carved in adamite marble..."

Great broad tree-lined avenues ran from north to west, criss-crossed by streets laid from east to west. The further reaches of the addition were inhabited by artisans, middle-class families, and industrial workers (swollen by the immigrant population). Defensive structures, on the lines of those designed by Francesco di Giorgio, transformed the new "Renaissance" Ferrara into what Ariosto described as an "exquisite fortress." Ercole's ideals of beauty and utility, elegance and virility are neatly summed up by Ariosto's felicitous choice of words. Practical realism was, in the end, as important as escapist fantasy in the lively world of ducal Ferrara. This was the city where Ariosto wrote his chival-ric masterpiece *Orlando Furioso* (published in three different versions in 1506, 1521, and 1532), yet it was also the setting for his satirical comedy *La Lena* (1528): in the former, Arthurian romance and dynastic celebration combine in an epic fantasy of polished brilliance; in the latter, the court gamekeepers surrepti-tiously sell pheasants they have poached from the duke's estates, watched by the silent statue of Borso.

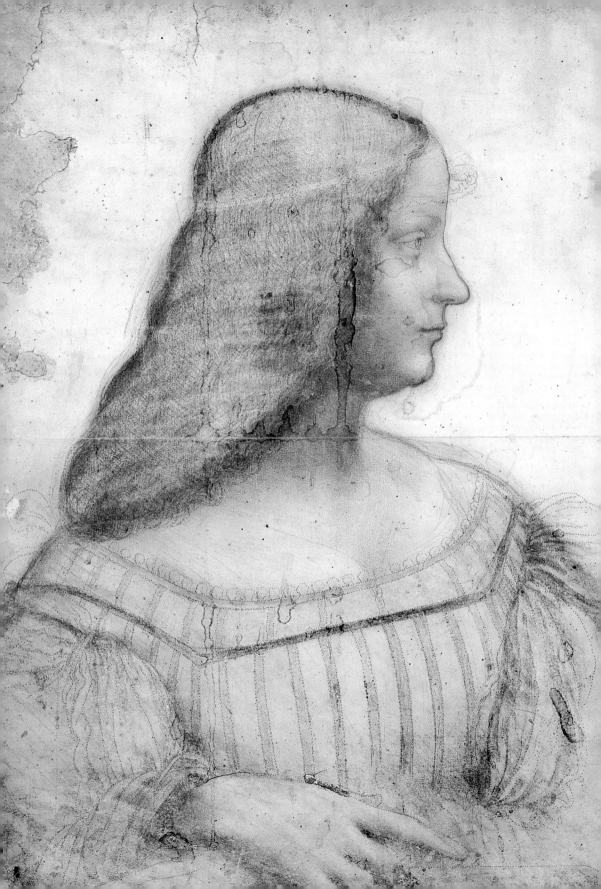

SIX

The Art of Diplomacy: Mantua and the Gonzaga

105. LEONARDO DA VINCI
Portrait of Isabella d'Este,
1499-1500. Drawing, 18¹/₂
x 14¹/₂" (46 x 36 cm). Louvre,
Paris.

Leonardo's portrait shows
Isabella d'Este, wife of
Francesco Gonzaga. A replica
of this preparatory drawing, or
"cartoon" in Oxford reveals
that Isabella was originally
shown with a book at her
fingertips – the drawing has
been cut down on all sides.
The lines of the cartoon are
pricked for transfer: Isabella
enjoyed this likeness and had
several copies made.

The solemn entry of Pope Pius II into Mantua for the great Church Congress of 1459-60 marked a triumph for Gonzaga diplomacy. Rulers and leading eccelesiastical figures from all over Europe poured into the city, with their splendid retinues of ambassadors, humanists, courtiers, and diplomats. The pope's Congress, called to initiate a crusade against the Turks, provided a unique opportunity for Marquis Ludovico Gonzaga (FIG. 106) to enhance his family's international prestige through a display of lavish hospitality. His highly respected German consort, Barbara of Brandenburg (FIG. 107), granddaughter of imperial elector Federick I of Hohenzollern, had actively promoted Mantua's bid to host the congress. Of a higher rank than her "small marquis" husband, she had called on the support of all her Hohenzollern relatives, especially her uncle, Margrave Albert, who was, as Barbara said, "very well known in the court of His Majesty Emperor Frederick III." When the news arrived that the pope had decided so to honor the small north Italian city, the court went into a frenzy of activity: Luca Fancelli, the Florentine engineer and stonemason who had been in Mantua since 1450, began the conversion of the old fortified Gonzaga castle into a luxurious princely residence, while the impressive palace complex known as the Corte was vacated for the pope and his retinue.

Above

106. ANDREA MANTEGNA
Camera Picta: detail of
Ludovico Gonzaga from the
Court Scene, 1465-74.
Palazzo Ducale, Mantua.

Below

107. ANDREA MANTEGNA
Camera Picta: detail of
Barbara of Brandenburg,
Ludovico Gonzaga's wife,
from the Court Scene, 1465-
74. Palazzo Ducale, Mantua.

The papal court arrived in 1459, staying eight months in the city. While it enjoyed the elegant rooms in the Corte – the great "hall of Pisanello," the "white suite," and "the green suite" among them – Ludovico, Barbara, and their court were packed into the Castello amid the dust and din of workmen. Among the Pope's entourage was the distinguished architectural theorist and humanist Leon Battista Alberti (then employed as papal abbreviator), who was to remain in the city for several months after the pope's departure. He was to return for extended stays in 1463, 1470, and 1471 to supervise building work on his great Mantuan churches of San Sebastiano and Sant'Andrea. Unfortunately, Ludovico's court painter, Andrea Mantegna, who had agreed to enter the marquis's service in January 1457, had still not left Padua. The Emperor Frederick, too, whose presence had been virtually guaranteed, never arrived.

The pope greatly appreciated the scale of Gonzaga hospitality, but found the city damp, excessively humid, and unhealthy (many of the papal retinue went down with fever), the streets muddy and the constant croaking of the frogs in the surrounding lake a wearisome distraction. Mantua, indeed, did not have much physically to recommend it. It was situated on a lake in the midst of swamps (malaria outbreaks were frequent), and was small and poor compared to the great neighbouring states of Venice and Milan. Nevertheless, the area was rich in farmland and Ludovico's ancestors had realized early on that they could improve the diplomatic standing of their court by investing their modest revenues, inflated by their income as *condottieri*, in architecture, scholarship, and the arts.

Initial work had concentrated on the complex of the Corte, which incorporated two old palaces of the Bonacolsi family (expelled by the Gonzagas in 1328). Of its numerous painted rooms, one of the most stunning was the Sala del Pisanello, a large hall containing an incomplete mural decoration on an Arthurian theme by Pisanello (FIG. 108). This may be the first major work commissioned by Ludovico, dating from around 1447-48, and abandoned when Pisanello left for Naples – indeed, a large portion of it did not get beyond the stage of sinopia underdrawing. The chivalric subject-matter – a grand tournament and banquet – was closely suited to Ludovico's ideals as a young *condottiere* and knight of the Order of the Swan, a prestigious German Order to which he and his wife belonged. Ludovico and his father Gianfrancesco are shown in the illustrious company of the heroes of the Round Table. A favourite dwarf from the court also charges into the mêlée, clad in Gon-

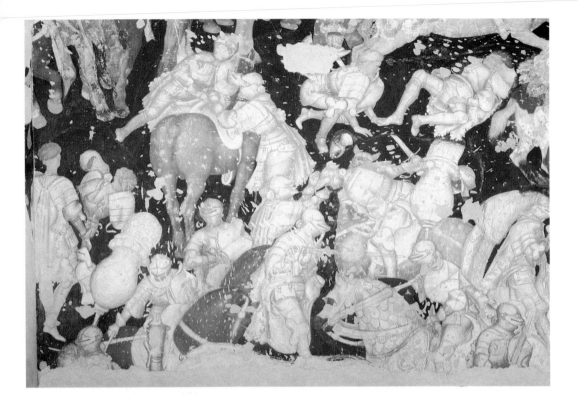

108. Pisanello
Tournament Scene (detail),
c. 1447-48. Fresco. Palazzo
Ducale, Mantua.

zaga colors. The frescoes would have provided the same plea-
sure and diversion as the large collection of French Arthurian
romances in the Gonzaga library.

As a *condottiere*, Ludovico was to gain his reputation in the
next decade as general of the Milanese forces. He was not as
brilliant on the field as Federico da Montefeltro, or as fearless as
Sigismondo Malatesta: the former was to decorate his palace
with a series of tapestries on the Trojan War, the latter with
tapestries illustrating the battles of Charlemagne. Yet the Gon-
zaga were custodians of a holy relic that they believed to be of
equal stature to the legendary Holy Grail (a chalice containing
Christ's blood), placing them on the same footing as the
knights whose tournament they had so enthusiastically
infiltrated. Alfonso of Aragon, the "warrior-king," claimed
ownership of the Holy Grail itself, in the form of a twin-
bowled sardonyx chalice with golden base and mounts studded
in rubies, pearls, and emeralds.

Mantua's relic of the "Most Precious Blood" contained a few
droplets that were credited with miraculous properties. These
had been preserved on the lance that the Roman centurion
Longinus stabbed into Christ's side at the Crucifixion (the lance

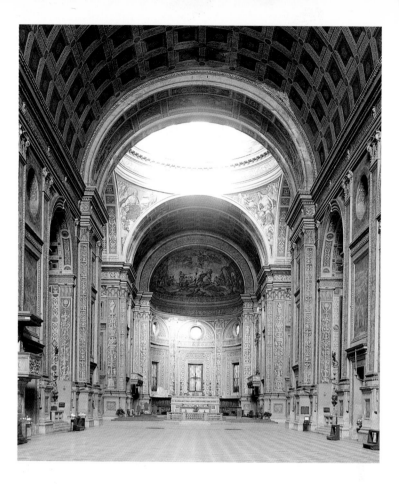

109. LEON BATTISTA ALBERTI
Nave of Sant'Andrea,
Mantua, foundation stone laid
1472; nave and portico
finished 1494.

Alberti designed Sant'Andrea
as an Etruscan-style temple
(as described in Vitruvius), in
keeping with the city's
legendary Etruscan origins.
The nave has an enormous
coffered barrel vault, with
three similarly vaulted
chapels to either side.

was housed in the mythical Grail Castle). The sixteenth-century chronicler Stefano Gionta relates subsequent events: "That same Longinus [a Christian convert] came to the city of Mantua ... Lodging in an almshouse on that very spot where is now to be seen Sant'Andrea ... he buried in the orchard of that almshouse that vessel which was the Precious Blood." The cult of the ancient relic was so important to the Gonzaga that the Most Precious Blood appears on the reverse of silver coins, medals, and the city's first gold ducat.

The pope's visit provided Ludovico with further impetus to transform Mantua into one of the most impressive of the smaller Italian city-states. Hearing some of the pope's criticisms from one of his agents, he immediately set about improving the city, beginning with the paving of the muddy central piazza. He no doubt discussed a range of ideas concerning urban planning with both Alberti and Pius II during their stay in the city: Pius himself was busy transforming Corsignano, the small town where he

was born, into an "ideal city" in the humanistic idiom (renamed Pienza). Ludovico was fascinated by questions of architectural design and construction: Filarete, in his treatise on architecture (1461-62), made the "most learned" Mantuan lord the mouthpiece for the following ideas: "I too was once pleased by modern buildings, but as soon as I began to appreciate the ancient ones, I grew to despise the modern ..." Fancelli, with whom Ludovico closely collaborated, was placed in charge of every detail of the execution of Alberti's Mantuan buildings.

The Palazzo del Podestà was restored to Alberti's plans and his temple, San Sebastiano, was begun though never completed. The monastery of Sant'Andrea, at the heart of the city, was rebuilt as a more worthy home for the Most Precious Blood, after a decade of vigorous opposition from the abbot. Alberti's design, submitted in 1470, replaced an earlier one by the Florentine architect Manetti. Alberti recommended his own in a letter to Ludovico as more suitable in every respect: "It will be more capacious, more eternal, more worthy, more cheerful. It will cost much less." The great interior (FIG. 109), partially modelled on Constantine's Roman Basilica of Maxentius, was intended both to accommodate and impress the crowds of pilgrims who came from far and wide to see the relic. The church's towering new stature (the facade incorporated a triumphal arch) transformed the character of Mantua's city center, re-orientating it towards the complex of court buildings nearby. The former monastery's revenues and property were appropriated by the Gonzaga, after the transferral of authority from the Benedictines to Ludovico's son, Cardinal Francesco.

Andrea Mantegna's ambitions, which were to become so entwined with those of his Gonzaga patrons, were also realized in Sant'Andrea (FIG. 110). On 11 August 1504 he was granted one of its chapels as his burial seat, and, according to the terms of his will, it was decorated with ornaments, sculpture, and paintings. He even purchased the land behind the chapel to ensure that the light through its circular window would remain unimpeded. This funerary chapel appears to testify to the remarkable reputation Mantegna commanded at his death in 1506, after forty-six years in Gonzaga service. But it is equally the fruit of his relentless pursuit of public honor and recognition: he petitioned Frederick III for the title of Count Palatine in 1469 (Ludovico's secretary noted, with some irony, "He hopes to get the title free") and was eventually knighted by Francesco Gonzaga in the 1480s; he had his compositions circulated as engravings so that they became known beyond the limited audience of the court; and he

built his own *palazzo* in the style of a Roman house (see FIG. 28, page 38) – an ambitious project that nearly bankrupted him. Yet, despite his artistic "dominion of Mantua," Mantegna's will was witnessed by his equals – all tradesmen, with the exception of his close friend, the court poet and physician Battista Fiera. His son even seems to have reproached Marquis Francesco (Ludovico's grandson) for not visiting the great artist on his death-bed.

Andrea Mantegna: Court Painter and Painter-Courtier

Mantegna had been approached to take up the position of court painter shortly after the death of Pisanello in around 1455. Marquis Ludovico would have been well acquainted with his work for the nearby Ferrarese court, and probably knew of his reputation through the humanist eulogies then circulating. At one point, when Ludovico despaired of Mantegna ever leaving Padua, he began negotiations with another artist associated with the Este court, Michele Pannonio. Mantegna, however, was a natural choice for the scholarly Ludovico. The marquis had been educated in Vittorino da Feltre's Casa Giocosa (Joyous House) –

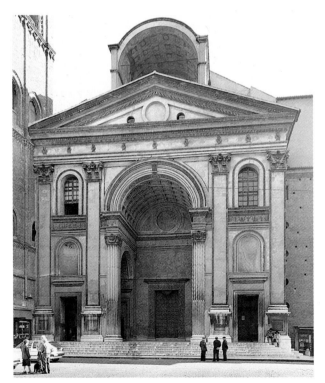

110. LEON BATTISTA ALBERTI Exterior of Sant'Andrea, Mantua, portico finished 1494.

the famous school established by his father. Alberti's treatise *On Painting*, dedicated to Gianfrancesco Gonzaga, was probably written with the Casa Giocosa in mind; for this was one of the few establishments where its learned allusions to ancient rhetoric, philosophy, poetry, and history, coupled with an emphasis on draughtsmanship, mathematics, and geometry, would have been clearly understood. Mantegna shared Ludovico's passionate interest in antiquity and was keen to illustrate and elaborate on Alberti's ideas. The three men probably discussed iconographic schemes when they met during Mantegna's first decade in Mantua.

On 15 April 1458 Ludovico made Mantegna the formal offer of "fifteen ducats a month, the provision of rooms where you can live

with your family, enough food each year to feed six, and enough firewood for your use." Mantegna accepted graciously, but asked for six months' delay to finish work to which he was already committed. Ludovico agreed, adding "take seven or eight, so that you can finish everything you have begun and come here with your mind at rest." On 23 January 1459, Mantegna was given a length of crimson damask embroidered with silver to make up his court livery. Seven days later he was formally designated *carissimum familiarem noster* (our most dear familiar) and granted the use of the Gonzaga coat of arms, together with the device of the sun bearing the punning motto *par un [sol] désir*. These, Ludovico declared, were to be "the least of the rewards" he could expect. A "little ship" sent by the marquis finally set out from Mantua in the spring of 1460, returning with Mantegna, his family, and belongings.

Mantegna's first major task was the decoration of the Gonzaga's private chapel in the newly refurbished Castello di San Giorgio. The chapel had been built according to Mantegna's specifications, and the artist may have traveled briefly to Mantua to approve it in mid-1459. Fancelli was in charge of the structural work and the interior refurbishment. Mantegna probably began the painted decoration in 1460, producing panels for up to ten years afterwards. The chapel was destroyed in the sixteenth century – the Cappella del Perdono at Urbino may be the closest existing parallel – but three panels now in the Uffizi (collected together as the "Uffizi Triptych") have long been associated with it. One of these, *The Adoration of the Magi*, is painted on a curved panel, probably to fit into the altar niche. Engravings of *The Deposition* and *The Entombment with Four Birds* of about 1465 (the latter featuring St. Longinus) may be connected with lost paintings for the chapel.

The chapel works are typical products of courtly art in that they are small-scale – the largest is 30^1/$_4$ x 29^1/$_2$″ (75.6 x 73.7 cm) – highly decorative, and peopled with numerous slender figures. The architectural setting of *The Circumcision* in particular, with its polished marbles, stucco mouldings, and gilt-bronze reliefs, is a showpiece for Mantegna's *all'antica* prowess. Mantegna was clearly anxious to conform to what was expected of him at this early stage in his court career: each little panel is worked up from detailed, carefully executed cartoons and the colors are varnished for extra gloss. His bold individualism had been criticized a few years earlier in Padua, when he had painted a fresco of *The Assumption of the Virgin* with eight apostles rather than the full twelve. In the Mantuan *Ascension*, the head and shoulders of the

Following pages
111. ANDREA MANTEGNA
Camera Picta: general view, showing north and west walls and ceiling, 1465-74. Dimensions: 26′6″ x 26′6″x 2′9″ (8 x 8 x 6.9 m). Palazzo Ducale, Mantua.

This small cubic room in the northeast tower of the Castello di San Giorgio was re-designed before Mantegna began decorating it. The ceiling was raised and two windows shifted, so that the light would fall gracefully on the frescoes. An additional entrance door was inserted in the west wall. Originally, a large canopied bed was set in the southeast corner of the room against Mantegna's painted decoration of gold-embroidered cloth hangings. Hooks from its canopy can still be found embedded in the plaster.

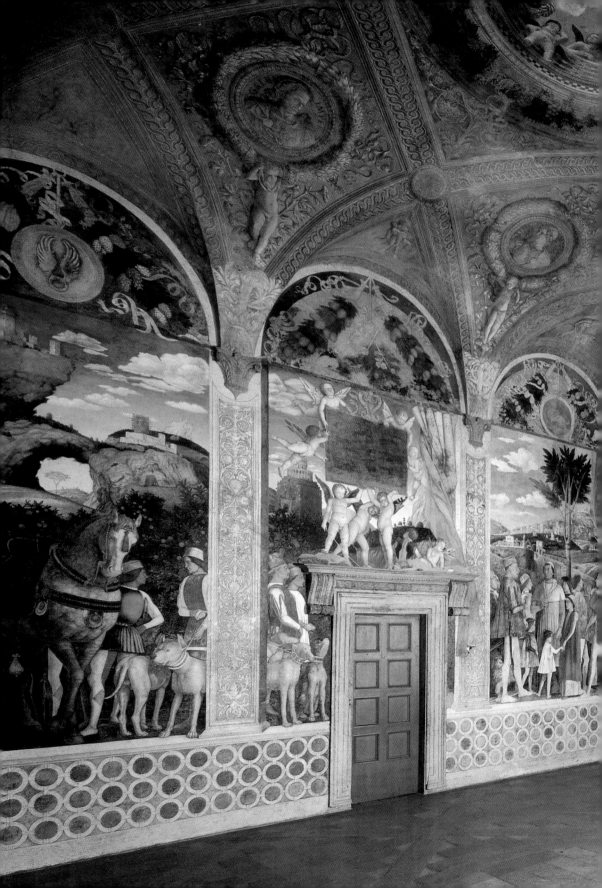

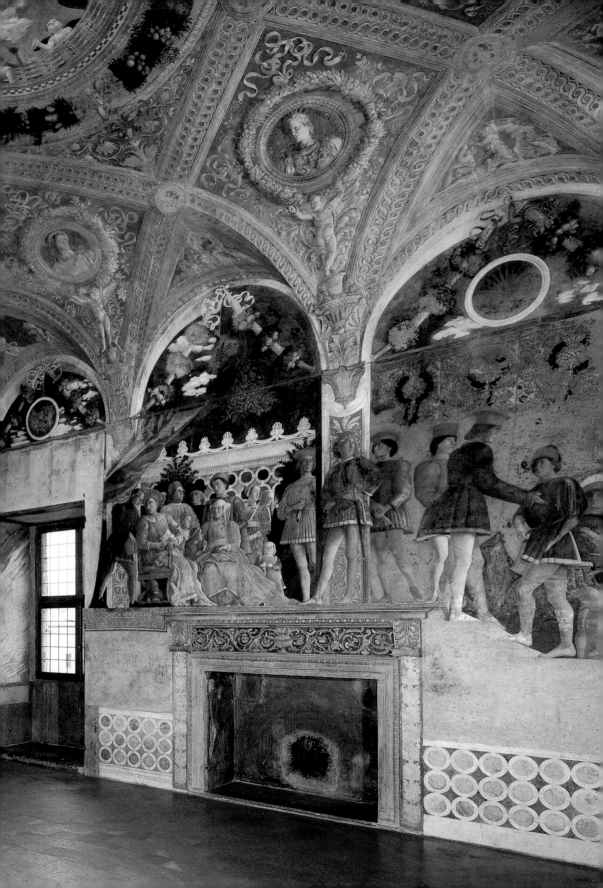

112. ANDREA MANTEGNA
Camera Picta: the oculus,
1465-74. Palazzo Ducale,
Mantua.

Peeping down at the viewer
through the oculus are ladies
of the court, *putti*, a peacock
and a Moorish figure. This
feminine dimension to the
room may serve as a playful
reminder of earthly vanity.
Ludovico would probably
have used the surrounding
mythological vaulting
compartments and bust
medallions of the emperors as
topics for casual conversation.
While they would have
triggered responses about the
virtues they embody or
allegorize, the oculus presents
a light-hearted defence of the
charge of Gonzaga pomposity.
For sheer entertainment value
and as a bravura display of
illusionistic skill, the oculus
was unrivalled in its day.

four apostles that make up the twelve are dutifully pressed in behind the main group.

In 1465 Mantegna began work on the decoration of a small square chamber on the first floor of the Castello – the date is frescoed in the splay of a window to look like graffiti scratched into the plaster. Nearly ten years later the Camera Picta (Painted Room, also known as the Camera degli Sposi) was completed (FIG. 111): Mantegna's dedicatory plaque to Ludovico Gonzaga and his wife Barbara of Brandenburg is dated 1474. Mantegna painted the stunning illusionistic ceiling first of all, with its fictive marble portrait busts, elaborate "stucco" mouldings, glittering gold "mosaic," and oculus – a simulated opening at the center of the vault giving way to a painted summer sky (FIG. 112). He then proceeded to depict the Gonzaga family and court (including the marquis's favourite dog, Rubino) sitting in a garden loggia directly over the north wall fireplace, gold-embroidered curtains on the south and east walls, and the Meeting Scene on the west wall (FIG. 113).

These frescoes, recently restored to their former glory, give us a privileged glimpse into the enclosed world of the Gonzaga inner court and are a remarkable display of Mantegna's *virtù*. On first impression, they seem to present a wonderfully "natural" and affectionate portrait of the illustrious marquis and his wife, along with their family, closest advisers, court favourites, horses, and attendants (FIG. 114). But the decoration is also a carefully contrived political artifice – a masterpiece of illusion in every way. This is made explicit in an ambassador's report of 1475, which alerts Ludovico to Duke Galeazzo Maria Sforza's complaint that his own portrait has not been included in "the most beautiful room in the world." The insult is compounded by the fact that the decoration includes, in Galeazzo Maria's own words, the "two most wretched men in the world:" King Christian of Denmark and the Emperor Frederick III (both of whom had thwarted his plans to buy himself a royal title). Ludovico tactfully averts a minor diplomatic incident by declaring that Mantegna's portraits "lack grace," and he wanted to avoid giving displeasure – Galeazzo Maria had already burnt a portrait

drawing of himself by the artist. The explanation seems to have been accepted: Galeazzo Maria had already planned a fresco decoration for his castle in Milan (1474) in which Ludovico was to be placed on the same footing as the marquis of the tiny state of Monferrato!

The original and distinguished function of the room provides the key to events to which the frescoes may allude. Situated on the first floor of the oldest part of the Castello, the room was used both as the marquis's bedchamber and as an audience room, where Ludovico received important visitors – lords, ambassadors, and diplomats – as well as his closest advisers and administrators. A small cabinet positioned on the west wall

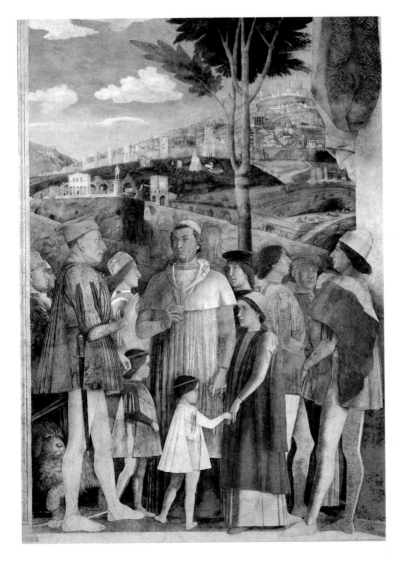

113. ANDREA MANTEGNA
Camera Picta: Meeting Scene (west wall), 1465-74. Palazzo Ducale, Mantua.

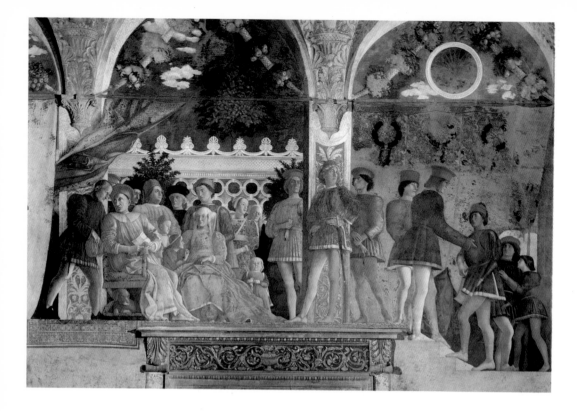

114. ANDREA MANTEGNA
Camera Picta: detail of Court
Scene (north wall), 1465-74
Palazzo Ducale, Mantua.

The figures in the fresco have
been identified as follows:
Ludovico Gonzaga and
Barbara of Brandenburg
(seated); Ludovochino and
Paola (the youngest son and
daughter) and Gianfrancesco
(the third son) shown
between them; Rodolfo (the
fourth son) and Barbara (the
eldest daughter) stand behind
Barbara of Brandenburg.
The other figures probably
include prominent secretaries
and advisers, as well as a
nurse, a female dwarf, and,
on the right, leading officials
and courtiers.

behind Mantegna's painted gold-embroidered cloth was proba-
bly used to store important letters and documents, as well as the
marquis's keys (including those to the chapel of the Most Pre-
cious Blood). This may explain why letters feature so strongly in
the room's decoration. The Gonzaga devices around the tops of
the walls, and the coat of arms emblazoned above the south
door, reinforce the room's ceremonial and dynastic character.

According to the Italian scholar Signorini's researches, the
court scene shows Ludovico receiving a letter (dated 30 Decem-
ber 1461 and now in the state archives) that contained an urgent
summons from the Duchess of Milan. Ludovico was employed
as Milan's lieutenant-general, and the letter informed him of
Duke Francesco Sforza's grave illness. In the event of his death,
Sforza rule could be challenged, and Ludovico's military services
would be called upon. On receiving this letter, Ludovico set off
immediately for Milan, meeting his sons Francesco and Federico
(his heir) at Bozzolo, on the border of Mantuan and Milanese
territories. Francesco had just been elevated to the princely rank
of Cardinal (22 December 1461), a momentous event for the
family and the most important outcome of Pius II's stay in Man-
tua. The meeting between father and cardinal-son is witnessed

by Barbara of Brandenburg's brother-in-law, King Christian I of Denmark, and Emperor Frederick III (Mantua's overlord), neither of whom was actually present at the occasion. The children Sigismondo and Francesco were not at that stage born, yet they too are included. Thus a real event is subsumed into a general celebration of Gonzaga prestige, and a triumphant flaunting of their papal and imperial connections.

The Camera Picta, it seems, was also expected to play a subtle role in influencing events: when the Milanese ambassadors came to Mantua to renegotiate Ludovico's military contract in April 1470 (Gonzaga solvency – and thus Mantegna's salary – was reliant on it) they were shown the frescoes in progress. The ambassadors reported that Ludovico showed them a room he was having painted "where are portrayed *al naturale* his lordship, Madonna Barbara his consort, Lord Federico, and all his other sons and daughters. While talking about these figures, he had both his daughters come, namely the younger, Madonna Paola, and the elder, Madonna Barbara, who seemed to us a pretty and gentle lady, with a good air and manners."

Mantegna's court fresco was therefore used to impress the ambassadors and show off the marriageable Gonzaga daughters, whose grace could be set off by the verisimilitude of their painted portraits (FIG. 115). Having rejected two Gonzaga daughters on the grounds of congenital deformity, Galeazzo Maria Sforza's passion for Barbara had been inflamed by a portrait he had commissioned, which apparently "drove him crazy" (although a match with Bona of Savoy had been arranged). The court fresco also presented the ambassadors with an embodiment of Ludovico's *condottiere* virtues – above all his fidelity to those to whom he "pledged his person and state."

Mantegna's other most prestigious work for the Gonzaga was *The Triumphs of Caesar* of c. 1484 to the late 1490s (FIG. 116) – a magnificent series of nine canvases celebrating the military triumphs of Julius Caesar "in images that are almost alive and breathing" (Marquis Francesco Gonzaga). There is still no conclusive evidence as to which Gonzaga commissioned this great work, or as to where the series was originally intended to hang. Federico Gonzaga, who succeeded Ludovico as Marquis in 1478, seems to have devoted the little time he had, when he was not embroiled in military campaigns, to the construction of a new palace, the Domus Novus, and to urgent renovation work on the old Corte (a wall in his bedroom had collapsed in the autumn of 1480, and in December part of the ceiling of the Sala del Pisanello fell in).

115. ANDREA MANTEGNA
Camera Picta: detail of
Barbara, Ludovico
Gonzaga's eldest daughter,
1465-74. Palazzo Ducale,
Mantua.

Unlike the Camera Picta, *The Triumphs of Caesar* has only generalized allusions to the Gonzaga, which suggests that Mantegna was given an unusually open brief. The few allusions there are – the imperial eagle (which the Emperor Sigismund had allowed the Gonzaga to use quartered on their coat of arms), the youths in red and white livery – are not exclusive to the Gonzaga court. Nevertheless, the series instantly won the family widespread acclaim. It was possibly the young Marquis Francesco Gonzaga who realized that Mantegna's marvellously inventive archaeological *maniera* – given a stage large enough to display it to its full advantage – could only enhance his reputation. If this is the case, then it marks a new phase in princely patronage.

Francesco had succeeded Federico in 1484 at the age of eighteen. Mantegna, who with each successive marquis worried anew about his terms of employment, wrote a few weeks later to Lorenzo de' Medici in Florence that "The disposition of this new lord renews my hopes, seeing him all inclined towards *virtù*." Mantegna's continual correspondence with Lorenzo de' Medici during Federico's reign, requesting financial assistance and sending a couple of paintings as diplomatic gifts (Federico was fighting for the Florentines), reveals that he was seriously unhappy during these years; he probably offered his services to Lorenzo de' Medici when the latter visited his house in 1483. Mantegna's worries, however, seem to have been dispelled when the new marquis bestowed on him the long-awaited knighthood and possibly the huge open-ended commission of *The Triumphs of Caesar*. Both these measures would have ensured that the venerable master was kept happy and busy in Gonzaga service.

Mantegna, by now a practiced courtier, quickly gauged how to treat the new marquis, who enjoyed being entertained (he greatly valued his dwarfs and buffoons) and whose chief loves were racehorses and military equipment. Writing from Rome, where Francesco had granted him two years' leave to decorate Pope Innocent VIII's chapel in the Vatican, Mantegna does the young marquis honor with "all the powers of my weak wits" – urging him to keep on paying his salary. The fear that the "bee" might be deprived of honey while absent from the "hive" seems to have haunted Mantegna during these two years. He shrewdly uses a racehorse analogy, speaking of the honor he hopes to obtain from working in Rome: "And so, as with Barbary horses, the first gets the ribbon, and I must get it finally." He then provides

116. Andrea Mantegna
The Triumphs of Caesar c. 1484 to late 1490s. Canvas II: *Captured Statues and Siege Equipment.* Tempera on canvas, 9′ 1⅞″ x 9′ 2¼″ (2.7 x 2.7 m). Hampton Court, London.

Mantegna's splendid canvases freely intermingle ancient visual and literary sources (here the colossal statues, wooden models of captured cities and booty are taken from accounts in Appian and Livy) with contemporary descriptions of classical triumphs and items derived from fifteenth-century pageantry and display. Courtiers would probably have recognized the horse with its "lion of San Marco" pendant as an illusion to Francesco Gonzaga's command of the Venetian forces: the inscription, with its reference to "envy scorned and overcome," also has the ring of a contemporary motto. Mantegna has possibly included a profile portrait of himself behind the mounted general. The nine canvases were hung in Francesco's newly built Palazzo di San Sebastiano in 1506, where they formed a living reminder of the glories of antiquity.

117. ANDREA MANTEGNA
Madonna della Vittoria, 1496.
Tempera on canvas,
9' 4⅝" x 5' 6⅜" (2.8 x 1.6 m).
Louvre, Paris.

Francesco with an amusing verbal caricature of the Sultan's brother who was living in the Vatican as the Pope's prisoner.

The seventh canvas of *The Triumphs of Caesar*, which may have been painted on Mantegna's return from Rome, features a courtly group of jesters and *buffoni* who poke fun at the ranks of forlorn captives paraded past them. This combination of jest and earnest would have delighted Francesco. His favourite dwarf Mattello made a speciality of sending up monks. One of Mantegna's sons, Francesco, was to use similar courtly ploys in an attempt to prolong his employment at the Gonzaga castle of

Marmirolo, which he was in the process of decorating with pictures of cities and the Triumphs of Alexander. He sent Francesco Gonzaga a drawing of the King of France, Charles VIII, who had invaded Italy and was being repelled by Francesco in his role as commander of the Venetian army. "Since I have heard from some people about the most serene King of France's appearance, and how greatly deformed it is, with the large eyes popping out, and faulty in the large aquiline misshapen nose, with few thin hairs on his head, the amazement of the image of such a little hunchbacked man made me have a dream about it."

Francesco's slender victory against Charles VIII's army at the Battle of Fornovo on 6 July 1495 was celebrated in a votive altarpiece, the *Madonna dell Vittoria*, painted by Mantegna (FIG. 117). The canvas was carried in triumph through the streets on the anniversary of the battle. Mantegna was paid 110 ducats – money that had been put up by an unfortunate Jew, Daniele da Norsa. The latter had removed a fresco of the Madonna from his house with the full authority of Sigismondo Gonzaga, Vicar of Mantua, only to be fined for the "offence" in the ensuing furore. Francesco, clad in armour, is shown kneeling in homage, with a decidedly worldly glow spreading across his reverent features. He is commended to the Madonna by Saints Andrew, George (patron saint of the Gonzaga), Michael, and Longinus with his blood-stained lance. The elderly woman may be the saintly Mantuan noblewoman Osanna Andreasi, to whose spiritual welfare Francesco's father had entrusted his family. The Venetian sculptor Pietro Lombardo had been commissioned to make a votive chapel for the "Most Unconquerable Emperor" (as he addressed the marquis): some years later, when Francesco was incarcerated by the Venetians (he was fighting on the opposing side), Lombardo was asked to reinforce the masonry of his cell!

Francesco also commissioned court artist Francesco Bonsignori (c. 1460-1519) to make a painting of the battle, sending him to Fornovo so that he could make drawings of the site. This was probably one of a set of "triumphs" that are mentioned in the same breath as Bonsignori's large series of "portraits of court gentlemen." At the end of his life, Bonsignori was to paint an altarpiece showing Francesco's wife, Isabella d'Este, in the company of Dominican nuns, kneeling in veneration at the feet of the Beata Osanna Andreasi. The work is dated 1519, the year of Francesco's death; Isabella is shown devout and modest in simple widow's dress. Long before her husband's death, however, Isabella had immersed herself in the cultural affairs of the Gonzaga court and taken Mantegna under her wing.

Isabella d'Este: Collecting for Pleasure and Prestige

Isabella d'Este, the eldest daughter and favourite child of Ercole d'Este and Eleonora of Aragon, had become Francesco's wife when she was seventeen years old. Like her mother, she took a keen interest in culture and had already developed a fastidious artistic eye. She had a special love of music and dance, played the lute and cittern (a very similar instrument), and was later to become highly accomplished on the *lira da braccio* (a bowed string-instrument). Mantegna, who was absent in Rome at the time of Isabella's arrival, took the wise precaution of writing to her former tutor Battista Guarino, asking him to recommend his services to her.

Isabella was anxious for fame and prestige and chose to concentrate on developing a role for herself as a considerable patron of the arts. In order to strengthen her credentials, she tried earnestly to learn Latin, but found it difficult to master. She was the only consort to hire a tutor for this purpose – the humanist Mario Equicola, who came from Ferrara to Mantua some time before 1500, and was appointed to the post in early 1508. She also surrounded herself with "experts" – humanist advisers, agents, and ambassadors – and traveled whenever she could. Her ambitions as a patron are embodied in the commission of a monument to the great Mantuan poet Virgil, an idea that Ludovico had considered with the humanist Platina in the 1450s and one which Isabella enthusiastically revived in the late 1490s.

Giovanni Pontano, who was approached through Francesco's Neapolitan ambassador for scholarly advice on the monument, paid tribute to Isabella's unusual initiative, especially considering that she was "a young woman, unable to read Latin." He advised that the monument be made of marble: bronze, though "more noble," was often melted down to make bells or cannon. Mantegna was to design it, using an authentic likeness of Virgil, and Pontano offered a polished verse for its base, instead of the proposed inscription *Isabella Marchionessa Mantuae restituit*. The project never seems to have gone beyond the preliminary stages and all that survives of it is a drawing (attributed to the school of Mantegna). A poem by Battista Fiera praising the endeavor is dedicated not to Isabella herself, but to his patron Francesco Gonzaga, who would have paid for the undertaking.

Isabella's ambitions were continually thwarted by lack of personal funds: art for her apartments had to be paid for out of her own household income, and she frequently had to pawn her

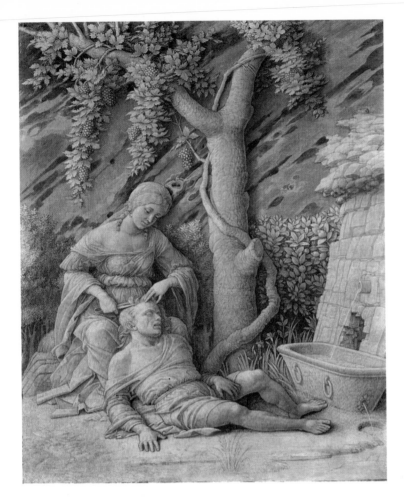

118. ANDREA MANTEGNA *Samson and Delilah*, c. 1495-1500. Glue size (distemper) on linen canvas, 18½ x 14¼" (47 x 37 cm). The National Gallery, London.

This delicate work is designed to be appreciated by the connoisseur of exquisite sculpture, cameos, and rare marbles. Like Mantegna's stylish simulated bronzes, it imitates both the precious materials and the lofty Roman style of the most prized collector's pieces. The picture has been associated with Mantegna's *Judith with the Head of Holofernes* in the National Gallery, Dublin, which represents an Old Testament ideal of female virtue (Isabella was fond of allegories). Here, Mantegna presents Delilah as the antithesis of Judith: the inscription on the gnarled tree-trunk reads 'a bad woman is three times worse than the devil.'

jewels. She was therefore denied the opportunity of the "magnificent" gesture, there being no scope for architectural commissions (the Virgil monument was the closest she came to public glory). Consorts were usually expected to emphasize their piety through small religious commissions or through the endowment of personal religious foundations. Isabella, however, was more interested in fashionable secular projects and classical connoisseurship. Even traditional biblical subjects – Old Testament types of vice and virtue – were preferred in decorative antique guise. Two small *grisaille* pictures, which were possibly designed by Mantegna for Isabella's *studiolo*, were painted to look like Roman reliefs of polished stone against a background of veined marble (FIG. 118). They would have been admirably set off by the *studiolo*'s rich marble-effect walls.

Isabella had her portrait painted by some of the greatest artists of the period, including Cosimo Tura, Leonardo da Vinci,

119. GIANCRISTOFORO ROMANO
Medal of Isabella d'Este
(obverse), 1498. Gold,
diamonds, and enamel,
diameter 2⅝" (6.8 cm).
Kunsthistorisches Museum,
Vienna.

This is a luxury gold cast of
the medal that Isabella
presented as a gift to poets she
favoured, with the inscription
"for those who do her service"
on the reverse. It was
exhibited alongside a precious
Ptolomaic cameo (FIG. 120) in
her *grotta*: the juxtaposition
was designed to invite
comparisons.

Mantegna, and Titian. She was keen to be represented in a flatter-ing manner and to be shown in the most fashionable clothes and accessories. Costume and jewelery were highly important in por-traits of ladies of status, who had little or no recourse to the tra-ditional attributes of nobility such as arms, chivalric decorations, or heavy gold chains. Their sumptuous brocades studded with jewels made them appear like "angels," and the angels in altar-pieces often resembled them. When Eleonora of Aragon was shown her daughter Beatrice's lavish wardrobe at Vigevano, she compared it to a sacristy filled with ecclesiastical robes. For the writer Giangiorgio Trissino, who created a word-picture of Isabella in his *Portraits* (*Ritratti*) of the finest ladies in Italy (1524), Isabella's gorgeous attire was a mark of "liberality" – a way of sharing her riches with everyone. Physical beauty, too, was regarded as the outward manifestation of virtue, in keeping with the latest Platonic ideas. Trissino described Isabella arriving for Mass at Milan Cathedral in about 1507 holding an open prayer book in her hand. She was wearing a black velvet dress embroi-dered with gold, her waist hugged by a gold-buckled girdle, and her lustrous hair glimpsed through a bejeweled gossamer net. Leonardo's portrait drawing, which met with Isabella's approval, originally showed her holding a book between her slender

fingers (see FIG. 105, page 143). Isabella's other most reliable sur-
viving portrait is on her medal, which she gave to literary men
as a mark of her special favour. She kept a deluxe version of it –
gold with a diamond-studded frame – in her *grotta*, alongside an
exquisite antique cameo (FIGS. 119 and 120).

Despite her love of music, only one scored manuscript (a
book of songs) can be associated with Isabella's patronage,
although there were several such musical books in her collec-
tion. The musicians and singers for the prestigious Gonzaga
chapel choir, established in 1510, were hired by Francesco, and he
was in charge of the initial musical repertoire of sacred masses
and motets (appointing the composer Marchetto Cara as musical
director in 1511). Nevertheless, Isabella commissioned new instru-
ments from some of the leading instrument-makers, hired a per-
sonal singing master from Ferrara, and enlarged the band of
court musicians for secular music-making. Her chief musical
instrument-maker, Venetian-based Lorenzo da Pavia, also acted
as her agent when she was negotiating with artists like Giovanni
Bellini. Like her sister Beatrice and her sister-in-law Lucrezia
Borgia, Isabella delighted in settings of vernacular poetry to
music, and several of the paintings in her *studiolo* allude to musi-
cal themes.

120. Cameo of Ptolomaic
royal couple, third century
BC. Onyx, height 4½" (11.5
cm). Kunsthistorisches
Museum, Vienna.

Apollo, late fifteenth century.
Bronze and parcel-gilt, inlaid
with silver, height with base
15¼″ (40 cm). Ca' d'Oro,
Venice.

Isabella's difficulties with Latin did not inhibit her cultural preferences. Instead of reading Latin texts, she acquired antique works of art for her *grotta*, for which she developed an "insatiable desire." She began her collection with small objects like gems, cameos, and vases, graduating to sculpture, medallions, and coins. Her taste for such objects was well known and she received many gifts: Mantegna's son, Ludovico, curried favour by sending her a medal, "because I know you delight in them extremely." Her gem-engraver Francesco Anichino, who resided in Venice, was regularly sent designs by Mantegna to carve. Her medal-maker and court sculptor Giancristoforo Romano helped her to circumvent the papal embargo on exports of Roman antiquities and, along with Mantegna and the sculptor Antico, advised her on the authenticity and quality of pieces. She commissioned bronze figures by Antico, and had his deluxe reductions of classical masterpieces, like the Apollo Belvedere (FIG. 121), recast from originals made for Bishop Ludovico Gonzaga. Mantegna painted *bronzi finti* (imitation bronze reliefs) to complement them, using shell-gold on top of a brownish underpaint.

Although she did not have the resources to attract the best painters to Mantua, Isabella could commission works from artists of major standing or, failing this, buy them second-hand. In this respect she established an important precedent, becoming one of the first courtly patrons to buy works by Italian artists for their own sake, virtually regardless of subject-matter. On Giorgione's death, one of Isabella's agents alerted her to the fact that there was a "very beautiful and singular" picture of a night scene among his effects. She tried to buy it through a Venetian merchant, only to find it had been painted on commission for someone else.

Florence and Venice (the latter less than a hundred miles from Mantua) were almost certainly the first to develop an art market to meet an increasing demand for local pictures, statues, and artifacts from clients both in Italy and abroad. When Gio-

vanni Bellini was approached to provide a picture for Isabella's *studiolo*, he succeeded in persuading her to take a "Nativity" in its place (which she hung in her bedroom), a type of picture for which he had a ready stream of buyers. A free agent with a busy and highly successful commercial workshop, Bellini seems to have quickly realized that Isabella would take from it whatever was available. Isabella's contacts also kept her informed of Leonardo's activities: Fra Pietro da Novellara's well-known account of an astounding cartoon by the master is contained in a letter to Isabella.

Isabella's first *studiolo* in a tower of the Castello was loosely modeled on those of her uncles (Borso and Leonello) at Ferrara, although she had the unusual idea of commissioning classical allegories from the "excellent painters today in Italy," rather than from artists working at the court. This may have been because Isabella originally intended Mantegna to produce the entire decoration, but quickly realized that he was too slow to produce all the paintings she needed. Mantegna completed two masterpieces, leaving a third barely started at his death. Isabella's detailed iconographic programs for the pictures, supplied by the Mantuan poet Paride da Ceresara and the Venetian humanist Pietro Bembo, have been represented as unusual in the context of Renaissance art; yet they are entirely normal within the context of Este Ferrarese patronage. Nevertheless, the Ferrarese practice of using humanist advisers for the *invenzione* (as in the Schifanoia frescoes) did not please artists who had gained some reputation as masters of *invenzione* themselves. Painterly *invenzione*, as Alberti had made clear, was related primarily to the devising of pictorial allegories. Mantegna, as court artist, produced the only great paintings of the series, the *Parnassus* (completed 1497) and *Pallas Expelling the Vices* (FIG. 122), probably because he was esteemed enough to contribute his own ideas.

Perugino, who was the most famous painter in Italy at the time (and the son-in-law of Luca Fancelli), produced a labored *Battle of Love and Chastity* (1505) after an extensive correspondence that tied him to an impossibly complex program. Lorenzo Costa's contribution, *The Garden of the Peaceful Arts* (FIG. 123), was painted at the suggestion of Isabella's brother-in-law and Costa's patron, Antongaleazzo Bentivoglio of Bologna, who also arranged and paid for the picture. Having failed to get Mantegna's brother-in-law, Giovanni Bellini, to contribute, Isabella commissioned a painting from the Bolognese Francesco Francia (which was removed from the *studiolo* in 1505). After Mantegna's death in 1506, Lorenzo Costa completed the master's *Comus* for

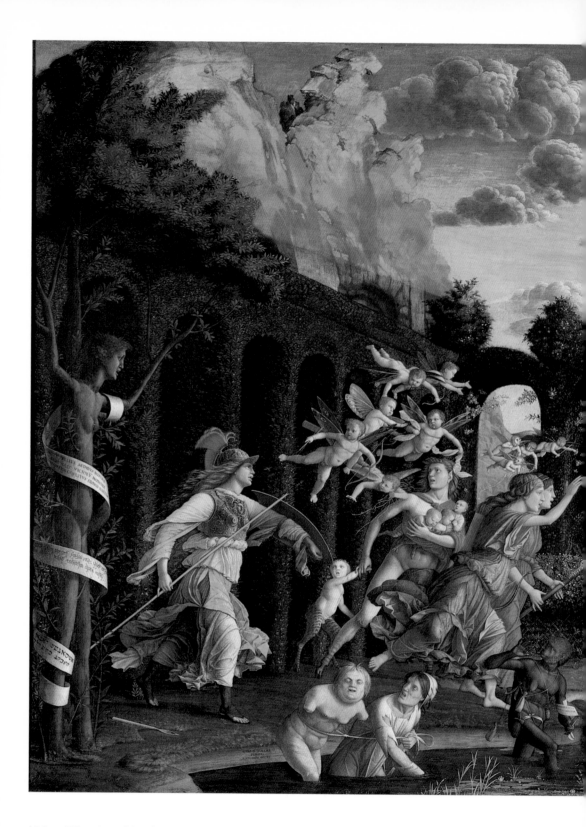

122. ANDREA MANTEGNA
Pallas Expelling the Vices from the Garden of Virtue, c. 1499-1502. Tempera on canvas, 5'3¹/₄" x 6'3⁷/₈" (1.6 x 1.9 m). Louvre, Paris.

This remarkable *fantasìa* is probably the result of Mantegna's collaboration with Isabella's humanist adviser Paride da Ceresara. The allegorical figures are identified by inscriptions: Pallas Athene (Isabella) rushes into the enclosed garden, holding a broken spear (symbol of knightly victory), and scattering the Vices in her wake. The anguished anthropomorphic tree on the extreme left symbolizes "Virtue Deserted": the Latin, Greek, and Hebrew inscriptions wound round her trunk call on the virtues in the heavens (Justice, Fortitude, and Temperance, shown in the sky) to return and banish "these foul monsters of Vices from our seats." The fourth Virtue, Prudence – which Isabella claimed as her own – is imprisoned in the rocky wall on the right. Mantegna's abundant powers of invention are demonstrated not only in the extraordinary figures (the armless "Idleness" or the monkey-like "Immortal Hatred, Fraud, and Malice"), but also in the explosion of volcanic rock, the profile heads forming from dark cloud, and the fertile river landscape beyond.

the room. Very obviously, the choice of painters was dictated not only by merit but also by family and personal connections. Botticelli told Isabella's Florentine agent that he would be happy to paint a picture for her *studiolo*, but he was not part of the marchioness's network and his offer was never accepted.

Isabella tried to get all her artists to conform to the example set by Mantegna's canvases. The painters were sent the iconographic program, the dimensions to work to, details of the medium (gouache with an oil varnish like Mantegna), and a piece of thread (the size of Mantegna's largest figure). Costa and Perugino were also sent drawings of the *invenzione*. Costa's style, though best suited to "cosmetic softness and blandishments," as Battista Fiera put it, found favour – probably due to his obliging nature and the fact that he was accustomed to the ways of courts. Perugino and Bellini, on the other hand, gave Isabella endless problems. When Perugino clothed a Venus who was meant to be nude, Isabella was most upset because he had changed the "sentiment of the fable" just "to show off the excellence of his art." Pietro Bembo advised Isabella that Bellini's pleasure depended on "sharply defined limits" not being set to his style, "being wont, as he says, to wander at will in his paintings." The lessons of the *studiolo* seem to have been quickly learned: on Mantegna's death, Lorenzo Costa was duly hired as his replacement.

With the succession of her son Federico as fifth marquis of Mantua, Isabella's role was superseded. Many of her courtiers switched their allegiance to Federico and his wife, Margherita Paleologo; even her tutor Equicola deserted her. Federico employed outstanding masters like Titian and Correggio, and brought Giulio Romano, Raphael's most gifted pupil, to Mantua as court artist. Isabella's approval remained one of the spurs to Federico's patronage, although his decidedly sensual tastes have always been presented as being very different from her own. However, Isabella was lively and broadminded. The words she uses to describe her own desire for art and antiquities – "insatiable" and "hungry" – suggest a more earthy than spiritual approach to art. One of her great sources of pleasure seems to have been her power to attract artists and erudite men into her service – her early emblem as marchioness was a magnet. She commissioned two Correggios for her second *studiolo*, one of which is unquestionably erotic (though presented in moral guise); and she particularly admired one of Titian's sensual Magdalenes, which had been presented to her son. Her daughters may have taken the veil, but her son Federico shared her sociable nature and secular tastes. It was to him that she bequeathed the worldly pleasures of her *grotta*.

123. Lorenzo Costa

The Garden of the Peaceful Arts (Allegory of the Court of Isabella d'Este), 1504-06. Tempera and oil on canvas, 5′5¼″ x 6′6″ (1.6 x 1.9 m). Louvre, Paris.

The program for this allegory was provided by Paride: the painting appears to represent the arts flourishing in a peaceful haven presided over by Isabella d'Este (possibly the lady being crowned by Cupid), and protected by the gods Mars (with a downward pointing halberd) and Diana. Figures perhaps personifying music, Georgic, and Pastoral poetry (the women seated in the foreground, caressing cows and sheep), and painting (the man in the plumed hat) are sheltered from the warring soldiers in the left-hand distance.

SEVEN

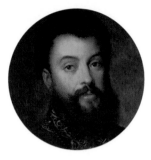

Continuity and Adaptation

124. RINALDO MANTOVANO
AND ASSISTANTS, FROM DESIGNS
BY GIULIO ROMANO
Sala dei Giganti (detail) 1530-
32. Fresco, Palazzo del Te,
Mantua.

The Palazzo del Te was built with double foundations and extra-thick walls on a swampy site. The whole architecture was designed to be strange and disjointed – with a vault that Vasari compared to an oven – so that even before the tumultuous decoration (in which Jupiter destroys the giants with a thunderbolt), the room seemed on the point of collapse. Vasari marveled at the effect provided by the continuous fresco decoration, which makes the room appear to be located on one vast plane in the countryside. When a fire was lit in the rusticated stone fireplace (now lost), the grotesque giants seemed to "burn" in its flames.

Castiglione's *Book of the Courtier*, a "portrait" of the court of Urbino in 1506, was written between 1513 and 1519. The book is cast in the form of a series of elegant and lively evening dialogues between eminent courtiers, presided over by the Duchess of Urbino, Elisabetta Gonzaga (her husband, the crippled and sickly Guidobaldo da Montefeltro, had retired to bed). At the time of its composition, Italy was in the throes of political turmoil. The French invasion of Italy of 1494-95 had seen Naples forfeit its kingdom, and the subsequent invasion of Milan in 1499 had precipitated a run of unstable governments (there were no less than eleven by the time of the *Courtier's* publication in 1528). Castiglione, who had spent his early years at the Milanese court, watched with sadness as Ludovico Sforza's great artistic treasures were dispersed. In Mantua in 1502, he met the exiled Guidobaldo da Montefeltro, who had been ousted from power by Cesare Borgia. When Pope Julius II restored his relative Guidobaldo to power, Castiglione went into the prince's service, bearing eloquent witness to the court of Urbino's sunset years (1504-16).

With each overthrow of government, artists, musicians, writers, and architects migrated to other centers. Most of them were lured to Rome, where Pope Julius II (ruled 1503-1513) was involved in a magnificent project to restore the city to its former grandeur and create the most glittering court in Christendom. Thus we find some of the greatest architects and artists of the age – Bramante, Michelangelo, Raphael, Giuliano da Sangallo (Lorenzo de' Medici's and Alfonso II's favourite architect) – working in the Roman milieu. Cardinals, many of them recruited from the ranks of princely families, had prestigious

courts of their own, financed by family wealth and ecclesiastical privileges. They built grand palaces and formed expensive collections of engraved gems, antique statuary, all'antica medals, and books adorned with sumptuous miniatures. Paolo Cortese's treatise On Cardinals (De Cardinalatu, 1510) called for them to observe the same courtly standards of "magnificence" and refinement in the decoration and arrangement of their residences.

Under Pope Leo X, Rome reached even greater heights of splendor and self-indulgence. But even Rome's bubble was temporarily burst by the advent of a non-Italian pope, Adrian VI (1521), who shunned his predecessors' ostentatious splendor and unseemly "worldliness." Castiglione wrote desolately from Rome, "It seems to me as if I am in a new world and Rome is no longer where it was." With the Sack of Rome in 1527 by imperial troops, artists were once more forced to emigrate to different centers. This continual dispersal of talent, and the courtly artist's well-developed ability to adapt to new environments, led to the spread of courtly styles and at the same time to their rapid transformation. The first-hand experience of Rome's ancient monuments, for example, had a lasting impact on artists from the courts, infusing their art with a new vigor and monumentality.

The confidence of the princely courts of the preceding century – when Borso d'Este built a great mountain on the Ferrarese plain and Ludovico Sforza triumphantly played off one power against another – was irreparably shattered. Ludovico, who had turned his back on war as a profession, felt he had been betrayed by humanism's elevated ideals. He had been praised to the skies by his humanist courtiers for his magnificence and virtù, but had lost his state. In his political testament of 1500, he advised his sons to put their faith in soldiers and fortresses. Machiavelli's The Prince (Il Principe), written in 1513, tried to inject a new note of realism and pragmatism into the practice of exercising and maintaining power. He wrote "there is such a gap between how one lives and how one ought to live that anyone who abandons what is done for what ought to be done learns his ruin rather than his preservation." Yet it was partly because of the difficulties in reconciling the conflicting roles of prince and condottiere that humanistic and chivalric ideals had been promoted so vigorously at the princely courts. In such circles, art continued to conform to an ideal rather than reflect harsh political realities.

Raphael of Urbino (1483-1520), a friend of Castiglione, helped to disseminate the courtly ideals that he had breathed in from birth. Son of Giovanni Santi, who had served as court artist to Guidobaldo and his wife Elisabetta Gonzaga, Raphael

had been brought up in the ambience of the ideal court that Castiglione remembered with such sweet nostalgia. Though he was never a salaried member of the court, Raphael received several court commissions and was probably tutored by Timoteo Viti (his father's successor as court artist) in the 1490s. Later, he was trained by Perugino, before receiving an invitation in 1508 from Pope Julius II to work in Rome. There his art achieved the "faultless perfection" that Vasari attributed to a study of the best ancient and modern masters and his reputation soared: he had his own palace and only his premature death prevented him from becoming a cardinal and thus the first artist-prince.

Raphael had a team of assistants who executed works from his cartoons and engraved his compositions. These cartoons and engravings found their way to different centers, where they had a profound impact on the artists who saw them. Titian was greatly taken by the cartoon of Raphael's portrait of Giovanna of Aragon, which he saw at Ferrara while he was working on paintings for Duke Alfonso d'Este's *camerino*. He had also seen another Raphael masterpiece when he slipped off to Mantua with the Ferrarese court painter Dosso Dossi while his patron was otherwise preoccupied by a joust. This was Raphael's portrait of Castiglione (FIG. 125), a painting which sums up many of the courtly ideals of the time. The picture is a visual manifestation of artistic and aristocratic *grazia* (grace), decorum, and stylish ease. The informality of Castiglione's pose and the disarming simplicity of the design belie the complexity of the image. Castiglione had urged the perfect courtier "to practice in all things a certain nonchalance that conceals all artistry and makes whatever one says or does seem uncontrived and effortless."

While Raphael was working on his famous series of Vatican rooms for Pope Julius II, and Michelangelo was painting the Sistine ceiling just a few apartments away, the young Federico Gonzaga was lodged in the Vatican Belvedere as a boy hostage to the Pope (1509). When he became the fifth Marquis of Mantua in 1519, Federico determined to bring the same full-blown magnificence to his state. Using the ebullient Venetian writer Pietro Aretino as his agent, and the refined Count Castiglione as his ambassador, he succeeded in enticing Raphael's foremost pupil, Giulio Romano (c. 1499-1546), to Mantua in 1524. Aretino was later to provide a similar service to the French king Francis I

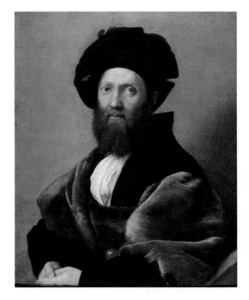

125. RAPHAEL OF URBINO
Portrait of Baldassare Castiglione, c. 1514-15. Oil on canvas, 32⅛ x 26½" (82 x 67 cm). Louvre, Paris.

The asymmetry of the count's face, with its different-sized eyes, helps give this famous portrait its graceful vitality. Castiglione himself had advised that harmony should never be too affected: "Imperfect consonances should be introduced to establish contrast" so that one enjoys "the perfect consonances even more."

and the Spanish emperor Charles V, spreading the fame of artists like Titian and Rosso Fiorentino through the power of his pen.

Giulio was to remain in Mantua as court painter and architect for twenty-two years; the sculptor and goldsmith Benvenuto Cellini (1500-1571) found him there "living like a lord." Whereas Mantegna had relied on few assistants, Giulio delegated manual execution of his extraordinarily rich ideas to a swarm of pupils. The sheer exuberance and sensuality of his paintings, his translation of antique prototypes into a "modern" idiom, and his brilliant feats of illusionism reveal the continuity and adaptation of fifteenth-century court ideals. The great Sala di Psiche in the Palazzo del Te is designed to delight (FIG. 126), while the Sala dei Giganti is a colossal and boisterous display of illusionistic skills calculated to thrill and overwhelm the viewer (see FIG. 124, page 171). With the palace itself Guilio took great architectural liberties, introducing irregular proportions and making a virtue of the resulting oddities.

In Giulio Romano's flamboyant decorations there are still the *ilarità* (gaiety), *delizie* (delights), and decorative illusionism that were so prized and promoted by the courts. With Giulio's illusionism, however, there is a move away from the elegant light-heartedness of the famous ceiling oculus of Mantegna. Perhaps as

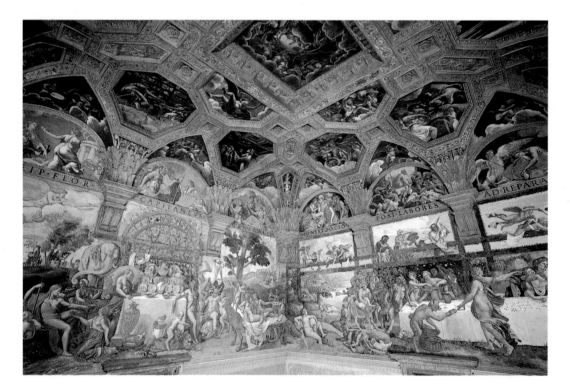

a reflection of the excesses and turbulence of the times, viewers were now looking to be terrified and dazzled by such effects. The decorum that had previously dictated the shape of courtly behaviour and the arts is only observed in so far as these decorations adorn a pleasure palace. The Palazzo del Te's "braggart and fanciful nature" had been associated with the "brassy success of a dynasty" that survived by prostituting itself to the papacy and the invading French and Spanish powers. The sixteenth century was to see the swallowing-up of small princely and republican states (Mantua and Lucca were among the few survivors) and the emergence of large "triumphalist" powers. A new artistic quality, *terribilità* – used by Vasari to describe the works of both Michelangelo and Mazzoni – has its parallel in the "awesome power" wielded by sixteenth-century popes and princes.

Mythological scenes, like those decorating the Sala di Psiche, were very much a genre promoted by the courts. The elitist nature of such images was made clear by a contemporary Dominican friar, who felt that "simple people," due to the preponderance of religious images in their lives, would not understand mythological subjects; they would "revere Hercules, thinking him Samson, and Venus, thinking her Magdalene." While the mythologies in Alfonso d'Este's *camerino* were deliberate recreations of ancient masterpieces (FIG. 127), they also allowed the patron to indulge his pleasure in sensual nudes, and the painter to rival the sculptor in the tactile sensations evoked through his dazzling handling of his medium.

Federico II Gonzaga followed the example of his mother Isabella d'Este and his uncle Alfonso I d'Este in collecting works by the finest painters. Art collecting, as the Florentine humanist Poggio Bracciolini argued, was not a mark of nobility in itself. If so, he told Lorenzo di Giovanni de' Medici in his *On Nobility* (*De Nobilitate*), "pawnbrokers would be noble." Bracciolini, however, was referring to the small-scale object-based collection formed by the Medici themselves, which could be readily translated into collateral. The new brand of art collection that graced the courts of the early sixteenth century consisted of outstanding painted masterpieces – collected for pleasure, prestige, and as an expression of taste. Alfonso d'Este, like his father Ercole and sister Isabella, had ambassadors and diplomats who acted as scouts, alerting him to the best works of art and artists available (his *camerino* was planned to showcase the work of the finest masters of Florence, Venice, and Rome). The agents' correspondence defines the individual *maniera* of painters, and shows a developing language of connoisseurship.

126. GIULIO ROMANO, WITH RINALDO MANTOVANO, BENEDETTO PAGNI DA PESCIA, AND ASSISTANTS Sala di Psiche: *Wedding Banquet of Cupid and Psyche*, 1527-30. Fresco. Palazzo del Te, Mantua.

According to Vasari, Giulio's pupils executed most of the room to his designs and then the master "almost completely retouched" their work so that it seemed to be entirely his own (a technique learned from Raphael). The groaning sideboard, however, on which the wine-god Bacchus nonchalantly leans, is completely by Giulio's hand: Vasari notes the rows of "unusual vases, basins, jugs, cups, goblets ... that are so lustrous they seem to be made of real silver and gold." The Emperor Charles V dined alone in the Sala di Psiche on his visit to Mantua in April 1530, with Federico II Gonzaga standing in attendance.

127. TITIAN
Bacchus and Ariadne, 1523.
Oil on canvas, 5'9" x 6'3"
(1.7 x 1.9 m). National
Gallery, London.

This is one of three
mythological paintings by
Titian for Duke Alfonso
d'Este's Camerino d'Alabastro
(named after its alabaster
reliefs by Antonio Lombardo).
The room was situated in the
Via Coperta, a covered,
raised passageway linking the
palace to the castle. It also
featured Bellini's *Feast of The
Gods* (FIG. 14) and paintings
by the Ferrarese court painter
Dosso Dossi. Raphael and
the Florentine master Fra
Bartolomeo were also
commissioned to produce
Bacchanalian masterpieces,
but these were never
executed. Titian's exuberant
scene is based on
descriptions in classical texts
and features cheetahs from
the duke's menagerie.

Vasari, in his *Lives of the Artists*, written for Cosimo de' Medici, Grand Duke of Tuscany, in 1550 and revised in 1568, defined *grazia* as one of the hallmarks of an artist's most beautiful style (*bella maniera*). Influenced by Castiglione, he urged the artist to disguise his labor and study and stress his *facilità* (ease) and *prestezza* (quickness of execution). The appreciation of these qualities was no doubt encouraged by the speed required of artists at court, and the levels of proficiency attained in fresco and oil techniques. Alberti had always stressed the joining of *diligenza* (diligence) with *prestezza*. Castiglione even recommended that a painting shouldn't be finished too thoroughly – but should hint that the artist is so skilful that he can afford to hold something in reserve. The correlation with Federico da Montefeltro and Alfonso d'Este's emblem of the bombshell is irresistible: an image of explosive power ready to be unleashed. This tantalizing "lack of finish," exhibited so boldly in Titian's later work, belongs to a world in which the artist's abundant powers of invention and fluency were coming to be valued more than delicacy of technique.

In his "Life of Giulio Romano" – painter, architect, designer *extraordinaire* – Vasari claimed that no one was "better grounded" (being the pupil of Raphael was the equivalent of noble lineage), "bolder, more confident, more inventive, versatile, prolific, and well rounded, not to mention for the present that he was extremely gentle in conversation, jovial, affable, gracious, and absolutely abounding in the finest manners." It was precisely this combination of professional skills and social accomplishments that was expected of a court artist in the first half of the sixteenth century. Vasari recognized that the court artist had to live in an environment ruled by envy and ambition, where there was no peace or tranquillity. Yet while the latter might be conducive to family life and artistic study, it did not act as a spur to artistic greatness. Only wealth and prestige, the fruits of powerful patronage, could stimulate the artist to climb to even greater heights. While Vasari, as a Florentine, stressed the pre-eminence of Florentine artists over those from other centers, he recognized that the courts were necessary to the furthering and rewarding of talent. Even Masaccio and Michelangelo felt the need to leave Florence and make their reputations at the papal court in Rome.

The difference between the court environment and the republican ambience of Florence is outlined in a famous passage in Vasari's "Life of Perugino." Florentine artists are spurred on to perfection by three things: constant criticism, since in a

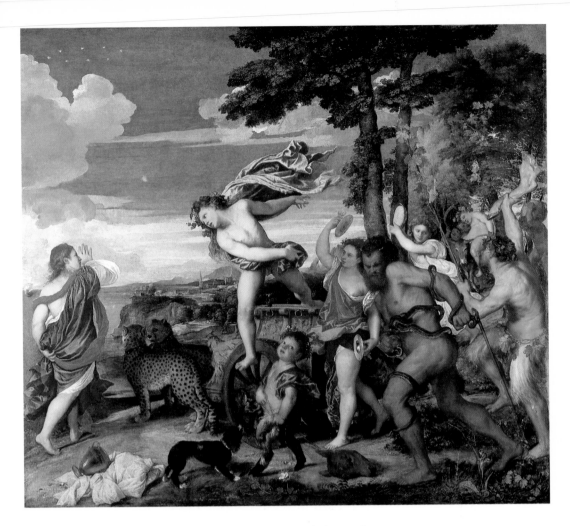

republic an artist can't rely on status to impress, being only as good as his last work; the need to be industrious in a city that "lacks a fertile countryside which might easily support its inhabitants"; and a thirst for glory. Yet if the perfection an artist has achieved goes unrewarded in financial and social terms, the desire for greatness turns into a festering resentment: "It is certainly true that when a man has learned all he needs to learn in Florence and, wishing to do more than live from day to day, like the animals, he wants to make himself rich, he must leave, and sell the excellence of his works and the reputation of the city to other places, just as the learned scholars from the university do."

This scenario of artists and humanist scholars looking for wealth and fame at the courts sets the stage for the elevation of the status of the arts. Their chances were best at the smaller courts, like Mantua, Ferrara, and Urbino. Thus humanist courtiers like

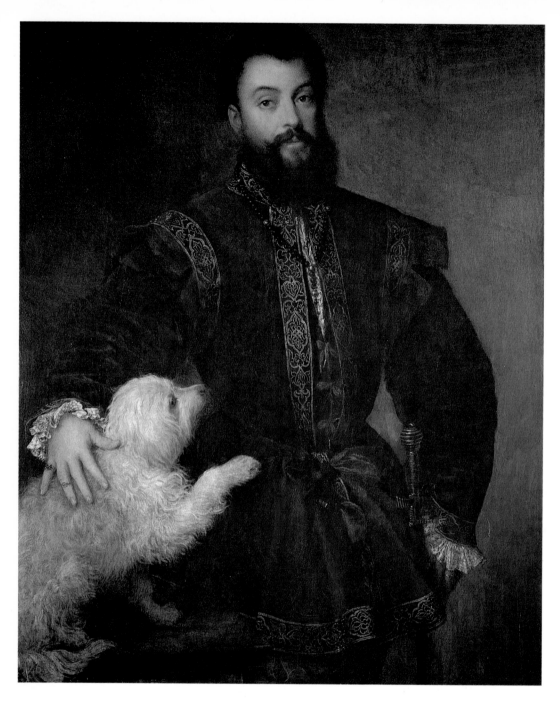

128. Titian
Federico II Gonzaga, c. 1530. Oil on panel, 4'1³⁄₈" x 3'3¹⁄₈" (1.2 m x 99 cm). Prado, Madrid.

Pietro Bembo and Castiglione recalled the intimate atmosphere of courts like Alessandro Sforza's at Pesaro or the Montefeltro's at Urbino with particular fondness. Later generations may have come to associate the courts with decadence and luxury, but it was in this environment that the Renaissance artist achieved a measure of independence.

Titian's career, more than that of any other artist, illustrates the lure of money and the greatness conferred by distinguished courtly patrons. Early in his career he was prepared to defraud a papal legate for whom he had painted an altarpiece by selling one of its side panels (a magnificent nude St. Sebastian) to Alfonso d'Este and replacing it with a replica. Titian went on to enjoy the patronage of Federico II Gonzaga, the Habsburg emperor Charles V and his son Philip II, as well as successive popes, turning from grand altarpieces to portraits and smaller decorative works. His portrait of Federico Gonzaga of c. 1530 reveals not only the assured confidence of the patron, but also the facility of the artist in this most courtly of art forms (FIG. 128). While Mantegna insisted on working from life, Titian could produce likenesses from medals, miniatures, or other paintings. Federico was so enamoured with Titian's portrait skills that he used the artist to further his relations with Charles V. Titian's portrait of the Holy Roman Emperor earned him 500 scudi (roughly the equivalent of 500 ducats) and the titles of Count Palatine and Knight of the Golden Spur.

Artists like Titian, Michelangelo, and Raphael, who achieved fame at the courts but never held permanent court positions, used their connections to guarantee their independent status. Michelangelo found himself in the enviable position of being able to decline invitations to work for the Turkish emperor, Francis I, Charles V, the Signoria of Venice and Florence's Duke Cosimo de' Medici. For the resident court artist, his "privileges" may have been extended to include the indulging of eccentricities of behaviour and the recognition of artistic freedom of expression (within certain limits), but he was still expected to "serve." The nature of the court artist's continuing dependency is made clear in a passage from the sculptor Benvenuto Cellini's flamboyant autobiography, of 1558 to 1562. Here he relates how his patron King Francis I took him to task one day: "It is a strange thing, Benvenuto, that you and others, clever as you are, refuse to recognize that you cannot display your talents by yourselves and that you can only demonstrate your greatness when we give you the opportunity; you should therefore show rather more obedience, and rather less pride and self-love."

Genealogies

The following genealogies have been simplified where necessary in the interests of clarity.

...... Illegitimate line

1. Aragon rulers of the Kingdom of Naples

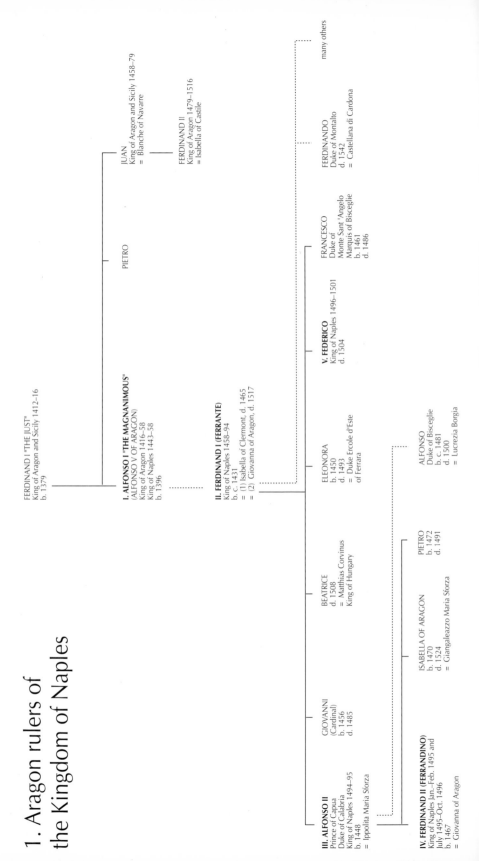

FERDINAND I "THE JUST"
King of Aragon and Sicily 1412–16
b. 1379

JUAN
King of Aragon and Sicily 1458–79
= Blanche of Navarre

PIETRO

FERDINAND II
King of Aragon 1479–1516
= Isabella of Castile

many others

FERDINANDO
Duke of Montalto
d. 1542
= Castellana di Cardona

I. ALFONSO I "THE MAGNANIMOUS"
(ALFONSO V OF ARAGON)
King of Aragon 1416–58
King of Naples 1443–58
b. 1396

FRANCESCO
Duke of
Monte Sant 'Angelo
Marquis of Bisceglie
b. 1461
d. 1486

II. FERDINAND I (FERRANTE)
King of Naples 1458–94
b. c.1431
= (1) Isabella of Clermont, d. 1465
= (2) Giovanna of Aragon, d. 1517

V. FEDERICO
King of Naples 1496–1501
d. 1504

ELEONORA
b. 1450
d. 1493
= Duke Ercole d'Este
of Ferrara

ALFONSO
Duke of Bisceglie
b. c. 1481
d. 1500
= Lucrezia Borgia

BEATRICE
d. 1508
= Matthias Corvinus
King of Hungary

PIETRO
b. 1472
d. 1491

GIOVANNI
(Cardinal)
b. 1456
d. 1485

ISABELLA OF ARAGON
b. 1470
d. 1524
= Giangaleazzo Maria Sforza

III. ALFONSO II
Prince of Capua
Duke of Calabria
King of Naples 1494–95
b. 1448
= Ippolita Maria Sforza

IV. FERDINAND II (FERRANDINO)
King of Naples Jan.–Feb. 1495 and
July 1495–Oct. 1496
b. 1467
= Giovanna of Aragon

2. Montefeltro rulers of Urbino

3. Visconti rulers of Milan

UBERTO VISCONTI
d. 1248

OBIZZO VISCONTI

TEBALDO VISCONTI
d. 1276

I. MATTEO I VISCONTI
Captain of the People 1287–1302
Imperial Vicar 1311–22
b. 1250
d. 1322
= Bonacossa di Squarcino Borri, d. 1321

II. GALEAZZO I VISCONTI
Signore of Milan and Imperial Vicar 1322–27
b. c. 1277
d. 1328
= Beatrice d'Este, d. 1334

III. AZZONE VISCONTI
Signore of Milan 1329–39
b. 1302
d. 1339
= Catherine of Savoy, d. 1388

V. GIOVANNI VISCONTI
Archbishop of Milan 1339–54
Co-Signore of Milan 1339–49
Signore of Milan 1349–54
b. 1290
d. 1354

IV. LUCHINO
Co-Signore of Milan 1339–49
b. 1292
d. 1349
= (1) Violante of Saluzzo
= (2) Caterina Spinola
= (3) Isabella Fieschi

STEFANO VISCONTI
Signore of Arona 1325
d. 1327
= Valentina Doria

VI. MATTEO II VISCONTI
Co-Signore 1354–55
b. c. 1319
d. 1355
= Gigliola Gonzaga, d. 1356

CATERINA
d. 1382
= Ugolino Gonzaga

ANDREINA
(nun)

MARCO
d. 1382
= Elizabeth
of Bavaria

LUDOVICO
d. 1404

CARLO
d. 1404
= Beatrice
of Armagnac

VERDE
d. 1403
= Leopold III
Duke of Austria

TADDEA
d. 1381
= Stephen III
Duke of Bavaria

VII. BERNABÒ VISCONTI
Co-Signore of Milan 1354–78
b. 1323
d. 1385
= Regina della Scala, d. 1384

VII. GALEAZZO II VISCONTI
Co-Signore 1354–78
= Blanche of Savoy, d. 1387

LUCIA
d. 1424
= Edmund Holland
Duke of Kent

AGNESE
d. 1391
= Francesco
Gonzaga

VALENTINA
d. 1393
= Peter I of Lusignan
King of Cyprus

ANTONIA
= Everard III
Count of Württemberg

MADDALENA
d. 1404
Frederick
Duke of Bavaria

ELISABETTA
d. 1432
= Ernest
Duke of Bavaria

CATERINA
d. 1404
= Giangaleazzo Visconti

VIOLANTE
d. 1386
= (1) Lionel, Duke of Clarence
= (2) Secondotto Paleologo, Marquis of Monterrato
= (3) Ludovico di Bernabò Visconti

VIII. GIANGALEAZZO VISCONTI
Signore of Milan 1378–95
Duke of Milan 1395–1402
b. 1351
= (1) Isabella of Valois, d. 1372
= (2) Caterina di Bernabò Visconti

BEATRICE
d. 1410
= Giovanni Anguissola

MARIA
d. 1362

IX. GIOVANNI MARIA VISCONTI
Duke of Milan 1402–12
b. 1388
= Antonia Malatesta

X. FILIPPO MARIA VISCONTI
Count of Pavia 1402–47
Duke of Milan 1412–47
b. 1392
= (1) Beatrice, Countess of Tenda, d. 1418
= (2) Maria of Savoy, d. 1469

VALENTINA
b. 1370
d. 1408
= Louis of Valois, Duke of Orléans

CHARLES
Duke of Orléans

LOUIS XII
King of France 1498–1515
(ruled Milan 1499–1512)

(Ambrosian Republic 1447–50)

BIANCA MARIA
d. 1468

= (3)

XI. FRANCESCO I SFORZA
Duke of Milan 1450–66
Marquis of Ancona
b. 1401
= (1) Polissena Ruffo
Countess Of Montalto
d. 1427
= (2) ? Caldora

GENEALOGY 4. SFORZA

4. Sforza rulers of Milan

MUZIO ATTENDOLO SFORZA
Count of Cotignola
b. 1369
d. 1424

ALESSANDRO
Signore of Pesaro 1445–73
b. 1409
d. 1473

XI. FRANCESCO I SFORZA
Duke of Milan 1450–66
Marquis of Ancona, b. 1401
= (1) Polissena Rufo
Countess of Montalto, d. 1427
= (3) Bianca Maria Visconti, d. 1468

GINEVRA
b. c 1440
d. c 1507
= (1) Sante Bentivoglio
Signore of Bologna
= (2) Giovanni Bentivoglio
Signore of Bologna

XII. GALEAZZO MARIA SFORZA
Count of Pavia
Duke of Milan 1466–76
b. 1444
betr. Dorotea Gonzaga, d. 1467 (?)
= Bona of Savoy, d. 1503

IPPOLITA MARIA
b. 1445
d. 1488
= Alfonso II of Aragon

FILIPPO MARIA
Count of Corsica
b. 1448 (?)
d. 1492

SFORZA MARIA
Duke of Bari
b. 1451
d. 1479

XIII. LUDOVICO MARIA SFORZA "IL MORO"
Duke of Bari 1479
Duke of Milan 1494–99 and 1500
b. 1452
d. 1508
= Beatrice d'Este, d. 1497

ASCANIO MARIA
Bishop of Pavia, Novara,
Cremona, and Pesaro,
Cardinal 1484
b. 1455
d. 1505

ELISABETTA MARIA
b. 1456
d. 1472
= Guglielmo VIII
Paleologo
Marquis of Monferrato

GIAMPAOLO
Marquis of Caravaggio,
Count of Galliate
d. 1535
= Violante Bentivoglio

LEONE
(Abbot)
d. 1501

BIANCA
d. 1497
= Galeazzo
Sanseverino

GIOVANNI MARIA
Archbishop of Genoa
d. 1520

XV. MASSIMILIANO SFORZA
Prince of Pavia 1499
Duke of Milan 1512–15
d. 1530

XVI. FRANCESCO II SFORZA
Duke of Milan 1521–24, 1525, 1529–35
Prince of Pavia 1530
d. 1535
= Christina of Denmark, d. 1590

SFORZA 'SECONDO'
Count of Borgonovo
b. 1433
d. 1501

TRISTANO
b. 1429
d. 1477
= Beatrice d'Este
da Correggio

MADDALENA
= Matteo Litta

DRUSIANA
b. 1437
d. 1474
= Jacopo Piccinino

FIORDELISA
b. 1452
d. 1522
= Guidaccio Manfredi

OTTAVIANO
Bishop of Lodi
and Arezzo
b. 1477
d. 1541

GALEAZZO
Count of Melzo
b. 1476
d. 1515

ISOTTA
b. 1428
d. 1485 or 1487
= (1) Andrea Matteo Acquaviva
Duke of Atri
= (2) Giovanni Maurizi

POLISSENA
b. 1428
d. 1449
= Sigismondo Malatesta
Signore of Rimini

CATERINA
b. 1463
d. 1509
= (1) Girolamo Riario,
Signore of Imola
= (2) Jacopo Feo
= (3) Giovanni de' Medici

COSTANZO
b. 1447
d. 1483
= Camilla of Aragon

GALEAZZO
d. 1519

XIV. GIANGALEAZZO MARIA SFORZA
Duke of Milan 1476–94
b. 1469
= Isabella of Aragon, d. 1524

ERMES MARIA
Marquis of Tortona
b. 1470
d. 1503

BIANCA MARIA
b. 1472
d. 1510
= Maximilian I
Holy Roman Emperor

ANNA MARIA
b. 1476
d. 1497
= Alfonso d'Este

BATTISTA
b. 1446
d. 1472
= Federico da Montefeltro
Duke of Urbino

GIOVANNI
b. 1466
d. 1510

ISABELLA
b. 1503
d. 1561
= Cipriano Del Nero

5. Este rulers of Ferrara

I. AZZO I
Signore of Ferrara 1209–12
b. 1170

II. ALDOBRANDINO I
Signore of Ferrara 1212–15

III. AZZO II
Signore of Ferrara 1215–22, 1240–64

RINALDO
d. 1251

IV. OBIZZO I Signore of Ferrara 1264–93
b. 1247
= (1) Jacopina Fieschi
= (2) Costanza della Scala

V. AZZO III
Signore of Ferrara 1293–1308
= (1) Giovanna Orsini
= (2) Beatrice of Anjou

VI. ALDOBRANDINO II
Signore of Ferrara 1308 (abdicated)
= Alda Rangoni

(Venetian then papal rule 1308–17)

VII. RINALDO
Co-Signore of Ferrara 1317–35

VIII. NICCOLÒ I
Co-Signore of Ferrara 1317–44

IX. OBIZZO II
Co-Signore of Ferrara 1317–52
b. 1294

X. ALDOBRANDINO III
Signore of Ferrara 1352–61
b. 1335

XI. NICCOLÒ II
Signore of Ferrara 1361–88
b. 1338

XII. ALBERTO
Signore of Ferrara 1361–93
b. 1347

XIII. NICCOLÒ III
First Marquis of Ferrara, Reggio,
and Rovigo 1393–1441
= (1) Gigliola da Carrara, d. 1397
= (2) Parisina Malatesta, d. 1418
= (3) Ricciarda di Saluzzo, d. 1431

XIV. LEONELLO (legitimated)
Marquis of Ferrara, etc. 1441–50
b. 1407
= (1) Margherita Gonzaga, d. 1435
= (2) Maria of Aragon, d. 1444

FRANCESCO

NICCOLÒ
b. 1438
d. 1476

XV. BORSO
Marquis of Ferrara 1450–71
First Duke of Ferrara 1471
Duke of Modena and Reggio
and Count of Rovigo 1452–71
b. 1413

ISOTTA
b. 1425
d. 1456
= Oddantonio
da Montefeltro

BEATRICE
b. 1427
d. 1492
= (1) Niccolò
da Correggio
= (2) Tristano Sforza

BIANCA MARIA
b. 1440
d. 1506
= Galeotto Pico
della Mirandola

many others

LUCIA
b. 1419
d. 1437
= Carlo Gonzaga

GINEVRA
b. 1419
d. 1440
= Sigismondo
Malatesta of Rimini

SIGISMONDO
b. 1433
d. 1507

XVI. ERCOLE I
Duke of Ferrara, etc.
1471–1505
b. 1431
= Eleonora of Aragon

GIULIO
b. 1478
d. 1561

LUCREZIA
d. 1516 or 1518
= Annibale Bentivoglio

BEATRICE
b. 1475
d. 1497
= Ludovico Maria Sforza
"Il Moro"

ISABELLA
b. 1474
d. 1539
= Francesco II Gonzaga

XVII. ALFONSO I
Duke of Ferrara 1505–34
b. 1476
= (1) Anna Sforza, d. 1491
= (2) Lucrezia Borgia, d. 1502

FERRANTE
b. 1477
d. 1540

IPPOLITO I (Cardinal)
b. 1479
d. 1520

SIGISMONDO
b. 1480
d. 1524

6. Gonzaga rulers of Mantua

I. LUIGI
First Captain of Mantua 1328–60
b. c. 1268

II. GUIDO
Captain of Mantua 1360–69
b. c. 1290

III. LUDOVICO
Captain of Mantua 1369–82
b. 1334
= Alda d'Este, d. 1381

IV. FRANCESCO I
Captain of Mantua 1382–1407
b. 1366
= Margherita Malatesta, d. 1399

V. GIANFRANCESCO
Captain of Mantua 1407–33
Marquis of Mantua 1433–44
b. 1395
= Paola Malatesta, d. 1453

MARGHERITA
b. 1418
d. 1439
= Leonello d'Este

CARLO
(condottiere)
b. 1417
d. 1456
= Lucia d'Este

GIANLUCIDO
b. 1423
d. 1448

CECILIA
b. 1426
d. 1451

ALESSANDRO
b. 1427
d. 1466

VI. LUDOVICO
Marquis 1444–78
b. 1412
= Barbara of Brandenburg
d. 1481

FRANCESCO
(Cardinal)
b. 1444
d. 1483

RODOLFO
b. 1451
d. 1495
= (1) Anna de' Malatesta
= (2) Caterina Pico

DOROTEA
b. 1449
d. 1467 (?)

BARBARA
b. 1455
d. 1505
= Eberhard
Duke of Württemberg

LUDOVICO
(Bishop of Mantua)
b. 1460
d. 1511

PAOLA
b. 1463
d. 1497
= Leonhard
Count of Görz

GIANFRANCESCO
Lord of Bozzolo
and Sabbioneta
b. 1446
d. 1496
= Antonia del Balzo,
d. 1538

and 2
others

VII. FEDERICO
Marquis 1478–84
b. 1441
= Margaret of Bavaria
d. 1479

SIGISMONDO
(Cardinal)
b. 1469
d. 1525

ELISABETTA
b. 1471
d. 1526
= Guidobaldo da Montefeltro
Duke of Urbino

MADDALENA
b. 1472
d. 1490
= Giovanni Sforza
of Pesaro

GIOVANNI
b. 1474
d. 1523

LUDOVICO
d. 1540

PIRRO
Lord of Bozzolo
and San Martino
dall 'Argine
d. 1529

CHIARA
b. 1465
d. 1503 or 1505
= Duc de Montpensier

VIII. FRANCESCO II
Marquis 1484–1519
b. 1466
= Isabella d'Este, d. 1539

IPPOLITA
(nun)
b. 1501
d. 1570

ERCOLE
(Cardinal)
b. 1505
d. 1563

LIVIA
(nun)
b. 1508
d. 1569

FERRANTE
Prince of Guastella
1539–57
b. 1507
= Isabella of Capua

LUIGI "RODOMONTE"
Lord of Sabbioneta
b. 1500
d. 1532
= Giulia Colonna, d. 1570

ELEONORA
b. 1494
d. 1570
= Francesco Maria della Rovere
Duke of Urbino

IX. FEDERICO
Marquis of Mantua 1519–30
Duke of Mantua 1530–40
b. 1500
= Margherita Paleologo
of Monferrato, d. 1566

Political map of Italy at the close of the fifteenth century

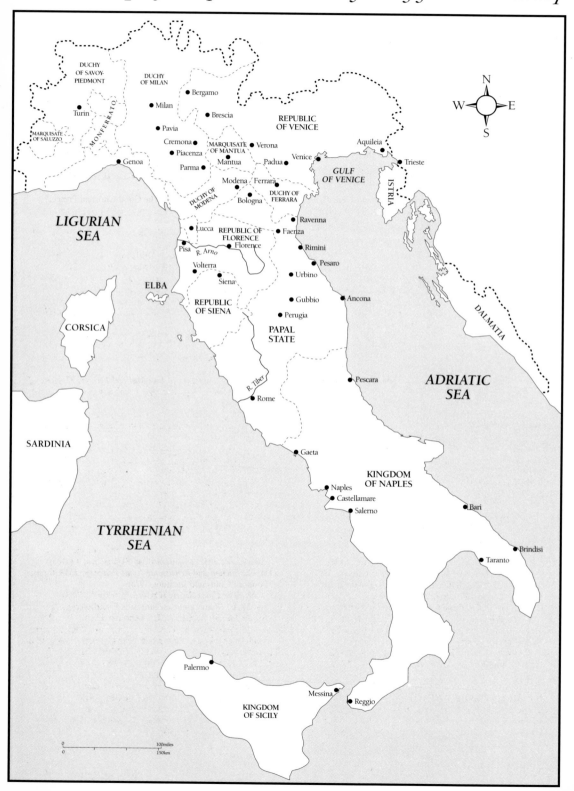

DUCHY OF SAVOY-PIEDMONT

DUCHY OF MILAN

MONFERRATO

MARQUISATE OF SALUZZO

Turin

Milan

Bergamo

Brescia

Pavia

Cremona

Piacenza

Parma

MARQUISATE OF MANTUA

Mantua

Verona

Padua

REPUBLIC OF VENICE

Venice

Aquileia

Trieste

GULF OF VENICE

ISTRIA

Genoa

Modena

Ferrara

DUCHY OF MODENA

Bologna

DUCHY OF FERRARA

Ravenna

LIGURIAN SEA

Lucca

REPUBLIC OF FLORENCE

Faenza

Florence

Rimini

Pisa

R. Arno

Pesaro

Volterra

Siena

Urbino

ELBA

Gubbio

Ancona

CORSICA

REPUBLIC OF SIENA

Perugia

PAPAL STATE

DALMATIA

ADRIATIC SEA

R. Tiber

Pescara

Rome

SARDINIA

Gaeta

KINGDOM OF NAPLES

TYRRHENIAN SEA

Naples

Castellamare

Salerno

Bari

Brindisi

Taranto

Palermo

Messina

Reggio

KINGDOM OF SICILY

0 100miles

0 150km

Bibliography

For translations and discussions of original Latin and Italian texts I am indebted in particular to the writings of Michael Baxandall (Bartolomeo Fazio, Lorenzo Valla, Guarino da Verona, Manuel Chrysoloras, Angelo Decembrio); Carol Kidwell (Giovanni Pontano); Creighton Gilbert; J. P. Richter (Leonardo da Vinci); and Martin Warnke. Translations of key treatises, such as Alberti's *On Painting* and Vasari's *Lives of the Artists* are included under their original titles. I have also given details of some specialist articles which contain important new research.

ACKERMAN, J. S., "The Certosa of Pavia and the Renaissance in Milan," *Marsyas*, 5 (1947-49)

ADY, C., A History of Milan under the Sforza (London: Methuen, 1907)

ALBERTI, LEON BATTISTA, *On the Art of Building in Ten Books* (eds J. J. Rykwert, N. Leach, and R. Tavernor; Cambridge, Mass. and London: MIT Press, 1988)

— *On Painting* (ed. M. Kemp and trans. C. Grayson; London: Penguin, 1991)

ALEXANDER, J. J. G. (ed.), *The Painted Page: Italian Renaissance Book Illumination 1450-1550* (exh. cat., London: Royal Academy of Arts and New York, Pierpont Morgan Library, 1994; Munich and New York: Prestel, 1994)

AMES-LEWIS, F., AND A. BEDNAREK (eds), *Mantegna and 15th-Century Court Culture* (London: Birkbeck College, 1993)

BAXANDALL, M., "A Dialogue on Art from the Court of Leonello d'Este: Angelo Decembrio's 'Politia Litteraria' Pars LXVIII," *Journal of the Warburg and Courtauld Institutes*, 26 (1963)

— *Giotto and the Orators* (Oxford: Clarendon Press, 1971)

— *Painting and Experience in Fifteenth-century Italy* (Oxford: Clarendon Press, 1972)

BENTLEY, J. H., *Politics and Culture in Renaissance Naples* (Princeton, N.J.: Princeton University Press, 1987)

BERNARDI, P., *Carthusian Monastery of Pavia* (Novara: Istituto Geografico De Agostini, 1986)

BERTELLI, C., *Piero della Francesca* (New Haven and London: Yale University Press, 1992)

BERTELLI, S., F. CARDINI, AND E. GARBERO ZORZI, *Italian Renaissance Courts* (London: Sidgwick and Jackson, 1986)

BOLOGNA, F., *Napoli e le rotte Mediterranée della pittura: da Alfonso il Magnanimo a Ferdinando il Cattolico* (Naples: Società napoletana di storia patria, 1977)

BOLOGNA G., *Milan e gli Sforza: Gian Galeazzo Maria e Ludovico il Moro (1476-1499)* (Milan: Rizzoli, 1983)

BORSI, F., *Bramante* (Milan: Electa, 1989)

BRAMBILLA BARCILON, P., AND P. C. MARANI, *Le Lunette di Leonardo nel Refettorio delle Grazie* (Milan: Olivetti, 1990)

BURCKHARDT, J., *The Civilization of the Renaissance in Italy* (2nd ed.; Oxford: Phaidon, 1981)

BURKE, P., *The Italian Renaissance: Culture and Society in Italy* (rev. ed.; Princeton, N.J.: Princeton University Press, 1986)

CAMPBELL, L., *Renaissance Portraits* (New Haven and London: Yale University Press, 1990)

CASTELFRANCHI, L., AND J. SHELL (eds), *Giovanni Antonio Amadeo: Scultura e Architettura del suo Tempo* (Milan: Cisalpino, 1993)

CASTIGLIONE, BALDASSARE, *The Book of the Courtier* (trans. G. Bull; London: Penguin, 1967)

CHAMBERS, D., AND J. MARTINEAU (eds), *The Splendours of the Gonzaga* (exh. cat., London: Victoria and Albert Museum, 1981)

CHAMBERS, D. S., *Patrons and Artists in the Italian Renaissance* (London: Macmillan, 1970)

— "Sant'Andrea at Mantua and Gonzaga Patronage 1460-1472," *Journal of the Warburg and Courtauld Institutes*, 40 (1977)

CHELES, L., *The Studiolo of Urbino: An Iconographic Investigation* (University Park, Pa.: Pennsylvania State University Press, 1986)

CLARK, N., *Melozzo da Forlì* (London: Philip Wilson, 1990)

CLOUGH, C. H. (ed.), *Cultural Aspects of the Italian Renaissance: Essays in Honour of Paul Oscar Kristeller* (Manchester: Manchester University Press, 1976)

— *The Duchy of Urbino in the Renaissance* (London: Variorum Reprints, 1981)

— "Federigo da Montefeltro: The Good Christian Prince," *Bulletin of the John Rylands Library*, LXVII, 1 (Autumn 1984)

CORDARO, M. (ed.), *Mantegna's Camera degli Sposi* (Milan and New York: Electa, 1993)

CORIO, BERNARDINO, *Storia di Milano*, (ed. A. Morisi Guerra; Turin: Unione tipografico-editrice-torinese, 1978)

CORTI, G., AND L. FUSCO, "Lorenzo de' Medici on the Sforza Monument," *Achademia Leonardi Vinci*, 5 (1992)

CZARTORYSKI, W., et al. (eds), *Circa 1492: Art in the Age of Exploration* (exh. cat., Washington, D.C.: National Gallery of Art, 1991)

DAL POGGETTO, P. (ed.), *Piero e Urbino: Piero e le corti Rinascimentali* (exh. cat., Urbino, Palazzo Ducale e Oratorio di San Giovanni Battista, 1992; Venice: Marsilio, 1992)

DEAN, T., *Land and Power in Late Medieval Ferrara: The Rule of the Este, 1350-1450* (Cambridge: Cambridge University Press, 1988)

DENNISTOUN, J., *Memoirs of the Dukes of Urbino... 1440-1630* (3 vols; London: Longman, Brown, Green, and Longman, 1851)

DICKENS, A. G. (ed.), *The Courts of Europe: Politics, Patronage and Royalty 1400-1800* (New York: McGraw Hill, 1977)

DRISCOLL, E. R., "Alfonso of Aragon as a Patron of Art," *Essays in Memory of Karl Lehmann* (ed. L.F. Sandler; New York: Institute of Fine Art, NYU, 1964)

DUNKERTON, J., S. FOISTER, D. GORDON, AND N. PENNY, *Giotto to Durer: Early Renaissance Painting in the National Gallery* (New Haven and London: Yale University Press, 1991)

EICHE, S., "Towards a Study of the 'Famiglia' of the Sforza Court at Pesaro," *Renaissance and Reformation*, 9 (1985)

ELAM, C., *Studioli and Renaissance Court Patronage* (MA thesis; London: Courtauld Institute, 1970)

ELIAS, N., *The Court Society* (Oxford: Blackwell, 1983)

EVANS, M. L., "New Light on Sforziada Frontispieces...," *British Library Journal*, XIII, 2 (Autumn 1987)

FILARETE, *Treatise on Architecture* (ed. and trans. J. R. Spenser; 2 vols; New Haven, and London: Yale University Press, 1965)

FORTI GRAZZINI, N., *Arazzi a Ferrara* (Milan: Electa, 1982)

FOSSI TODOROW, M., *I Disegni del Pisanello e della sua cerchia* (Florence: Leo S. Olschki, 1966)

From Borso to Cesare d'Este: The School of Ferrara 1450-1628, (exh. cat., London: Matthiesen Fine Arts, 1984)

GERBONI BAIARDI, G., G. CHITTOLINI, AND P. FLORIANI (eds), *Federico da Montefeltro: Lo Stato, Le Arti, La Cultura* (3 vols; Rome: Bulzoni, 1986)

GILBERT, C. E., *Italian Art 1400-1500: Sources and Documents* (Englewood Cliffs, N.J., and London: Prentice Hall, 1980)

GOLDTHWAITE, R., *Wealth and the Demand for Art in Italy 1300-1600* (Baltimore: John Hopkins University Press, 1993)

GRAFTON, A., AND L. JARDINE, *From Humanism to the Humanities: Education and the Liberal Arts in Fifteenth- and Sixteenth-century Europe* (London: Duckworth, 1986)

GREEN, L., "Galvano Fiamma, Azzone Visconti and the Revival of the Classical Theory of Magnificence," *Journal of the Warburg and Courtauld Institutes*, 53 (1990)

GUNDERSHEIMER, W., *Ferrara: The Style of a Renaissance Despotism* (Princeton, N.J.: Princeton University Press, 1973)

HALE, J. R., *The Civilization of Europe in the Renaissance* (London: HarperCollins, 1993)

HARTT, F., *A History of Italian Renaissance Art: Painting Sculpture, Architecture* (rev. ed.; London: Thames and Hudson, 1987)

HAY, D., *Europe in the Fourteenth and Fifteenth Centuries* (2nd. ed.; London: Longman, 1989)

HERSEY, G. L., *Alfonso II and the Artistic Renewal of Naples, 1485-1495* (New Haven and London: Yale University Press, 1969)

— *The Aragonese Arch at Naples, 1443-1475* (New Haven and London: Yale University Press, 1973)

HILL, G. F., *A Corpus of Italian Medals of the Renaissance Before Cellini* (2 vols; London: British Museum, 1930)

HOLLINGSWORTH, M., *Patronage in Renaissance Italy: From 1400 to the Early Sixteenth Century* (London: John Murray, 1994)

HOPE, C., *Titian* (London: Jupiter, 1980)

— "The Early History of the Tempio Malatestiano," *Journal of the Warburg and Courtauld Institutes*, 55 (1992)

IANZITI, G., *Humanistic Historiography under the Sforzas* (Oxford: Clarendon Press, 1988)

JACOBS, E. F. (ed.), *Italian Renaissance Studies* (London: Faber and Faber, 1960)

JENKINS, A. D. FRASER, "Cosimo de' Medici's Patronage of Architecture and the Theory of Magnificence," *Journal of the Warburg and Courtauld Institutes*, 33 (1970)

JONES, P., *The Malatesta of Rimini and the Papal State: A Political History* (London: Cambridge University Press, 1974)

JONES, R., AND N. PENNY, *Raphael* (New Haven and London: Yale University Press, 1983)

KEMP, M., *Leonardo da Vinci: The Marvellous Works of Nature and Man* (London: Dent, 1981)

KEMPERS, B., *Painting, Power and Patronage: The Rise of the Professional Artist in the Italian Renaissance* (London: Allen Lane, 1992)

KENT, F. W., AND P. SIMON (eds), *Patronage, Art and Society in Renaissance Italy* (Oxford: Clarendon Press, 1987)

KIDWELL, C., *Pontano* (London: Duckworth, 1991)

KING, D., "Gasparo Visconti's *Pasitea* and the Sala delle Asse," *Achademia Leonardi Vinci*, 2 (1989)

KRISTELLER, P. O., *Mantegna* (London: Longman, 1901)

LEONARDO DA VINCI, *The Literary Works of Leonardo da Vinci* (ed. J. P. Richter, 2 vols; Oxford: Phaidon, 1977)

LIGHTBOWN, R., *Mantegna* (Oxford: Phaidon, 1986)

LOCKWOOD, L., *Music in Renaissance Ferrara, 1400-1505* (Oxford: Clarendon Press, 1984)

LUBKIN, G., *A Renaissance Court: Milan under Galeazzo Maria Sforza* (Berkeley and London: University of California Press, 1994)

LUGLI, A., *Guido Mazzoni e la Rinascità della Terracotta nel Quattrocento* (Turin: Allemandi, 1990)

LYTLE, G. F., AND S. ORGEL (eds), *Patronage in the Renaissance* (Princeton, N.J.: Princeton University Press, 1981)

MACHIAVELLI, NICCOLÒ, *The Prince* (ed. P. Bondanella and trans. P. Bondanella and Mark Musa; Oxford: Oxford University Press, 1984)

MALAGUZZI VALERI, F., *La Corte di Lodovico il Moro* (4 vols; Milan: Ulrico Hoepli, 1913-23)

MANCA, J., *The Art of Ercole de' Roberti* (Cambridge: Cambridge University Press, 1992)

— "The Presentation of a Renaissance Lord: Portraiture of Ercole I d'Este, Duke of Ferrara (1471-1505)," *Zeitschrift für Kunstgeschichte*, 52 (1989)

MARCIANO A. F., *L'età di Biagio Rossetti: Rinascimenti di Casa d'Este* (Ferrara: G. Corbo, 1991)

MARTINDALE, A., *The Triumphs of Caesar by Andrea Mantegna* (London: Harvey Miller, 1979)

MARTINEAU J., AND S. BOORSCH (eds), *Andrea Mantegna* (exh. cat., London: Royal Academy of Arts, 1992; London: Thames and Hudson, 1992)

MARTINES, L., *Power and Imagination: City States in Renaissance Italy* (New York: Knopf, 1980)

MILLON, H. A., AND V. MAGNAGO LAMPUGNANI (eds), *The Renaissance from Brunelleschi to Michelangelo: The Representation of Architecture* (exh. cat., Venice: Palazzo Grassi, 1994; London: Thames and Hudson, 1994)

MORROGH, A., et al. (eds), *Renaissance Studies in Honor of Craig Hugh Smyth* (2 vols, Villa I Tatti conference; Florence: Giunti Barbèra, 1985)

MORSCHECK, C. R., *Relief Sculpture for the Facade of the Certosa di Pavia, 1473-1499* (New York and London: Garland, 1978)

NATALE, M., AND A. MOTTOLA MOLFINO (eds), *Le Muse e il Principe: Arte di Corte nel Rinascimento Padano* (exh. cat., Milan: Museo Poldi Pezzoli, 1991; 2 vols, Milan: Franco Cosimo Panini, 1991)

OLSEN, H., *Urbino* (Copenhagen: G. E. C. Gads, 1971)

PADE, M., L. WAAGE PETERSEN, AND D. QUARTA (eds), *La Corte di Ferrara e il suo mecenatismo 1441-1598* (Copenhagen: Atti del Convegno Internazionale, 1989)

PANE, R., *Il Rinascimento nell'Italia Meridionale* (2 vols; Milan: Edizioni di Comunità, 1975)

PAPAGNO, G., AND A. QUONDAM, *La Corte e lo Spazio: Ferrara estense* (3 vols; Rome: Bulzoni, 1982)

PARTRIDGE, L., AND R. STARN, *Arts of Power* (Berkeley and Oxford: University of California Press, 1992

PATERA, B., *Francesco Laurana in Sicilia* (Palermo: Novecento, 1992)

PENMAN, B. (ed.), *Five Italian Renaissance Comedies* (Harmondsworth: Penguin, 1978)

PICCOLOMINI, AENEAS SILVIUS [Pope Pius II] *Memoirs of a Renaissance Pope: The Commentaries of Pius II* (ed. L. C. Gabel, trans. F. A. Gragg; London: Allen and Unwin, 1960)

POLICHETTI, M. L., *Il Palazzo di Federigo da Montefeltro* (Urbino: Quattroventi Edizioni, 1985)

POLLARD, J. G. (ed.), *Italian Medals: National Gallery of Washington Studies in the History of Art* (Washington D.C.: National Gallery of Art, 1987)

Renaissance Studies, III, 4 (1989), devotes an issue to court scholarship.

RETI, L. (ed.), *The Unknown Leonardo* (London: Hutchinson, 1974)

ROGER, M., "The Decorum of Women's Beauty ...," *Renaissance Studies*, II, 1 (1988)

ROSENBERG, C. M., *Art in Ferrara during the Reign of Borso d'Este (1450-1471)* (PhD thesis; Ann Arbor, Mich.: University of Michigan, 1974)

— "The Bible of Borso d'Este: Inspiration and Use," *Cultura Figurativa Ferrarese tra XV e XVI Secolo*, 1 (1981)

— (ed.), *Art and Politics in Late Medieval and Early Renaissance Italy: 1250-1500* (Notre-Dame, Ind. and London: University of Notre-Dame Press, 1990)

ROSSI, M., AND A. ROVETTA, *Il Cenacolo di Leonardo* (Milan: Olivetti, 1988)

ROTONDI, P., *Il Palazzo Ducale di Urbino* (2 vols; Urbino: L'Istituto Statale d'Arte, 1950)

RYDER, A. F. C., *The Kingdom of Naples under Alfonso the Magnanimous* (Oxford: Clarendon Press, 1976)

SALMONS, J., AND W. MORETTI (eds), *The Renaissance in Ferrara and its European Horizons* (Cardiff: University of Wales Press, 1984)

SCHER S. K. (ed.), *The Currency of Fame: Portrait Medals of the Renaissance*, (exh. cat., New York: Frick Collection, 1994; London: Thames and Hudson, 1994)

SIGNORINI, R., *La più bella camera del mondo: la Camera Dipinta* (Mantua: Editrice, 1992)

SKOGLUND, M. A., *In Search of the Art Commissioned and Collected by Alfonso I of Naples* (PhD thesis; Columbia: University of Missouri, 1989)

SMYTH, C. H., AND G. C. GARTANINI (eds), *Florence and Milan: Comparisons and Relations* (Acts of Two Conferences at the Villa I Tatti, Florence 1982-84; Florence: La Nuovo Italia editrice, 1989)

THOMSON, D., *Renaissance Architecture: Critics. Patrons. Luxury* (Manchester and New York: Manchester University Press, 1993)

TUOHY, T., *Studies in Domestic Expenditure at the Court of Ferrara* (PhD thesis; London: Warburg Institute, 1982)

VASARI, GIORGIO, *The Lives of the Artists* (trans. J. C. and P. Bondanella; Oxford: Oxford University Press, 1991)

— *Le Vite de' Più Eccelenti Pittori, Scultori ed Architettori* (ed. G. Milanesi, 9 vols; Florence: Sansoni, 1906)

VERHEYEN, E., *The Paintings in the Studiolo of Isabella D'Este at Mantua* (New York: New York University Press, 1971)

WARNKE, M., *The Court Artist* (Cambridge: Cambridge University Press, 1993)

WEIL-GARRIS, K., AND J. F. D'AMICO, "The Renaissance Cardinal's Ideal Palace: A Chapter from Cortesi's 'De Cardinalatu'," *Studies in Italian Art and Architecture...* (Memoirs of the American Academy in Rome, 35; Rome: American Academy in Rome, 1980)

WELCH, E. S., "The Image of a Fifteenth-century Court: Secular Frescoes for the Castello di Porta Giovia, Milan," *Journal of the Warburg and Courtauld Institutes*, 53 (1990)

— "Galeazzo Maria Sforza and the Castello di Pavia, 1469," *Art Bulletin*, LXXI, 3 (September 1989)

WESTFALL, C. W., *In This Most Perfect Paradise* (London: Pennsylvania State University Press, 1974)

WHITAKER, M., *The Legends of King Arthur in Art* (Woodbridge, Suffolk: D. S. Brewer, 1990)

WOODS-MARSDEN, J., *The Gonzaga of Mantua and Pisanello's Arthurian Frescoes* (Princeton, N.J.: Princeton University Press, 1988)

— (ed.) "Art, Patronage and Ideology at Fifteenth-century Courts," *Schifanoia: Notizie dell'Istituto di Studi Rinascimentali di Ferrara*, 10 (1990)

Picture Credits

Details of collections are given in the captions. Additional information, copyright credits, and photo sources are given below. Numbers are figure numbers unless indicated.

Alinari, Florence: 3, 32, 60, 79

James Austin, Cambridge: 11

Raffaello Bencini, Florence: 7, 17, 18, 62

Biblioteca Ambrosiana, Milan: 69 (Codex Atlanticus 53 v-ab)

Biblioteca Comunale Ariostea, Ferrara: 89 (photo B&G Studio Fotografico, Ferrara)

Biblioteca Estense, Modena: 97 (Lat. 422, MS V.G. 12, vol.I c.280 v), 103, and page 119 (detail of 97)

Biblioteca Nacional, Madrid: 75 (Codex 2, 149 r.)

Bibliothéque Nationale, Paris: 68 and 76 (Imp. Res.Velin 724) Museum Boymans van Beuningen, Rotterdam: 31

The Bridgeman Art Library, London/Giraudon, Paris: 20

The British Library, London: 34 (MS Add 28962 fol.281 v.)

Calmann & King, London: 110 (photo Ralph Lieberman)

Foto Chiolini, Pavia: 77, 80, 81

Museo Civico, Rimini: 25, 26, 56

The Cleveland Museum of Art: 15 (© The Cleveland Museum of Art, Leonard C.Hanna, Jr. 64.150)

Giancarlo Costa, Milan: 71

Devonshire Collection, Chatsworth: 96 (Reproduced by permission of the Chatsworth Settlement Trustees)

Arti Doria Pamphili, Rome: 90

Fotografica Foglia, Naples: 24, 37, 41, 43, 44, 45, 46, 47, 102, and page 45 (detail of 45)

Foto Moderna, Urbino: 2, 8, 54, 57, 61, 64, 66, 67, 82, 50, and page 91 (detail of 67)

Giovetti, Mantua: 16, 28, 111, 124, 126

Landesmuseum für Karnten, Klagenfurt, Austria: 5, and page 7 (detail of 5)

The Metropolitan Museum of Art, New York, Fletcher Fund, 1946: 4

Ali Meyer, Vienna: 119, 120

Paolo Mussat Sartor, Turin: 101

National Gallery, London: 1, 52, 95, 100, 118, 127

National Gallery of Art, Washington: 14 (Widener Collection), 91 (Samuel H. Kress Collection), 92 (Samuel H. Kress Collection), 99 (Ailsa Mellon Bruce Fund); all © 1995 National Gallery of Art, Washington, Board of Trustees

© Olivetti, Milan and Soprintendenza ai Beni Artistici: 85 (photo A. Quattrone)

Museo Poldi Pezzoli, Milan: 94

© Museo del Prado, Madrid: 35, 93, 128, and page 171 (detail of 128)

Réunion des Musées Nationaux, Paris: 42, 59, 105, 117, 122, 123, 125, and page 143 (detail of 122)

The Royal Collection, Windsor © Her Majesty Queen Elizabeth II: 116

Scala, Florence: pages 2-3, 6, 9, 10, 12, 13, 19, 23, 33, 36, 48, 49, 51, 53, 55, 58, 63, 65, 70, 72, 78, 83, 84, 87, 88, 98, 104, 106, 107, 108, 109, 112, 113, 114, 115, 121, 174, and page 93 (detail of 87)

Thyssen-Bornemisza Collection, Lugano: 29

© The Trustees of the Victoria & Albert Museum, London: 21, 22, 38, 39, 40, 73, 27, 30, 86, and page 17 (detail of 22)

Index